PRACTICAL VIDEO

The Manager's Guide to Applications

John A. Bunyan
James C. Crimmins
N. Kyri Watson

Knowledge Industry Publications, Inc.
White Plains, New York

PRACTICAL VIDEO: The Manager's Guide to Applications
by John A. Bunyan, James C. Crimmins, N. Kyri Watson

Library of Congress Cataloging in Publication Data

Bunyan, John A.
 Practical video.

 Bibliography: p.
 Includes index.
 1. Video tape recorders and recording.
I. Crimmins, James C., joint author. II. Watson,
N. Kyri, 1955- joint author. III. Title.
TK6655.V5B85 778.59 78-23533
ISBN 0-914236-20-2

Printed in the United States of America

090538

Table of Contents

Acknowledgments

Writing a book about how video is being used by institutions is a task that requires the willingness of video users to share their experiences, their programming and their time. We are grateful to the following people for giving us the opportunity to find out what is really going on in private television: Sam Agnello, Vernon Aker, A.R. Allen, Marshall E. Allen, Steve Autor, J.H. Avery, William Battison, Terry Baxter, Dr. Ronald Beckstrom, Henry Bohne, Cliff Braun, William Buckles, J.D. Carter, Tom Clayton, Donna Cunningham, Bruce Doud, Brian Dunphy, F. Keith Fearon, Elmer Friman, Sister Irene Fugazy, Eugene Goellner, Sgt. Michael Grant, Barry Hantman, Deborah Harter, Dr. Donald Hess, Paul Hinkleman, Jerry Holt, Dr. Erling Jorgensen, Robert Kermgard, Blair Knepher, Ken Koonsman, Thomas Krug, Eileen Matz, Jerry Melmed, Dan Mencucci, John Mulhern, Judith Nathan, Benjamin J. Oliveri, John Olsen, Bruce Ornsten, David Parsons, Robert Passaro, Michael D. Shetter, Calvin Smith, Ray Snyder, Jack Spatafora, Walter Vail, Richard Van Deusen, Walter Wagoner, Jr., David Watkins, Lynne Young.

For their assistance, we would also like to thank Michael Lattif, Thatcher Drew, Peggy Rajski, Robert Claflin, Donald Goodwin, Don Shea, Barbara Wasser, Sharon Mast, Grace Judson, Jonathan Golden and illustrator John Parkhurst. And a special thanks to Deborah A. Hudson for the valuable contribution of her time and talents.

John A. Bunyan
James C. Crimmins
N. Kyri Watson

1

Introduction

Ten years ago "video," as differentiated from simply "television," meant a low cost security technology, an experimental art form or a handful of experimental institutional projects — a "live" hookup of schools to a local educational production studio, for instance. Today, "video" still means "non-broadcast television," but it has taken on an incredible range of new identities. It is a principle means of medical education. It is complex networks connected by cable, satellite, microwave and the U.S. mail linking managers and employees, engineers with universities and a government agency with its field offices. And it is hundreds of hardware companies supplying tens of thousands of products in what will be, by 1980, a $1.5 billion market.

The 1970s brought about considerable technological advances, particularly the video cassette, which reduced the cost of distributing programming. Institutional involvement with video continues to grow, yet the success of projects and programming varies widely.

Matching the stories of success are the less visible examples of failure, such as an educational or corporate network which has fallen into gradual or sudden disuse. While individuals on the receiving end of television programming are usually willing to give video its chance in an institutional setting, viewer patience is short with programming whose benefits are not clear and useful. This is where the failures usually begin.

Video technology development has heretofore accounted for much of the press about video and for a great deal of the money invested in video by all

institutions. Compared to hardware improvements, the entire video industry has neglected programming development and effectiveness. The reasons are related to economics. Institutions are willing to pay for the hardware tools of production because these are regarded as necessary "capital" investments. Thus, outside suppliers have provided a steady stream of new equipment. But when it comes to programming, user organizations have sought to do production themselves in an effort to contain the institution's overall cost of "television operations." In fact, staff service departments within organizations have probably provided close to 90% of all institutional programming. In general, these departments of corporations, schools, universities and government agencies have not proven themselves to be particularly willing to take on the risk of innovation. Outside suppliers of programming are often less constrained in this regard. Programming, now only slightly more advanced than it was 10 years ago, has become the limiting factor to industry growth.

Since the greatest promise for private television now rests with the people and not the tools, the focus of this book is on what people are doing with video and what video is doing for people.

Video is successfully helping to manage the increased information and knowledge demands in businesses, schools, universities, government agencies at all levels and health care institutions. It is training more workers in less time, and educating more students for fewer dollars.

Some successful video operations have reported measurable benefits from video for their organizations. One manufacturer reports that video has increased trainee learning by 100%. A medical school says its students now achieve better scores on the National Boards. One manufacturer reports that video instruction takes one-fourth the time of conventional methods. Another business says video has lifted morale and reduced turnover. A school system has evidence that video lessons increased special education students' learning and retention by 80% between pre- and post-tests.

In the 1950s, video tape recording was the domain of commercial television broadcasters. The available equipment was bulky and expensive 2-inch quadruplex. A few large universities and medical schools ventured into private use — some setting up sophisticated studios, others using cameras and monitors to show live intricate procedures to more people. But for the most part, the cost and size of video equipment was prohibitive for the majority of non-commercial users.

In the mid- to late 1960s, smaller, simpler, less expensive helical scan video tape recorders were marketed, making private television production possible for a variety of institutional users. Thousands of schools, government agencies and businesses began experimenting with small format black and white program production. Businesses and industries began adapting video on a wide scale to in-house training programs, and that sector soon took the lead among private video users.

By the early 1970s, the video cassette "revolution" was underway. Though cassettes were developed with an eye toward a home consumer market, their first application was to create a low cost system of private television for institutional use. Television production and distribution in all institutional sectors were transformed by video cassettes. Television programs could be easily reproduced, mailed, shelved and played. In addition, "video publishers" began to produce and distribute standardized ("off-the-shelf") programs for use by business, health care and education; companies sprang up across the country offering a wide range of production and post-production services. The cassette side of the private television industry will represent an investment of more than $1 billion in programming and hardware by 1979.

Technological innovations such as miniaturization and increased availability of satellite transmission to private users have facilitated use of video by many institutions. They have turned to television because of such widespread factors as:

- geographic dispersion of companies and government agencies;
- excessive demands on the time of internal experts and the high cost of time of outside consultants;
- rising costs of quality education;
- necessity of continuing education throughout the careers of professionals, especially engineers, physicians and teachers;
- need for on-line education and training resources to be available wherever the student, trainee, medical personnel or teacher is;
- diminishing impact of and time to use written communications;
- expense of travel;
- commonalities between many institutions and disciplines that necessitate efficient and cost-effective sharing of information and exchange of ideas on a large scale.

These trends have spurred many of the current video programming applications: training employees in new skills, or in using old skills more efficiently; bringing employees and management, teachers and school boards, students and college presidents face-to-face; implementing policy in operating divisions worldwide; keeping employees, students and clients informed on happenings inside the organization and in related areas outside; extending the utilization of internal resources, such as top professors and managers; multiplying the return on fees paid to outside experts; providing on-line instructional capabilities at all levels. Marketing applications, such as product introductions and direct sales, have become areas of programming that many companies now consider as important as training. Patient and client education, public relations, entertainment, research and documentation have likewise found priority niches in many organizations. It also must be said that many applications have been born of experimentation and the need to justify the expense of a private television network.

According to a study done by Judith M. and Douglas P. Brush, the overall size of the private television industry doubled between 1973 and 1977.[1] They also estimate that 46,000 individual productions, totalling approximately 15,000 viewing hours, were produced by over 700 businesses and nonprofit organizations in 1977.[2] The study did not include educational and medical users, which would push the figures even higher. The Brushes project that the rate of growth in private television use will average 40% per year for the next four years, and that by 1980 the industry will have tripled in size.

But what does all this activity in private television mean to viewers? How does the "magic of television" work? Does seeing a role model, a top salesperson plying his trade, for example, cause the novice to imagine himself or herself to be a crack salesperson? Does that fantasy manifest itself in the novice's selling ability and behavior with clients? There is a paucity of solid, objective research on the effect of television on viewers, but to the degree that it can be understood how video works for organizations, we can speculate about its effects.

Chapter 2, Video Programming Applications, covers many specific areas in which video has been used successfully. It summarizes what has been done and why and, in many cases, how. The Case Histories, Chapters 4 through 7, are individual profiles of businesses, schools and universities, government agencies and health care institutions active in video programming. They cover a sampling of video operations ranging widely in size and sophistication with the emphasis on programming that works well.

Chapter 3, Production, describes the stages of program production, from choosing hardware to production planning to distribution. It is intended not for the experienced video manager, but to answer questions for the new user, the administrator or manager who needs an introduction to the considerations a video program entails. It is intended to foster an awareness of the factors which are crucial to a program's success.

In the last analysis, the most relevant questions this book might answer are basic ones to anyone concerned with video in an institution: "Who else is out there?" "What are they doing?" And a final important question which we have only begun to answer is "Why?" Why does one university routinely use its video network for live simultaneous broadcasting of class lectures to surrounding classroom buildings and to the community, while another seemingly similar university can find little use for its full color studio capabilities? Why does one corporation use television for management communications, marketing and sales, while other corporations in a similar business and of similar size and

[1] *Private Television Communications: An Awakening Giant* (New Providence, NJ: International Industrial Television Association, 1977), p. 19.

[2] *Ibid.*, p. 49.

dispersion use it exclusively for training lower level employees? *Practical Video: The Manager's Guide to Applications* profiles users and programs to best answer these questions; some general observations are included in the final chapter.

A full description of why institutions have done what they have, what has happened and why, is a much larger assignment than can be approached here. The examples herein do not include many of the giants in private television networking: Ford, AT&T, IBM. But neither do they dwell on special situations which have no general applicability. The objective was to provide coverage of a variety of organizations, small and large, with differing business and communications needs, varying applications, some with in-house and some going outside for production, some immensely successful and others whose video achievements have fallen short of their goals, or at least developed differently than planned. This variety can provide readers with points of reference, options and possibilities for continuing or launching a video operation.

Chronological History of Major Discoveries and Developments in Television and Video Tape Recording

1839 Electrochemical effects of light discovered.

1877 The microphone and phonograph.

1884 The Nipkow Disk, a rotating disk scanner.

1887 The gramophone.

1889 Rotating mirror scanning system, which used a rotating drum with small mirrors to reflect the image onto a selenium screen.

1893 Motion pictures.
 Invention of the first magnetic recording device using wire as the recording medium.

1894 Radio signals transmitted for the first known time.

1895 The first practical application of wireless telegraphy.

1897 Scanning in a zig-zag fashion introduced.
 The cathode ray oscilloscope, the Braun tube, introduced.

1905 Development of the photo-electric cell.

1906 Radio telephone.

1920 KDKA in Pittsburgh became the first commercial radio broadcasting station in the U.S.

1923 Earliest electronic camera tube, the iconoscope, patented by Vladimir Zworykin.

1925 First successful demonstrations of television in England by J.L. Baird and in the U.S. by C.F. Jenkins.

1927 An experimental television program was carried by cable between New York and Washington under the direction of Bell Telephone Laboratories.

1928 The first TV drama was broadcast by General Electric on experimental TV station WGY in Schenectady.

1931 A German firm, I.G. Farben, developed coated magnetic tape.

1937 RCA television sets with 5x9 inch picture tubes went on display at the World's Fair. Programming came from the RCA TV studio and film facilities in New York and from a mobile unit.

1938 Orthicon camera tube developed by RCA.

1941 The first commercial television broadcast occurred via WNBT Television in New York.

1946 RCA announced the image orthicon camera tube, which achieved a sensitivity almost 100 times that of any previous tube.
RCA marketed black and white television sets.

1947 NBC televised an operation at Johns Hopkins seen by several hundred doctors and nurses.
Television broadcasting began.
U.S. manufacturers developed both wire and tape recorders for industry use.

1949 RCA shadow mask color tube introduced.

1950 Vidicon camera tube announced by RCA.

1951 PAL and NTSC color television systems announced.
The first demonstration of black and white video recording.

1952 Broadcast channels allocated to nonprofit, educational use.

1953 SECAM color television system announced.
Plumbicon camera tube announced by North American Philips.

1955 The first color television signal transmitted from RCA in New York to 3M in St. Paul.

1956 The first practical video tape recorder, a quadruplex recorder, was introduced by Ampex Corporation.
The Eisenhower presidential inauguration was recorded on video tape.
The first commercial use of video tape for network delay of a news program.

1959 The National Educational Television and Radio Center in Ann Arbor, MI, received a multi-million dollar Ford Foundation grant providing Ampex tape recorders for qualified U.S. educational TV stations.

1961 RCA introduced the first fully transistorized video tape recorder.

1962 First exchange of live transatlantic television programs via the orbiting satellite, Telstar.
FCC ruling allowed pay TV on a trial basis.
First solid state black and white VTR priced at under $50,000 marketed by Ampex.

1964 CATV systems in operation across the country. RCA introduced quadruplex VTRs at half the cost of broadcast-quality predecessors.

1967 Combined resources of American and Soviet satellites made possible simultaneous transmission worldwide.
The 1/2-inch helical scan VTR introduced.
International Video Corp. introduced the first low-cost 1-inch color helical scan video tape recorder.
The first battery-operated, portable color quadruplex VTR introduced by Ampex.

1968 Ampex disc recorder with slow motion and stop action capability used for the first time.

1969 Video transmission from the moon.
Sony introduced the U-Matic 3/4-inch cassette VTR.
Mass production of audio cassettes began.

1970 First International Video Cassette Symposium held.
Standardization of 1/2-inch video tape equipment.
Birth of two-way cable TV.

1971 Adoption of SMPTE time code system.

1972 Open-access cable television programming began in New York City.
Commercial production of 3/4-inch video cassette recorders.

1973 First low-cost portable hand-held color video camera.

1976 Sony Betamax introduced.

1977 Digital VTR demonstration in England.
Production of broadcast-quality standardized 1-inch VTRs.

2

Video Programming Applications

INTRODUCTION

Video's role in organizations is fundamentally different from that of other audio-visual tools. It is looked upon by users as a general communications medium capable of effectively solving many problems that print and audio-visual media cannot. Because of this view, literally hundreds of different applications of television communications are being tried worldwide. This chapter, organized according to the main user groups, provides an overview of the primary programming areas in which video has cut costs and/or provided tangible benefits for specific institutions.

Business and industry have taken the lead in originality of applications and program formats as well as in volume. Video got off to a strong start in company training departments, and management saw no good reason to confine its benefits to this area when it could perform equally well in other critical areas. Business and industry now account for well over 50% of all video usage.

Because of video's capability to handle a diversity of tasks — training, instruction, information storage, research support, experimentation and documentation, to name a few — the medium was quickly adopted, though largely at much lower levels of involvement, by other institutions. Educational users account for 25%-30% of video usage, government takes 10%, and health/medical about 10%.

Communications needs vary widely among and within organizations; therefore, the following lists are not intended as ready-made video solutions to

communications problems. The tremendous growth in the number of video users, the size of networks, the dollar amount spent on hardware and software, and the number of applications for which television is used, as illustrated in this chapter, have not been an accident nor have they happened without incurring certain problems. Choosing the best possible methods of reaching communications goals — the type of program and distribution method for delivery of particular kinds of information to specific, well-defined audiences — is the critical factor in the success of a network. Some of the program designs possible in the various programming areas included in this chapter are discussed in greater detail in Chapter 3, Production, and in the Case Histories.

BUSINESS AND INDUSTRY

Business and industry were the first institutional users to be involved in video communications on a large scale, and they are currently the most active. The most obvious reason is simply that businesses generally have more funds to invest in and maintain new technology than do the majority of other institutional users. In addition, the geographic dispersion in many businesses makes the need for video more apparent and immediate.

In 1974 Judith M. and Douglas P. Brush published the first study of corporate television use.[1] According to the study, more than 300 businesses and industries spent over $48.5 million for program production and distribution. These organizations originated more than 13,000 programs. The total size of the market at that time, including both hardware and software, was $207 million. The Brushes published a second study in 1977 which indicated that the overall size of the private television industry had doubled since 1973 and would reach $500 million in 1978. They predicted that by the end of 1980 the industry should triple in size, reaching the $1.5 billion mark.

These figures reflect the tremendous expansion of private television networks and programming applications in business and industry. Television's timid, but successful, beginning in employee training helped establish an atmosphere for experimentation on a large scale. Development of the video cassette also spurred extensive use by making video technology much more accessible to the average corporation. In addition, companies recognized that the relatively high cost of becoming involved with television could be justified more easily when the medium was used widely throughout the organization. Therefore, of the companies using television, few use it for a single purpose. More commonly, a company will apply video throughout various levels, divisions and operating groups.

In the *Video Systems* magazine 1978 Market Survey of its subscribers, respondents in the business and industry sector listed the following applications

[1] Judith M. and Douglas P. Brush, *Private Television Communications: A Report to Management* (White Plains, NY: Knowledge Industry Publications, Inc., 1974). The new edition was published by the International Industrial Television Association, New Providence, NJ.

as those most widely used. Arranged from highest to lowest percentage, respondents are producing video programs for:

- marketing/sales training
- corporate communications
- specific job training
- arts and entertainment
- management development
- product information
- employee orientation/benefits
- safety training
- security and surveillance
- instruction (academic/business)
- personnel recruiting
- production control

According to the Brush study, there are 75 private television networks (six or more locations away from the main office receiving programs) in business and industry. Examples of the larger networks are the Ford Video Network, which links more than 5000 dealerships, and IBM's network, which encompasses more than 1000 cassette units in more than 40 countries. Other companies with more than 100 players include Xerox, Pepsi Cola, Coca Cola, Burroughs, Merrill Lynch, and many of the larger insurance companies. Also, according to the 1978 Brush study, the typical video user produces one program every two weeks at a cost of about $3000 and distributes to at least 18 locations. Unfortunately, these survey averages do not describe the how and why of typical corporate video users. This section on applications in business and industry illustrates the bare facts with case studies.

THE APPLICATIONS

Employee Communications

- Recruiting. A video cassette can present a dynamic, persuasive portrait of a company, including its managers and/or employees. Recruiting tapes can be part of the recruiter's presentation, travel independently through the mail or be used in the home office. Southwestern Life Insurance Company shows women applicants a taped interview with one of the company's leading women agents. International Paper Company sends information cassettes to colleges and universities around the country.

- Orientation. Video introductions to a company can provide strong, uniform orientation to new employees and cut down on this expensive use of management time. Fisher Scientific Company's employee orientation in-corporates several short tapes, one of which is a motivational welcome by the company's president, while another is a documentary-like overview of

the company and its divisions. The documentary overview approach is common because it facilitates highly informative short presentations. Mutual Benefit Life Insurance Company presents, via cassette, a fully visualized program on the various stages of a salesperson's career, using track and field athletes as an analogy.

• Employee Benefits. Using video to explain company plans gets the task done in an effective, efficient and consistent manner. Benefits programs are often panel discussion style or incorporated into orientation programs. However, a Phillips Petroleum program used an animated character talking to two benefits people and employee interviews to get the message across.

• Career Advancement. What is required for an employee to further his or her career? The Illinois Bell Telephone Company uses video to present a clear description of the opportunities and expectations of various jobs to employees.

• Safety. Individual programs describing and demonstrating safety procedures are essential to every operating group. The Linde Division of Union Carbide Corporation produces tapes which simulate different job experiences for employees working with substances under high pressure. Fisher Scientific Company and John Deere are others who make use of taped safety demonstrations. Two commercial video tape producer/distributors that have programs on safety are Datafilms and AIMS Instructional Media Services, Inc.

• Pre-Retirement Counseling. Retirement is a major life change which troubles most employees. Unfortunately, counseling groups are frequently unattended; individual counselors often seek out employees, rather than the reverse. Counseling in this area can boost the morale of those about to reach retirement and affect positively the attitude of other employees. Hewlett-Packard's retirement series includes programs on financial planning and use of time after retirement. Fisher Scientific Company's program on retirement features an interview with a senior employee and a young employee. The Manpower Education Institute of New York City makes the *Ready or Not* retirement package available through Deltak.

• Quarterly and Annual Reports to Employees. Where is the company going? What is top management doing about problems? What is the story behind the company's current and projected earnings? What does this all mean to employees? Johnson & Johnson, Southwestern Life Insurance, Fisher Scientific and Illinois Bell Telephone are examples of companies producing tapes that answer these types of questions for employees. These programs are typically panel discussions, or the information is presented in regular employee news shows.

• The Annual Shareholders Meeting. This presents an excellent chance to tape top managers, who are normally inaccessible to employees. W.R. Grace, whose activities spread to 45 states and 41 foreign countries, shows edited versions of the meetings to its more than 60,000 employees, giving them a

chance to see how the shareholders relate to the company. Allis-Chalmers Corporation does not edit its shareholders meeting but keeps it on file in original form not only for informational purposes but to serve as documentation as well.

• Issues Affecting the Company. Communicating to employees the meaning of legislation affecting the company can often help make employees and managers a most effective public relations staff. When a company takes a stand, employees should know the reasons so that they can represent the company to the public, their family and friends. Illinois Bell produces informational tapes on rate filings and the status of rate cases. Standard Oil of Indiana produced a program taking a stand against divestiture. Mobil Oil Corporation found that the chairman addressing employees' questions on tape was the way to make sure as many employees as possible get the word straight from top management on the issues that were troubling them.

Management Communications

• State of the Company Reports. A video cassette allows top managers to address managers at all levels and locations on the company condition. Mutual Benefit Life, IBM and Foxboro Company are examples of companies that provide this kind of programming.

• The Corporate Long Range Plan (LRP). A video program can communicate to managers the basics of the LRP without jeopardizing confidentiality. Union Carbide informs managers of changes in the LRP from year to year, which helps them feel they are part of the company's future.

• New Management and Trends. A video tape can put a new executive and his ideas in corporate offices worldwide without burdening his first few months with extensive travel. Gulf Oil Canada Limited introduced a new senior executive to the company via cassette. Foxboro Company and Allis-Chalmers have presented top management of merged companies via cassette to management and employees.

• Corporate Services. Services that a company provides are often under-utilized. Brochures often go unread and, even when read, the printed word cannot get the message across with the immediacy of television. Many companies, including John Deere and Illinois Bell Telephone, produce programs on their in-house television production capabilities and services. Another common subject is how to work with computer systems; Fisher Scientific informs division managers on how to use data processing. Citibank provides tapes on the available services of the bank's special marketing services group.

• State-of-the-Art Reports. With video cassettes, management can be kept abreast of developments outside the company (in research and development centers, universities, institutes, etc.) that have an impact on the company's business. Illinois Bell produces documentary-style programs on new tech-

nologies, such as fiber optics. *Video Journal*, produced by Playback Associates, presents technical and scientific trends and developments having an impact on the petroleum industry. Advanced Systems Inc. rents and sells a series entitled *Computer Technology Video Updates*.

• Policy. Video programs can be designed to complement existing policy manuals and memoranda on new policies in ways that improve speed and consistency of implementation. Mobil Oil produced a policy program on divestiture. Mutual of New York and Equitable Life have programs on affirmative action. The Union Carbide Chemical and Plastics Division provides management with a tape on financial policy. Gulf Oil Canada Limited produced several programs on equal opportunity for women. These programs are generally panel discussions and interviews. However, some companies, such as Southwestern Life Insurance, incorporate the information into news programs for managers.

Management and Employee Training and Development

Video, often in coordination with print material, is widely used as a teaching tool. In many situations video can provide effective training and development programs more economically than any other method. Training and development programs on tape also lend to this area added freedom and flexibility. These programs, ranging from lectures to dramatizations, can be structured for group or individual viewing and for use with or without a leader. They can stand alone as single tapes, or in a series with collateral material. Topics in this area range from basic supervisory skills to reading efficiency.

Much of the programming used by companies in the management development area is commercially produced. However, since it is often desirable for these programs to be highly motivational, some companies, such as Fisher Scientific and Gulf Oil Canada, prefer to custom produce development programs that are tailored to their own employees, company career paths and specific company development programs.

The use of video in management and employee training and development can also be as simple as operating a small camera and a recorder to help develop public speaking skills, or to make candid recordings of seminars and conferences.

• Outside Experts. By capturing experts from outside the company or institution on tape, their knowledge can be preserved and made available worldwide over time. In addition, the fee a company pays to an outside expert can often be paid only once, while the benefits are accessible again and again. Phillips Petroleum video taped presentations by a seismic expert and by negotiator Chester Karass. Mutual Benefit Life uses tapes by Dr. David Merrill on "Style Awareness." The first program Gulf Oil Canada Limited produced was a talk on the future of Canada's resources by a university professor. Many

companies make use of Art Deegan's "Management by Objectives" program. ACE (Association for Continuing Education) has a library of programs featuring experts in different areas.

• Internal Experts. The extensive expertise of talented company managers often goes underutilized. A manager can make a contribution on tape that can be used over a long period of time without taking the manager away from the job for repetitive speech making. Top sales reps at IBM, Xerox, Mutual Benefit Life and Southwestern Life discuss their selling techniques on video so that peers can benefit from their knowledge. John Deere dealers across the country talk on tape about how they handle such areas as job safety. A Foxboro Company expert on chromatography explains and demonstrates the principles of chromatography.

• Education/Skills Development. Many universities and commercial producer/distributors provide educational and personal development telecourses for business and industry. For a list of these, see the section on Education. Hewlett-Packard, Johnson & Johnson and Hughes Aircraft are just a few of the companies that subscribe to continuing education services for employees and managers.

Specific Job Training

Training was the first area of business and industry to make use of video tape, and it is still the largest application of television in the corporation. Almost every company involved with television (as well as many of the commercial producer/distributors) would be included in a complete list. However, a few examples are John Deere and Company, Pepsi Cola, Fisher Scientific and Foxboro Company, which all produce training programs in the areas of sales skills, production and service. Deltak has a video-based training library with courses in data processing, management, science and engineering, manufacturing, customer relations and sales. The South Carolina ETV Network cablecasts management training courses for area businesses.

Formats and structure of training programs are varied. They can be expository programs, in which a talking head alternates with voice-over demonstrations, straightforward demonstrations, lectures and dramatizations. Any of these formats can be interactive, i.e., the trainee turns off the playback machine and turns to the workbook or goes to the lab situation. And training programs can be for group or for individual use, with or without an instructor, with or without collateral materials.

Job training and television have been in tandem for a number of years, and various approaches have been pursued. The only rule that applies is that the approach not only fit the application but that it be suited to the audience's motivation to learn.

Marketing Applications

• Product Introduction. New products can be introduced to sales person-nel and managers in widely scattered field locations simultaneously. Pepsi Cola's network can reach 400 bottlers nationwide to announce a new product, promotion or advertising campaign. Hewlett-Packard produces demonstration tapes to familiarize salespeople worldwide with new Hewlett-Packard products before they are announced to the public. Foxboro Company has produced a series of tapes on several product lines which include demonstrations and information on the product's development and manufacture. Manufacturers Hanover introduces new products and bank services to home and branch office management via cassette.

• Marketing Support. Promotional back-up, applications support, sales strategies and industry reports on potential markets can be provided to field locations efficiently and uniformly via video cassette. The use of marketing support programming is also proliferating in annual sales meetings. Fisher Scientific has produced entertaining and motivational promotional programs on numerous products. Illinois Bell Telephone produces programs on new market-ing concepts which contain location interviews with marketing executives. Pepsi Cola produces many of its marketing support programs in the studio with a professional on-camera spokesman.

• Direct Sales. Video cassettes for customer viewing can extend the salesperson's presentation capabilities. Hewlett-Packard and Fisher Scientific customers view product introduction tapes originally produced for sales force viewing. Fisher Scientific also produces mini-documentaries for customer view-ing which promote a particular division, such as Fisher Chemical Division, and support sales efforts. John Deere and Company customers can view tapes on farm equipment on a visit to the home office or at dealerships. A number of department stores use monitors on the floor to attract customer attention to new merchandise. Panasonic produced a video tape to demonstrate its home video cassette machine to customers in stores.

EDUCATION

Elementary and secondary schools have long made extensive use of audio-visual materials for instructional purposes. In the 1960s schools picked up the business and industry lead in television use and, with the help of government grants, video systems in schools began to flourish. Instructional Television Fixed Service (ITFS) systems, using microwave converters, allowed systems to broad-cast programs over the air without using regular television frequencies. By the 1970s, however, lack of technological and creative expertise, shortage of money and resistance to utilization by teachers dampened the momentum, and a number of television enterprises in schools were aborted.

In those schools where television has survived, early research indicating that video is a cost-effective teaching method is being borne out. Where there are

funds and interest, applications are also emerging in a number of creative and experimental areas outside traditional curricular thinking. In addition, there are a number of educational TV networks which supply a wide range of courses that simply require that a class tune in on the scheduled ITFS broadcast. These programs often are designed for incorporation into the regular curriculum and include teaching guides and other collateral material.

While still concentrating heavily on instructional programming — whether traditional or innovative, packaged or "home grown" — schools have also begun to recognize TV's potential for bringing the school and the community closer together. Televised school board meetings, special student activities and informational programs on special school services are only a few examples of the pioneering in this area.

The use of television for instruction in colleges and universities goes back to the early 1950s. Large state universities have been leaders in video instruction, along with community colleges, which tend to adopt non-traditional teaching methods readily. Video programming in higher education has been most often applied to support the traditional curriculum materials, to facilitate extension programs and to function as a research tool. The results are that universities and colleges using television are able to provide more education for fewer dollars and with greater flexibility in terms of geographic delivery and scheduling.

While much of the programming in higher education is not considered innovative in terms of style and form, the fact is that this audience starts out with a high motivation to learn and a desire to have the information presented in a clear and well-organized manner without distractions. At the same time, however, students know what television can be, and they expect a sophisticated interpretation of the subject matter.

Video Systems magazine's 1978 Market Survey of its readers reports that 94.6% of the educational respondents use television for instruction, and that 59.9% apply television for what the survey identifies as arts or entertainment. The next three applications in order of percentage of reported use are job training, medical/health instruction and employee orientation/benefits. Although this chapter is broken down into different headings, these figures suggest that educational users are only slowly branching out into the areas other than instruction that are included here.

THE APPLICATIONS

Elementary Level

• Instruction. Many instructional television networks across the country broadcast programming to be integrated into classroom study. The programs include all aspects of language arts (basic language and reading skills, motivation to read as a leisure activity, writing skills, etc.), science, math and social studies.

Numerous state departments of education, including Florida, South Carolina, New York and Illinois, obtain duplication rights to off-the-shelf instructional programming and distribute to schools around the state.

- Instruction for the Handicapped. Television can involve and motivate handicapped students by bringing difficult concepts "to life." Project TEACH in the San Diego City Schools' Hearing Handicapped Department worked on the precept that hearing-impaired students gain most information visually. TV excited the students and motivated their language development and desire to communicate. *Project Video Language* is an extension of TEACH which uses video programming involving mime, animals and adventure stories to aid in teaching language acquisition skills. The Missouri State Schools for the Severely Handicapped use TV to instruct severely mentally retarded and emotionally disturbed students in language skills, fine arts and day-to-day practical skills such as making a sandwich.

- Special Productions. A second grade class at the Glassboro Public Schools in Glassboro, NJ, visited the local police station. Using film and photographs provided by the police and video tape footage acquired for them by high school students, the second graders wrote a script and produced a video tape about the experience. In coming years the teacher can use the program to prepare other classes for the trip. New Trier Township Television, IL, has produced an orientation for preschoolers and their parents to allay fears about entering the first grade.

Intermediate and Secondary Levels

- Instruction. Television can often capture the attention of students when even the best teachers cannot. In addition, television can stretch the bounds of traditional curriculum. ITV of the Archdiocese of New York produces programming to supplement religious and secular education. The New Trier Township Television produces programs on such topics as biology and driver education as well as broadcasting off-the-shelf instructional programs. The Danville District #118 Schools make extensive use of off-the-shelf programming, broadcast over the local cable station access channel.

- Student Productions. News shows, projects and demonstrations can be performed and produced by students. Involvement in production can be a motivating experience — students not only have a basis for a vocation but they learn how to improve various communications skills and how to use creative energies productively. The Edison Intermediate School, IL, has an extensive television project which encourages all students to acquire some experience with television production. Edison students produce two news shows on a regular basis. Students also produce supplemental programs, such as lectures by the mayor and a local historian, and informational programs, such as an interview with a state senator. High school students in Johnson, RI, produced tapes on

social problems under the Elementary and Secondary Education Act (ESEA) Title III project Close-Gap. Students directed the project from subject matter selection through the completion of production. When federal funds for the project ran out, the community absorbed the cost of its continuation.

• Student Services. Television can be an efficient way for schools to provide student services. South Carolina Instructional Television offers programs on career goal development and on various types of businesses and industries. New Trier Township Television produces tapes on career education and orientation as well as informational tapes on what the various school departments offer. The Johnson, RI, school department, under project Close-Gap, ran a TV project for the rehabilitation of potential school dropouts.

• Documentation. AMIC (Association for Mentally Ill Children) Day School in Watertown, MA, video tapes behavior patterns of emotionally disturbed and autistic students, using the tapes to set teaching goals and document student progress.

• Public Relations. A school can produce programming which, when aired over local cable systems or viewed in scheduled groups at the school, can educate and inform parents about school affairs. Danville District #118 Schools have taped sports events, school plays, concerts, discussions of school integration and an art series for community viewing. Danville also broadcasts informational tapes for parents on special school services, such as the hot lunch program. New Trier Township Television produces "video memos" to inform parents of school needs. Edison Intermediate School cablecasts some of the student news shows over the local CATV system.

Higher Education

• Instruction. Instructional television in colleges and universities can make a course available to more students than can be accommodated in one lecture hall. A video tape can bring a flood site to a geology class, the inner city to a class in community development, or a case study to a psychology class. In other words, television can bring experiences to students which would otherwise not be available. The Santa Fe Community College in Gainesville, FL, produces programs designed by faculty members to supplement course materials in subjects such as Spanish, math, art, psychology and general science. Boston University's School of Public Communication uses video to teach television production. Taped lectures in courses such as general biology at Michigan State University proved cheaper per student credit hour than live instruction, with no significant difference in teaching effectiveness. The Nebraska Educational TV Council for Higher Education makes programs available on academic subjects from advertising to zoology. Other examples include Oklahoma State University, Pennsylvania State University, Telstar Productions Inc., and The Florida Department of Education.

• Continuing Education/Extension Courses. Core curriculum courses are delivered from universities via video cassette, cable and microwave to outside organizations (such as businesses, industries and government agencies) to be taken for degree credit and career advancement or simply for personal enrichment. The University of Arizona Microcampus delivers, via tape, lecture courses in many areas, including liberal arts, business, engineering and public administration, at the graduate and undergraduate level, to remote sites such as Hughes Aircraft Company and the Arizona Highway Department. In addition to the many universities supplying this and similar services, a number of commercial producers supply tapes for continuing education. Advanced Systems, Inc. has a library of courses for rent in the field of data processing. Among the universities and commercial producers providing continuing education programming, Michigan State University has an extensive continuing education program in education, medicine, engineering and agriculture; and Oklahoma State University has video system links to businesses and other colleges and university campuses. ACE (Association for Continuing Education), a cooperative, nonprofit educational organization managed by and for private industry, broadcasts live seminars over Stanford University's Instructional Television Network in areas such as management development, engineering technology, supervisory training and mathematics. The University of Mid-America, where over half of the students enroll for non-credit personal enrichment courses, broadcasts video lessons on local educational stations. UMA courses include "Anyone for Tennyson?", utilizing the PBS poetry series, and "Principles of Accounting." The Association for Graduate Education and Research of North Texas (TAGER) is a consortium of 10 colleges and universities and eight Texas businesses. An extensive listing of sources of continuing education programming can be found in *THE Catalog*, a catalog of televised higher education published by Associated Western Universities, Inc.

• Community Education. Television can be a most effective means of meeting expanding needs in life-long learning. Cable and public television can allow community members to take college courses at home for degree credit or personal enrichment. Michigan State University has been involved in this since the mid-1950s. The Santa Fe Community College cablecasts courses such as introductory psychology, history, anthropology and math.

• Research. Long used as research tool, video tape can document experiments and serve as a permanent visual record to support research reports. At the University of Kansas, psychology experiments are recorded for later analysis. In addition, the video tape provides permanent visual reference material for students and professors. Cornell University faculty produce research reports on tape to be sent to national conferences that they are unable to attend.

• Special Events. Guest lecturers, sports events and plays can be taped and made a part of a permanent library of special interest tapes. The College of Staten Island, Cornell University and Michigan State University are examples in this area.

• Student Productions. At the University of Wisconsin at La Crosse, student-run television is a vehicle for students' news and views. Students produce magazine-format programs, which consist of issues and news as they relate to students, campus calendar, and special features, such as interviews with visiting celebrities. The programs are also distributed to the community by the local CATV system.

Teacher Training

Video is widely used for teacher training at all levels of education. University of Kansas, Pennsylvania State University and Missouri State Schools for the Severely Handicapped are using immediate playback capability to allow a teacher's classroom performance to be analyzed on the spot. The University of Texas Center for Teacher Education links video playback analysis to a computer for research purposes. The Florida Department of Education supplies in-service teacher tapes on television production techniques. San Diego City Schools' Hearing Handicapped teachers learn sign language with the help of video. The Archdiocese of New York uses television for standardized and rapid in-service training. New Trier Township teachers learned the new math with the help of a math expert on tape. Granite School District has produced in-service tapes on metrics, energy, music and science.

HEALTH/MEDICAL

Medical television was initiated at Johns Hopkins University in 1937 when a surgical operation was televised over closed-circuit television. Several years later medical schools at the universities of Kansas and Pennsylvania and Michigan State were applying television as a regular teaching method. By the mid-1960s the majority of medical schools in the United States were using television as a basic teaching tool.

Because of the promise of high resolution cameras, video-microprojection systems, live two-way audio-visual hook-ups, video cassette networks and, now, satellite transmission, medical television networks have become common in medical schools, medical centers and hospitals for student instruction and continuing education for physicians. As an offshoot, in-service training for nurses, paraprofessionals and technicians has become an important part of medical programming. Less widespread, but growing, is the use of video for patient and public health care information.

More than 1000 hospitals are equipped with playback facilities and receive programming via cassette, cable and ITFS from medical schools. Many hospitals have in-house facilities for program production as well. In addition, professional producers and pharmaceutical manufacturers provide programs to hospitals, medical schools, physicians' offices and clinics.

Like programming in higher education, medical television tends not to use sophisticated production techniques. The typical medical audience is highly motivated to receive the televised information and prefers a highly functional, straightforward approach to the subject matter. Therefore, candid photography and demonstrations are the norm.

THE APPLICATIONS

Medical Education

• Instruction. Television in medical schools, allied health schools and teaching hospitals can allow students to observe innovative procedures performed by experts and actual case studies of rare diseases. TV also makes possible more uniform instruction in basic sciences and routine procedures. The Texas Medical Center video tapes demonstrations of medical and surgical procedures and techniques and makes the tapes available to physicians and medical schools across the country. The American Society of Clinical Pathologists and Medcom, Inc., have libraries of programming available to supplement medical school basic science curriculum. Purdue University School of Veterinary Medicine supplements labs with taped demonstrations, lectures with video taped case studies and records demonstrations of surgical procedures for students to view before doing the surgery themselves. Nebraska TV Council for Nursing Education, Inc., provides programs covering a wide range of patient care subjects. Indiana University School of Medicine combines televised lectures and clinical situations for the "Introduction to Medicine" course to show students a patient at various stages during a disease. Medical students at Duke University take video examinations and can also be video taped in the clinic to get feedback on their performance with patients.

• Continuing Education. Television plays a crucial role in keeping physicians updated and preparing them for recertification. Indiana University School of Medicine has the largest medical video network, dedicated largely to physician continuing education, with three ongoing series distributed via a statewide Medical Education Network, CATV and a Videocassette Mailing Network. In addition, Indiana University has participated in national network symposiums for continuing education out of New York City and in several national medical demonstrations via satellite. Others involved in physician continuing education include the Milton S. Hershey Medical Center, Michigan State University, Wayne State University, Greater Cleveland Hospital Association, American Hospital Association, Louisiana State University School of Medicine and the Louisiana Hospital Television Network, and Telstar Productions (a commercial producer/distributor). Generally, most hospitals providing continuing education for physicians also make these tapes, or versions of the tapes, available for nurses and paraprofessionals.

Employee Training and Development

● Orientation. Employee orientation via video cassette can save hospital supervisors a great deal of valuable time. Blythedale Children's Hospital, NY, produces orientation tapes for new hospital staff and volunteers that acquaint them with therapy procedures used at Blythedale and with the types of dysfunctions with which they will be dealing. The Tucson Medical Center produces staff orientation tapes to inform new staff of benefits and safety procedures.

● Specific Job Training. Keeping up to date on treatments and procedures is critical to providing the best health care service. Hendrick Memorial Hospital in Texas buys off-the-shelf programming for in-service training of nurses and paraprofessional staff. Tucson Medical Center produces tapes on various procedures for staff review. Tucson Medical Center also records workshops and lectures for patient care personnel in such areas as care of the patient with pituitary gland surgery, arthritis and various neurological dysfunctions. Blythedale Children's Hospital produces in-service training programs for staff and for other hospitals interested in Blythedale programs on such topics as pathology of movement and feeding brain-damaged children.

● Informational. Central Wisconsin Center for the Developmentally Disturbed produces a newsletter type of program for staff with information on what is happening at similar institutions. Tucson Medical Center produces a monthly news show about employees for employees. Blythedale Children's Hospital records workshops and lectures.

Patient and Public Information

● Orientation and Patient Education. Video tapes for patient viewing reduce the burden on physicians and hospital staff to repeat basic information. Tucson Medical Center broadcasts health related programming on such topics as heart disease and stress on two closed-circuit channels connected to monitors in patients' rooms. University of Illinois School of Medicine has produced 46 five-minute patient education programs that are aired on the state Medical Education Network. Hendrick Memorial Hospital patients view a tape that introduces them to most of the departments and services with which they will come in contact.

● Patient Entertainment. Blythedale Children's Hospital broadcasts movies and special staff productions on closed-circuit television in patients' rooms. The Central Wisconsin Center for the Developmentally Disturbed tapes a popular local children's show off the air for delayed viewing by patients.

● Preventive Medicine/Public Information. Television can be used to educate a wider public on health problems than could be reached by the traditional brochure approaches. A series called the *Picture of Health,*

produced by the University of Florida and distributed throughout the state to commercial and non-commercial television stations, emphasizes family health care subjects and medical topics of general interest. The University of Illinois at the Medical Center Office of Public Information has for 10 years produced the *Consultation* series, which gives health information in layman's language on topics such as arthritis, cancer, stroke and pre-natal care. The University of Washington offers a telecourse in heart disease and hypertension. The Division of Educational and Instructional Resources of the University of Maryland's School of Dentistry has produced a series of tapes covering dental health subjects for showing in clinic waiting rooms. *Project Health*, produced by BNA Communications, Inc., is a series of eight tapes covering how to avoid a heart attack, alcoholism and the why's and how's of physical fitness. Tucson Medical Center produces tapes, distributed by Tucson Public Libraries, on health problems that occur primarily in that region of the country.

Medical Records/Documentation

● Patient Archival Tapes. Video tape records of patients' case histories and progress can make physician and staff review more efficient and complete. Blythedale Children's Hospital makes recordings of patients at intervals from admission to discharge.

● Diagnostic. Video taped interviews and examinations of patients can reveal useful information on playback that was missed originally. In addition, an examination on tape can be sent to a diagnostician in another location. At Blythedale Children's Hospital initial tapings of patients assist therapists in writing evaluation reports because tapes can be replayed, still framed or played in slow motion. The Indiana University School of Medicine's television network features regular hospital rounds on television, and the viewers at other hospitals participate in discussions by a two-way audio hook-up. This application is also widely used in diagnosing psychiatric patients.

● Research. Researchers at Duke University Medical Center record experiments and findings to be shown at regional and national medical conferences. At the University of Mississippi and the Bethesda Naval Hospital tapes have recorded the behavior of unattended patients who have been given "delayed-action" drugs.

● Treatment. Use of video tape in psychotherapeutic situations (individual interviews, group therapy sessions, role play) gives visual feedback on the patient's perceptions of himself and his surroundings. User examples include the Langley Porter Neuropsychiatric Institute and Duke University Medical Center.

● Documentation. Central Wisconsin Center for the Developmentally Disabled and Blythedale Children's Hospital use video tape to document the

progress and treatment procedures of patients. The tapes are sometimes viewed by patients and parents as well as staff and are also sent along with the patient when he or she transfers to another institution.

GOVERNMENT (FEDERAL, STATE AND LOCAL)

There is video activity at all levels of government, but usage by federal agencies far surpasses use at state and local levels. While the government has used audio-visual materials extensively for communications and training, it should be noted that, for the most part, television in government is still in the embryonic stage of development. Due to bureaucratic processes in the adoption of new technology and the already large investment in other audio-visual tools, there is still heavy dependency on films, filmstrips, slides and print for internal communications and training, while much video use is confined to public service spots for broadcast television.

At present some of the more interesting programming applications are beginning to spring up in state and local agencies; however, extremely limited budgets are common. Few government agencies have the budget to update their original investments in video equipment, to hire full-time television staff or to employ sophisticated production techniques. However, there appears to be a good deal of variety among organizations in the approaches to programs and, as more funds are appropriated, widespread use of television at all levels of government is certain.

THE APPLICATIONS

Employee Training and Development

• Specific Job Training. Many government agencies have a high turnover of employees, and training remains a high priority. The approaches to video programs produced for training purposes vary more from governmental organization to organization than in any other institutional group. On a regular basis the New York Police Department produces for officers short training messages that resemble broadcast commercials. In Boise, ID, new judges role play (with professional actors as witnesses and litigants) and observe themselves on playback as a part of job development. The New York State Department of Correctional Services trains inmates in television production by having them produce training tapes (among other types of programming) for Correctional Services staff. The New Haven Legal Assistance Association has produced a library of taped lectures, site visits and workshops in areas such as housing laws, discrimination and unemployment compensation. The New Jersey Department of Health Division of Narcotic and Drug Abuse Control demonstrates television production techniques to counselors via video tapes. The U.S. Bureau of Prisons trains correctional staff with video programs that use a combination of on-camera narrator and dramatization.

• Communications. A video cassette can distribute efficiently and uniformly a part of the constant flow of information occurring nationally and internationally in government. The New York State Department of Correctional Services produces informational tapes such as the Commissioner's message on how inmates can be eligible for furlough and a new security device for correction officers. The New York Police Department video taped the Police Commissioner's statement on a specific policy matter. The U.S. Bureau of Prisons produces programs on research findings and court decisions and their implications for day-to-day operations.

• Investigation. The Wilmington (DE) Bureau of Fire video tapes the people in the vicinity of a fire to be able to replay the tape and look for suspects or known arsonists.

• Coverage of Events. The Los Angeles Police Department video tapes such events as lectures by judges and attorneys and coroners' presentations. The U.S. Bureau of Prisons covers such events as the dedication of new facilities.

• Documentation. The Westport, CT, Police Department video tapes drivers under the influence of alcohol and uses the evidence at hearings. The U.S. Bureau of Prisons will video tape the scene of prison disturbances.

Public Service Information

• Public Relations. Government agencies produce informational tapes on services they make available to the public as well as educational tapes for community and broadcast use. The New Jersey Department of Health has produced programs on drug and alcohol abuse for viewing in schools and on public television. The New York State Department of Correctional Services produces tapes for nonprofit agencies, such as the Red Cross, which are broadcast on local network affiliated stations. The Wilmington Bureau of Fire provides fire safety tapes for public viewing.

Client Services

• Education. Educating clients via video cassette can free agency staff to spend more time solving individual problems. The New Haven Legal Assistance Association produces client self-help tapes on problems of utility payments, family law, small claims court and other topics. The Polk County, IA, Department of Social Services decreases the burden on social workers by making tapes for viewing by welfare recipients on how to get the benefits to which they are entitled.

• Therapy. At the New Jersey Department of Health, counselors tape therapeutic sessions so that participants can have immediate feedback on their group behavior and social interaction.

SUMMARY

When video users in business and industry discovered that the benefits from the use of television in employee training could be realized in many other areas, many original applications began to surface and create a favorable climate for experimentation. Educational users have only slowly begun to experiment with television use outside of instruction. Users in both educational and medical institutions have tended to remain with a relatively straightforward, no-frills approach to specialized traditional instruction, owing primarily to the very high motivational levels of typical educational and medical audiences. Financial limitations have held back widespread use of television by government agencies. However, there is a considerable difference in the ways in which government organizations are using video, and continued growth in that sector is certain.

This chapter does not provide answers to all communications problems that institutions encounter. It points out many of the applications of video programming that various users have employed to meet their individual communications needs. Critical to the success of any video operation is the requirement that each user must choose the most appropriate methods of reaching its individual communications objectives.

3

Production

INTRODUCTION

This chapter is an overview of video equipment resources and production procedures. There are many excellent technical guides for those interested in the engineering of video equipment or special creative functions. This chapter is written for the non-technical video user who is looking for a basic overview of the subject without becoming too involved in the technical requirements. Most terms that are not described in the chapter can be found explained in the glossary in the back of this volume.

The first section of the chapter is an inventory of available equipment with notes on the trade-off between technical quality, price and portability. The second section describes production personnel and basic production procedures.

Equipment and production are included in the same chapter because the two categories are interrelated. Programming goals will affect the kind of equipment used. For example, if broadcast quality is required, low cost systems will cause endless difficulties. On the other hand, the equipment will have an impact on the style and content of the programming. Sixty pound cameras and 2-inch quadruplex equipment will give an excellent studio look but prohibit coverage of a ground-breaking ceremony a hundred miles away.

The video user should try to find the right system for the job he has in mind, but he should avoid becoming too involved with technical requirements. A good system is important, but no amount of hardware can guarantee effective television project leadership or turn a dull and trivial program into an effective undertaking.

PRODUCTION EQUIPMENT

Every video system starts with a camera and a video tape recorder (VTR). All but the most mobile systems include at least one television monitor and an audio system for recording sound.

This equipment combination can be expanded to achieve far greater sophistication and flexibility by adding more cameras, recorders, a switcher, special effects generators, time code generators, multiple microphones, audio mixers, lights, etc. The purpose here is not to investigate every piece of equipment in depth, but to give an understanding of the options available in choosing the basic components.

Determining the components of a video system depends on the kind of programming the user expects to be doing. The basic considerations are:

- **The audience.** Who are they and what standards of visual quality do they expect? Where are the viewers located? What kind of playback facilities are required?

- **Program style and content.** Should tapes be produced in black and white or in color? How many cameras are required? Are special effects, mobile equipment or fine audio quality needed?

The Ampex AVR-2 2-inch quadruplex VTR unit is a broadcast quality unit.

Courtesy of Ampex Corp.

● **Editing requirements.** Will the editing involve touch-ups on highly organized material or complicated edits in both sound and picture? Some editing systems are faster than others. How soon is the edited version needed?

● **Budget.** Most compromises on equipment stem from basic money considerations. A poorly funded system will not achieve program goals; an overpriced one will destroy cost-effectiveness.

Every user's technical requirements are different, and many grades and types of hardware exist to meet the variety of needs. The next few sections provide an overview of basic equipment.

Video Tape Recorders (VTRs)

Video tape recorders (VTRs) are categorized according to the width, or format, of the tape on which they record. The five formats currently in use are 1/4-inch, 1/2-inch, 3/4-inch, 1-inch and 2-inch. It used to be true that each step up in format indicated noticeably higher technical quality and sophistication. However, given the rapidly advancing pace of video tape technology, this blanket statement can no longer be made. Two-inch had traditionally been broadcast television's standard, but new 1-inch technology now rivals that of 2-inch — and

When taping away from the studio, a recorder such as this Ampex 1-inch portable field recorder may be used.

Courtesy of Ampex Corp.

The Bosch Fernseh BCN 40 1-inch VTR is used for mastering programs in many non-broadcast studios.

Courtesy of Robert Bosch Corp.

at significantly lower cost. Advances in the state of the art can also be seen in the improved quality of 3/4-inch recordings which are often more than adequate for a large number of institutional users.

The accompanying chart in Table 3-1 summarizes the characteristics, primary users, price ranges (list prices shown include editing function) and several principal manufacturers of the five VTR formats. Although 1/2-inch has become popular thanks to the push of VTR manufacturers into the home market with this format, original programs which will later be duplicated are still being typically produced on at least 3/4-inch tape at a minimum, with many better equipped non-broadcast facilities relying on superior 1-inch format. Cost of equipment tends to decrease with size. The greatest variety of VTRs are currently in the 1/2-inch field.

Different formats are not compatible; a program produced on one format cannot be played back on a different format VTR or playback machine. However, any one format can be converted to any other format. For example, 2-inch quadruplex might be used for the recording and editing stages when a very high quality master tape is desired. The 2-inch edited master tape might then be transferred to a 3/4-inch cassette for low cost duplication and distribution.

Table 3-1. COMPARISON OF CHARACTERISTICS OF VIDEO TAPE FORMATS

FORMAT	MAIN USERS	CHARACTERISTICS	COST	PRINCIPAL MANUFACTURERS
1/4-inch	Schools Universities	black & white and color lightweight reel to reel not broadcast quality	$2000	Akai
1/2-inch	Business and industries Government Schools Universities Home	black & white and color reel to reel and cassette lightweight portable and studio models not broadcast quality low cost dubbing	portable $800 to $2500 studio $900 to $2500	Hitachi Denshi America, Ltd. Akai North American Philips (Norelco) JVC Panasonic Sony
3/4-inch	Business and industries Schools Government Universities Home Professional producers	industrial and broadcast quality portable and studio models relatively low cost off-line editing cassette	portable industrial $3000 to $4500 studio industrial $1800 to $6500 portable broadcast $23,000 to $45,000	Panasonic JVC Sony NEC America
1-inch	Commercial networks Business and industries Professional producers	new semi-portable models broadcast and industrial quality capable of slow motion, freeze frame reel to reel good dubs up to 10 generations	industrial $7000 to $23,000 broadcast $33,000 to $56,000	Ampex Corp. Sony International Video Corp. Fernseh
2-inch (quadraplex)	Commercial networks Business and industries Schools Universities Professional producers and facilities suppliers	broadcast quality very stable recording reel to reel good dubs up to 5 generations	$70,000	Ampex Corp. RCA

Video Cameras

Video cameras are broadly differentiated by quality and size, and fall into two main categories: broadcast and industrial. The highest quality picture is afforded by broadcast cameras. Industrial cameras, capable of producing good quality pictures, though not broadcast standard, are adequate for most institutional users. Tables 3-2 and 3-3 summarize basic characteristics, principal users, manufacturers and price ranges of broadcast and industrial quality studio and portable cameras. Within each of these general categories exists a variety of specific camera models providing a wide range of quality and price from which to choose. Many non-broadcast video producers are relying exclusively on portable cameras, but even with the many technical improvements they still do not have many of the features available on studio equipment. The prices of quality cameras of all types have decreased considerably in recent years.

The camera is usually the major factor determining the picture quality of a given video system. Choice of camera depends largely upon what the video system will be used for. For instance, many schools, businesses and government agencies use video tape primarily for role playing and other teaching exercises; in these cases an industrial portable camera is usually sufficient. Hospitals and medical schools, however, often tape intricate surgical techniques and require a camera with high quality picture resolution capabilities.

The camera is only part of the complete video tape system and it must be paired with a suitable VTR. For instance, a 1/4-inch VTR is usually paired with

The Sony portable industrial 3/4-inch VTR and camera with a camera control unit is popular for remote shooting, but also is used for low-budget "student" work.

Courtesy of Sony Corp.

Table 3-2. CHARACTERISTICS OF STUDIO CAMERAS

	MAIN USERS	CHARACTERISTICS	COST	PRINCIPAL MANUFACTURERS
BROADCAST STUDIO CAMERAS	Commercial networks Large businesses and industries Large universities Professional producers and facilities suppliers	– high quality picture resolution – capable of operation in a wide variety of light levels. – internal electronics can be adjusted by external controls – some models can be made mobile	$25,00 to $75,00	International Video Corp (IVC) Fernseh North American Philips (Norelco) Harris JVC
INDUSTRIAL STUDIO CAMERAS	Businesses and industries Schools Universities Government Medical institutions		$5000 to $25,000	Sony Panasonic Ikegami Electronics Inc. Hitachi Denshi America Ltd. Marconi Electronics NEC America Sharp RCA

Table 3-3. CHARACTERISTICS OF PORTABLE CAMERAS

	MAIN USERS	CHARACTERISTICS	COST	PRINCIPAL MANUFACTURERS
BROADCAST PORTABLE CAMERAS	Local television stations Government Medical institutions Schools Universities Businesses and industries Professional producers and facilities suppliers	– require high levels of light – adaptable to studio use – facilitate location taping – provide relatively low cost production capabilities – internal electronics cannot be adjusted by external controls	$15,000 to $40,000	IVC Fernseh North American Philips (Norelco) Harris JVC Sony Panasonic Ikegami Electronics Inc. Hitachi Denshi America Ltd. Marconi Electronics Thomson-CSF Labs NEC America Sharp
INDUSTRIAL PORTABLE	Small businesses and branch offices Universities Schools Government		$2000 to $9000	

HOW THE CAMERA WORKS: The camera lens focuses the image of the key onto a photoconductive layer of chemicals on the faceplate of the camera tube. The photoconductive layer is arranged into over 300,000 microscopic dots, each of which give off an electrical charge as the photoconductive layer "reads" the key. The charges vary according to the amount of light hitting each dot; for instance, parts of the key in the shadow will produce a weaker charge than the lighter parts. An electron gun at the back of the tube scans the photoconductive layer with a beam of electrons that moves from left to right and from top to bottom. The beam translates the electrical charges of the dots into voltage output, otherwise known as the camera signal.

The AKAI 1/2-inch cassette recorder with detachable monitor and black and white camera.
Courtesy of AKAI America, Ltd.

a low cost, hand-held monochrome camera. A 3/4-inch cassette recorder can be paired with broadcast quality cameras to produce good picture quality at a relatively low cost.

Factors to consider in determining the appropriate camera are:

- resolution or clarity of image,
- color quality,
- lag characteristics (i.e., flare effect as the camera pans across bright areas), durability, weight and size,
- lens compatibility (inexpensive cameras often offer only one lens option),
- automatic circuitry (many cameras are equipped with automatic exposure and color balance circuits or automated zoom mechanisms),
- low light capability.

Editing Equipment

Explanations of the types of editing can sound complicated, although the actual processes of tape editing are relatively simple to perform. The best way to understand the types of editing is to see each demonstrated. This section describes video tape editing equipment to introduce new video users to the options.

There are three basic types of editing equipment: manual, control track and computerized SMPTE time code editing. In the early days of video, editing was done by actually cutting and splicing the tape. This was unsatisfactory because it made the tape unfit for reuse, it clogged video heads and often produced a glitch, or loss of picture, at the splice.

The Bosch Fernseh KCK broadcast quality color camera for studio and mobile van use is a sophisticated piece of equipment.

Courtesy of Robert Bosch Corp.

Manual editing involves transferring scenes electronically from one tape to another using two VTRs. One VTR plays the production tape; the other records selected scenes onto a blank master edit tape. The two VTRs are rolled back about five seconds before the start of the selected scene on the production tape and the edit point of the blank reel. Both machines are switched into the play mode simultaneously and, at the approximate edit point, the machine containing the master edit tape is manually switched to record.

The problem with manual editing is the lack of precision, since the two machines are not locked together electronically. Edits are not always smooth because the cut depends on split-second timing on the part of the machine operator.

Control track editing electronically controls the timing of the edit. The electronics read a series of synchronizing pulses on the edge of the tape and lock the two VTRs together. When they are rolled back, the machines are completely synchronized. The record function switches on automatically at a pre-set edit point.

THE VIDEO TAPING PROCESS: Video taping is a process of storing and retrieving information that has been converted to electronic signals. The picture of the cellist above is converted into an electrical current by the camera. This electrical signal travels via cable to the VTR where it activates magnetic recording heads. As the video tape is moved past the heads, variations in the electrical signal cause metallic oxide particles on the tape to be aligned into specific patterns. For replay the tape passes a playback head to cause an electrical signal to be generated from these patterns which results in the production of pictures and sound of the cellist's recital.

A computerized video tape editing system is used for the quickest and smoothest type of editing process available.

Courtesy of Datatron, Inc.

Computerized editing makes use of a standardized SMPTE time code which is recorded on one of the audio tracks on the tape and displayed on the video screen. The time code assigns a number to each hour, minute, second and frame of the tape. The computer is programmed to respond to specific frame numbers and automatically performs the edit to perfect frame accuracy. Computer editing is by far the fastest and most precise way to edit. Not surprisingly, it is also the most expensive editing system.

Editing equipment is often the most expensive part of the total equipment system, though technical improvements are tending to make low cost systems more and more practical. Many video users purchase basic low cost equipment and rent more complex equipment from outside suppliers when needed.

PRODUCTION ROLES

Video production is a team enterprise and effective video managers select their crew with considerable care. The crew can include as many as 50 or more people in the case of top quality broadcast television programming, or production can be a one-person operation. It would not be at all unusual to see a newscaster from a tiny station jump from his car, jot down some notes, set up his equipment, run around in front of the camera to record the "on location report" and race off again to deliver the evening news. The system works for them. But for most applications, allocating responsibility is a more effective approach.

Somewhere between the two extremes is a combination of people, talents and responsibilities that meets the special needs of each organization and each

equipment package. What follows is a description of a typical broadcast production team. Most institutional or corporate users will find that their personnel are performing two or more of these functions at the same time.

Producer

The producer is the organizer or project manager who is ultimately responsible for the quality, content and distribution of the video tape. His or her specific duties vary. Sometimes the producer must aggressively research and develop program ideas; other times the program may come to the producer fully developed and scripted.

The producer has complete authority over the total production. He determines quality control — both creative and technical. He must understand and monitor the work of every other team member. He negotiates and controls the budget. He makes subjective judgments on scripts, visuals, edits, etc. It is a big job, and most producers rely heavily on the talents and creativity of their production team.

Director

The director makes the decisions regarding blocking, camera angles, framing and graphics. He or she is responsible for getting maximum performance from

Control track tape editing, using a device such as this, is far more efficient than manual editing.

Courtesy of Convergence Corp.

actors or (more frequently) non-professional performers. He or she coordinates the efforts of the camera operators and other technical personnel. The director makes most creative decisions and is responsible for the minute by minute production and editing.

Writer/Researcher

The writer/researcher is responsible for the script or content of the production and usually becomes the most knowledgeable person on the crew about the subject matter. He or she must have the ability to coordinate words and pictures in a way which meets the producing organization's objectives while holding the viewer's interest.

Technical Director (TD)

The technical director is an engineer with immediate responsibility for the other engineers and all studio equipment. The TD works in conjunction with, and takes orders from, the director. He operates the switcher and monitors the television picture during production for problems such as glitches, drop outs, etc.

Camera Operator

The camera operator's skill in the handling of his equipment greatly affects the quality of the final tape. Monitors on video cameras and immediate playback make it relatively easy for the beginner to learn visual skills, such as focusing, framing, etc. The camera operator is usually responsible for setting up the camera before production. During production, the camera operator takes orders via a headset from the director.

Engineers and Technicians

The engineers are responsible for the operation of the video system. They include: a *video engineer* who sets up cameras electronically (matching the cameras to house bars — the basic colors that the camera should accurately reproduce — and to each other); the *video tape operator* who operates the VTR; the *maintenance engineer* who keeps all equipment in working order. Other technicians include an *audio* person who operates sound equipment and monitors audio volumes or "levels"; *gaffers*, or lighting people; and *grips*, who build sets and move equipment.

Designers and Artists

Scenic designers and graphic artists work closely with the producer and director to create scenery, props and graphics. They may require help from a make-up person or costume designer.

Assistant Director/Floor Manager

An assistant director/floor manager (AD/FM) works on the set off-camera and serves as a liaison between director and performers, in addition to being in charge of the set and prop details. An AD/FM is responsible for the performers being ready and for cueing participants to camera changes during the taping. An AD is responsible for continuity — insuring that all segments of the show have been taped and are the correct length. On smaller productions, the FM is responsible also for striking the set, storing graphics and props, etc.

Location Crew

Location (anywhere other than a studio) personnel are sometimes organized in the same manner as studio personnel, the location essentially functioning as a remote studio. But there is another paradigm in location work based on the experience of Electronic Newsgathering (ENG) teams. ENG equipment allows the video producer the kind of portability common in documentary film production. The crew might consist of a producer, a sound person, a camera operator and an engineer. Personnel are added depending on the complexity of the situation. For example, elaborate coverage requires added camera crews or a large lighting situation might require a gaffer.

On documentary productions, roles are much less defined than in the studio. Technicians often contribute significantly to the creative content of the production. The producer might find himself performing technical chores when needed.

Whatever the production situation, the producer who leads an effective crew will be far ahead of the game in acquiring the value added that makes interesting video programming.

PRODUCTION TECHNIQUES

Every production starts with a story that needs telling. The principles of good story-telling remain fairly consistent no matter what medium is used. But some fairly standard techniques have been worked out over the years for structuring and adapting different kinds of stories to video tape.

Productions are roughly divided into three phases: pre-production — where the critical strategic decisions are made; production — actual taping of the show, and post-production — including editing and distribution.

PRE-PRODUCTION

The major decisions concerning production and editing are made during pre-production. Some shoots will be more carefully planned than others.

Dramatic shows, for example, are occasionally planned so carefully that every element of production and editing is predetermined. Documentary programs place heavy emphasis on creativity in both shooting and editing. In any case, certain broad areas are planned as closely as possible.

- Programming objectives – what is the purpose and audience for the program?
- Program format – how will the story be presented?
- Program content – how will the information be organized, whether it is built from a script, a treatment, notes or cues?
- Visual content – camera angles, blocking, sets, etc.
- Technical plan – the tape format, crew composition, production schedule, etc.

Getting Started: Need, Objective and Audience Input

Video tape production starts with a need, often a problem that the program will help solve. Once the need is identified it is adapted to video tape in a proposal that defines the audience, distribution method, general content, format and budget.

The proposal generally goes through an approval process that varies greatly from organization to organization. The approval process is an important way of making sure the program meets its objectives and that the message is clearly understood and properly presented.

The needs of the audience should also be addressed at this stage in pre-production. Video communication is more than just sender and message. The message must somehow touch the receiver's values for communication to succeed. Understanding the needs of the audience sharpens the focus of the program; it is what gives video the power to tell stories rather than just process information. The crucial questions are:

- Who exactly is the audience?
- What do they need to know?
- What do they know already?
- What biases might they bring to the viewing situation?
- Why should they be interested in the program?
- What are the benefits of the program for the audience?

The Method: Program Format

The choice of method, or program format, is a decision based on the nature of the information (how will it best be communicated), who the audience is (how will it best be received) and the budget and capabilities of available staff and facilities.

Most commercial television viewers are familiar with some of the basic program formats: drama, documentary, newscast, interview, game show and

Shooting a "talking head" in a studio with a simple set and basic lighting.

Courtesy of Compact Video Systems, Inc.

variety show. Other formats such as the "talking head" (explained below) are common in institutional productions.

• Drama or vignette. Dramas are scripted stories using actors who play roles. Dramatizations can teach by example. Viewers identify with the characters and relate their actions to personal experience.

• Documentary. Documentaries report on events in the real world through the eyes of a central character, who may be the narrator. They demand a storyteller's eye and a journalist's discipline to make them work and often use an off-camera narrator to maintain continuity.

• Newscast style. Industrial news shows are usually patterned after network television newscasts. Many businesses, schools and hospitals produce news shows on a regular basis to sum up organizational, local, national and international current events affecting day-to-day operations. Televising company news, for instance, can give the news impact and help eliminate the not-so-efficient grapevine.

• Game show. Like network television game shows, this format is entertaining and encourages audience participation.

• Variety show. Similar to network variety shows, this format can be useful when there are several different aspects to a presentation – e.g., if the company is introducing several new products, the program could include several "acts" with the products being the "variety."

• The talking head. A talking head program involves turning a camera on a presentor while he or she presents a report or responds to questions. The talking head format often makes use of additional visual materials, but generally uses the least action of any format. The materials can range from very simple graphics to documentary inserts or remote video displays. Public Television's *MacNeil-Lehrer Report* is a good example of this technique.

A broadcast quality studio during shooting.

Courtesy of Reeves Teletape

• Animation. Animated characters can establish an open and informal learning situation. Animation is often a good attention-getter with children.

• Interview style. This format is similar to network television talk shows, and represents an alternative to the talking head. An interviewer can help relate the information to the audience interests, while controlling the pacing of the show.

The choice of format will have a large bearing on the next three production decisions — whether to tape on location or in the studio, whether the program will be scripted and what kind of graphics to use.

Taping in the Studio

Traditionally, most television production has taken place in the studio. For many years the equipment was simply too heavy and complicated to move. Now studios come in all shapes and sizes and make use of a whole range of equipment possibilities.

The studio offers a number of advantages:

• it is a controlled environment (for example, it is soundproof);
• the equipment is installed and virtually ready to go;
• the video user can gather all his performers and resources in a single room.

Sets and props are important elements in studio taping and they must be designed for practicality. Most studios reserve a nearby room or a corner of the

studio itself for storing set materials and props that can be re-used. There is usually at least one syke or hanging curtain that provides a quick and simple background.

Good lighting in the studio is critical to the appearance of the tape. Lights are usually arranged on rolling stands or hung from a grid of pipes suspended from the ceiling. Studio lighting must give the performers a natural appearance, provide sufficient light to operate the recording equipment and achieve the appropriate mood for the program.

Good video lighting is relatively flat and low contrast. Avoid strong shadows on the face and reflections from clothing like white shirts, jewelry or eyeglasses. The trained eye is a good judge of the relative proportions of light falling on different parts of the set. What the eye sees is what the television sees, and usually accentuates. One technique is to turn off the monitor's color and examine the overall set lighting to spot under- and over-exposed areas. A light meter is helpful. Regardless of the quality of the video equipment, a poorly lit subject or scene has a negative effect on picture quality and the quality will deteriorate more quickly in duplication.

Inside of a 25-foot video production truck for full broadcast quality production on location.

Courtesy of Compact Video Systems, Inc.

Performer's Checklist

Non-professional performers in the studio are probably not going to look like "stars," but there are a few basics about being in front of a camera that can help.

• Appearance. Relax — look natural and comfortable. Hair should be neat, but a fresh haircut can look artificial. A little make-up can compensate for a very pale or shiny complexion. Light and medium shades of brown, blue and gray are the best colors for clothing. Double knit fabrics, small plaids and checks will put pounds on and cause moire patterns on the video. Wearing long socks prevents flashes of calf.

• Movement. Restraint is the key word. Sudden movements such as flying hands, swinging legs, constant shifting in seats, crossing and uncrossing legs are exaggerated by the camera and will distract viewer attention from the point being made.

• Eye Contact. Looking directly into the camera lens establishes eye contact with the viewer and contributes to the impression of sincerity. Eye contact can also sharply focus viewers' attention and involve them in what is being said.

Taping on Location

Most studio production is word-oriented. But video is a visual medium and offers the opportunity to take the equipment into the field to tell a part of the story in pictures. Good pre-production planning is essential to successful location shooting.

In its simplest form, location shooting means finding a better set. It is far easier to tape a complicated laboratory experiment in the lab than it is to set up a lab in the studio. The location is converted into a remote studio. Performers are rehearsed, cables are strung, furniture is moved and lights are carefully placed.

But location taping offers the opportunity to break away from the studio paradigm. The story is told of two video crews waiting to cover a sensitive labor negotiation. The chief negotiator appeared outside the negotiating room and reported excitedly to an official in the presence of one waiting tape crew the details of an important breakthrough. He then proceeded down the hall to give a dry news conference type of report to the assembled crowd and the other tape crew. Who brought home the better video tape?

People often present their story in a more animated and realistic way when they are not faced with the relatively alien studio environment. A plant manager who has just restructured his factory in an innovative way may deliver an

adequate technical report in the studio. If he is taped in the midst of his new factory he is much more likely to exhibit the kind of excitement he feels about his work. An audience relates to that excitement on a gut level and the information becomes much more important to them.

The documentary approach is usually most effective when the technical paraphernalia must be kept to a minimum. Cameras and recorders should be checked and aligned ahead of time. Technicians should not interrupt the situation to check the color balance. In some situations monitors are not used and the tapes are checked for technical quality after the shooting is over.

In the documentary situation the video producer is faced with a fine line between technical quality and program content. Technical quality should be acceptable but minor imperfections are a small price to pay for excellent content.

Scripts and Outlines

The program format dictates whether or not a script should be used. A fully visualized program or a drama, for instance, requires a script. A newscast or talking head may use an outline and cues. Many institutional productions are conversational and utilize a combination of working outlines and cues.

SAMPLE TELEVISION SCRIPT

TITLE: RELOCATING
OPENING MONTAGE 1:10

SLIDE ANIMINATION OF PHILADELPHIA METRO AREA. ENDING ON SHOT OF NEW BUILDING MODEL

BOB PETERSON
Welcome to Philadelphia — What you have just seen is a first look at the area in and around our new Division Headquarters in Philadelphia, Pennsylvania. I'm Bob Peterson, Chairman of the Relocation Committee. Following Dale Smith's recent letter, all of us on the Committee want to communicate all of the information we can on our new location. Where is it? What is it like? How can each of you begin to plan for this move? As a first step Sharon Hamstead, who is our Manager of Public Affairs in our Philadelphia office and who has lived in the area for the past three years, will try to bring some of the facts and flavor of Philadelphia and the surrounding areas to all of you with this video tape.

STUDIO SET
BOB PETERSON ON CAMERA
To right of key screen

MEDIUM CLOSE-UP
BOB

In the next 20 minutes or so, we will show you how the site fits into the area's geography; take a capsule look at the residential communities, the schools, the recreational facilities and the cultural opportunities you will find there; and we'll also tell you something about our new office building.

(Contd. on p. 50)

WIDEN TO REVEAL
SHARON HAMSTEAD
To left of key
LONG SHOT
SHARON & BOB

While I'm sure this one program will not answer *all* of your questions, it will give you some feeling for the advantages and the good living that this location has to offer. Now, since living in the area is almost as new to me as it is to you, I have asked Sharon Hamstead who knows the area to conduct our video tour — Sharon?

Cut to 2 shot
MEDIUM SHOT
SHARON AND MAP
ZOOM TO MAP
HELICOPTER FOOTAGE
OF THE AREA: 41 sec.
SITE:
STUDIO AND MAP IN KEY
SHE POINTS TO THE AREA

SHARON HAMSTEAD
Thank you Bob. Possibly the best place to begin is with a map. The site of the new headquarters building is about 10 miles from the center of Philadelphia. It is located just off the Interstate. As you can see, this road circles the city and is fed by all the major highway arteries. To give you an even better picture of the site let's see how it looks from the air. The site is the cone-shaped area. This is the general area in which we were flying. (SHE POINTS) As you can see, the airport is located here and is easily accessible from the new office site.

CLOSE-UP
MAP WITH COUNTIES ON IT

MEDIUM SHOT
SHARON & MAP

Philadelphia, as you would expect, is the hub of this region. Many of the people living in the surrounding metropolitan area find themselves fighting the daily rush hour. By locating our building out here we'll be able to avoid most of that. This is due in part to the fact that most people will probably decide to live nearby.

Those who prefer city life and opt for sections of Philadelphia itself will be commuting against the flow.

INSERT COMMUTATION MAP

MEDIUM SHOT
SHARON & MAP KEY

To give you an idea of commutation times to work at our site by car, we've prepared this special map. The site is at the center of the map. Anyone living within this area can expect a 15-minute ride or less.

ELECTRONIC ARROW
POINTS OUT THE AREA

If you live within this area ..,. the driving time will be about a half hour.

ELECTRONIC ARROW
POINTS
CLOSE-UP MAP

The farthest line out indicates a 45-minute commute during the morning rush hour.

ZOOM OUT TO LONG
SHOT
SHARON & MAP

As you can see, you've got great areas to choose from. Within these areas, you'll find a broad choice of urban, suburban and even rural living. One special feature is that you can travel, for example, from an urban to a rural setting very easily which makes it possible to enjoy the advantage of more than one lifestyle at a time. If there's one word to sum up the communities and housing in the Philadelphia area, it's "variety." In fact, I think it's safe to say that there are homes to satisfy everyone's tastes and pocketbooks. In addition to variety, you'll also have plenty of quantity. Real estate figures show that at any given time, some 4500 homes are for sale in the area.

DISSOLVE TO FILM
FOOTAGE

Examples of charts, maps and title cards.

There are some guidelines by which to determine whether the program will be scripted or outlined. Consider the most important ingredient of communication — the audience. When there is a clear understanding of the audience and its needs, the script or outline content can be approached and written in a style that is appropriate for the format.

Prompting devices (such as teleprompters and cue cards) are often used when a prepared text, such as a speech, is being presented on television. The problem with using prompting devices is that the performer usually reads the message and comes across to the viewer sounding stilted and disingenuous. When using any kind of prompting device in a production, performers should practice before the actual production.

Graphics

Television graphics are seen only once, and then briefly. The ideas graphics express must be grasped immediately and completely. In addition, the limited size of the television screen and the very nature of television (which causes small details to drop out in the process of creating the image on the screen) reinforce the necessity of simple, easily understood visual aids.

The graphic material most frequently used in institutional productions falls into two groups: standard graphics (title cards, slides, crawls) and special graphics (maps, charts, simple animations).

• Title cards. There are three basic types of title cards: plain, which contain simple lettering to be used to present program titles or credits; illustrated, which include art work; and "super" cards, which show lettering or art work superimposed over an object or live action.

Usually title cards are 14x17 inch illustration board, but the *essential* area to which all graphic material must be confined is a 6-3/4x9-3/4 inch rectangle centered on the card. For plain or illustrated title cards, dark letters or art work on a light background are most effective. To make supercards, the graphic should be light on a black background. Title cards are usually put on studio easels for easy camera pickup.

• Slides. Television slides are made by photographing the original graphic presentation on 35mm film and mounting the transparency between two 2x2 inch glassplated mounts. The slides are transferred to video tape by equipment called a film/slide chain.

Preparing a slide for a film/slide chain (background).

A telecine, or film/slide chain, is used to transfer 35mm slides and 8mm, 16mm and 35mm motion picture film to video tape.

Courtesy of Thomson-CSF Laboratories

• Crawls. A crawl text that moves across or up the television screen can be generated electronically by a character generator or it can be displayed by means of a large rotating drum.

The crawl is generally used for superimposing a list of credits at the end of a show or for displaying important points in the presentation. In preparing a superimposed crawl a strip of heavyweight paper the width of the drum, with white lettering running from the top of the strip to the bottom, is used. A plain crawl is prepared with black lettering on medium gray paper.

• Maps and charts. Most commercially available maps are too detailed to be useful on television. It is best to redraw maps to suit the presentation's individual requirements. Only the most necessary details are included. Dark art work on light gray cardboard gives the best photographic results.

Charts showing statistical data are usually specially prepared for television use. If the performer will be referring directly to the charts, they should be drawn on an oversized illustration board. If they are to be shown alone, they can be prepared like title cards. Generally, all charts should have as little written text as possible.

• Simple animation. One of the simplest forms of animation is to prepare a super card and reveal the graphic to the camera by slowly moving a black card across the front.

Planning Pictures: Picture Composition,
Camera Angles and Storyboards

Planning the individual shots ahead of time will help the production stage run smoothly and insure that edits work well. The most extreme example of production planning is the contemporary television commercial in which every shot and every word are carefully debated and orchestrated ahead of time. In dramatic productions the director will usually annotate the script with specific camera moves that fit the blocking and dramatic content.

There are four basic types of camera shots used in television:

• Wide shots. Wide shots are generally used to establish the scene. They are used less in television than in film because the medium is less capable of showing detail in a panoramic picture. However, the notion of an establishing shot is important; audiences like to have information about the environment in which the action is taking place.

• Medium shots. This shot frames the subject(s) from approximately the knees up. It is used more frequently in television than a wide shot. The medium shot can be a good establishing shot within a small area.

A crawl, usually used to show beginning or ending credits of a show, is often superimposed on another scene.

Curt TV

Relocating:

The problems of

choosing suitable

housing and

facilities during

company transfer.

Produced
and directed
by members of
the corporate
communications
department in
cooperation with
the local Chambers
of Commerce or

A character generator electronically generates numbers and letters. Depending on the sophistication of the unit, it can include different type faces, different crawl speeds and so on. The character generator is plugged into the switcher and can be utilized during production or post-production.

Courtesy of Thomson-CSF Laboratories

• Medium close-up. This is the most frequently used shot in television. It covers an area from roughly the elbows up and seems to be the most comfortable distance from which to watch someone talking to the camera. This shot shows good facial detail as well as some background.

• Extreme close-up. This shot is confined to an area the size of a person's face. It plays on the immediacy and intimacy of television and can have a very powerful effect on the viewer.

Composing pictures can make or break the success of the program. Composition involves:

• Framing. Perfect symmetry can be boring and unrealistic. For example, more space is usually given to the side of the frame toward which the subject is looking. Most framing is simply common sense. Pictures that look awkward are to be avoided.

• Camera angle. Most cameras are positioned at about the same height as the subject and slightly to one side. If the subject is presenting dramatic or emotional information the camera often moves to a full front close-up. Low or high angles are rarely used except for special photographic effects.

• Movement. Camera movement is accomplished with zoom lenses or a dolly. In a zoom, the camera is stationary and movement comes through optics that change apparent distance. In a "dolly," the camera is actually moved toward, away from or parallel to the subject. A dolly toward a subject is a dramatic movement usually reserved for special situations. A common zoom technique is to start with a wide shot and zoom in on the subject as the story develops.

• Cutaways. Cutting from one angle to another is an effective way to keep the audience interested, to move from one action to another, or to emphasize different aspects of the same scene, as audience reaction to a speaker's comments.

A *storyboard* can help enormously in the planning of shots and compositions. It is a sort of shooting script made up of drawings or still photographs with accompanying text depicting the important points of the story or message. The quality of the drawings is not important, as long as they convey in some fashion the images that will be photographed. The storyboard can provide concrete reference points during the actual taping of a program.

Pre-Production Planning for the Edit

Production decisions affect the editing of a program. Below is a list of some taping techniques that will make editing easier and reduce editing time, which can help if the schedule or budget is tight.

1

Relocating to:

2

Philadelphia

3

Philadelphia

"Welcome to Philadelphia. What you have just seen is . . . new Division Headquarters in Philadelphia . . . facts and flavor of Philadelphia and the surrounding areas to all of you with this video tape."

4

"In the next 20 minues or so, we will show you . . . advantages and the good living that this location has to offer."

5

"Now, since living in the Philadelphia area . . . asked Sharon Hamstead, who knows the area, to conduct our video tour — Sharon?"

6

"Thank you, Bob. Possibly the best place to begin . . . let's see how it looks from the air."

7

"The site is the cone-shaped area."

8

"This is the general area . . . Philadelphia, as you would expect, is the hub of this region."

9

"Many of the people living in the . . . Those who prefer city life and opt for sections of Philadelphia itself will be commuting against the flow."

10

"To give you an idea of commutation times to work at our site by car, we've prepared this special map."

11

"The farthest line out indicates a 45-minute commute . . . which makes it possible to enjoy the advantage of more than one lifestyle at a time."

12

"If there's one word to sum up . . . some 4500 homes are for sale in the area."

An illustration of a storyboard.

- A switcher is one way to "edit" different shots "live" during a production and can be used to reduce post-production editing requirements.

- Taping scenes in the order in which they will appear in the finished program will save the time of changing reels and searching for scattered scenes during the edit.

- Keeping an accurate record during production of where scenes are located according to the counter on the VTR will save a lot of searching time.

- Planning the footage for the program opening and close, and getting extra production footage to cover all the editing possibilities that might come up — e.g., for cutaway shots — will help avoid having to re-shoot at a later date.

- Planning when the graphics will be recorded (during the production or in the editing studio) may save some worry time and some last-minute scrambling.

PRODUCTION

At the end of the pre-production planning stage all major decisions regarding the actual production have been made. The set is prepared, the location is scouted, the crew is in place, scripts written, performers briefed and equipment warmed-up. Presumably everything will work as planned.

There are, however, some important details to be aware of during the taping that cannot always be anticipated. Keep the following points in mind:

- watch video and audio recording levels for deviations from expected parameters;
- watch for shadows and hot spots (bright reflections caused by over-lighting);
- make certain cameras are matched;
- monitor color levels, video gain and contrast;
- listen for interference on audio lines (caused by extraneous noises, radio frequency or crosspatching);
- keep a sharp eye on picture composition;
- be sure that what is being taped is exactly what is wanted; if not, re-shoot the scene;
- if the taping is not continuous, know exactly where the shooting left off and where it should begin again;
- if something appears to be wrong, check it out!

A switcher is a control unit that enables switching from one video source (camera, VTR, film chain) to another during production or post-production editing. Most switchers include a special effects generator for generating optical effects, such as fades, wipes and dissolves, between scenes. Switchers range widely in the number of effects and input sources possible. The Grass Valley 1600-IL, above, is an example of a simple switcher adequate for most industrial users. The Grass Valley 7K switcher, below, is generally used by commercial networks and professional studios.

Courtesy of The Grass Valley Group

In scripted productions, there should be few surprises. But don't be afraid to adjust scripts or camera angles to fit the needs of the moment. If an actor has difficulty delivering a certain line, consider changing the line on the spot. If a camera position is not working, move the camera.

In non-scripted productions, the producer and director should be working from a general list of cues or program notes. The production session will be changing and growing by the minute. How the creative people ingeniously manage to solve the production problems will determine the program's success.

POST-PRODUCTION

The Edit

Editing the production footage down to the finished master tape is often the make-or-break step for a program. The way in which the edit is approached is crucial to the overall appearance and effectiveness of the final program. Good editing should keep the program compact, well paced and compelling. The edit represents a major portion of the time and cost of video production. A poorly planned edit is a frequent source of budget over-runs.

Once the production footage has been gathered, the steps in the editing process are:

- Preview all footage and make a complete set of notes or even a formal log of the contents of the master tapes. Previewing is often done with a duplicate of the tapes which has a visual time code display. This provides a reference for finding material again in the edit itself.

- Prepare a blueprint of the edit which notes how the various scenes will be cut together.

- In some cases the editor will want to try out the cut using an inexpensive editing system before committing to the final edit in an expensive studio.

- Write and record any voice-over narration that will be used in the final edit.

- In the editing studio, assemble the master tape according to the blueprint.

A professional editor will have an almost intuitive sense of how pictures cut with each other. In general, edits should not jar the viewer with improbable picture cuts. A close-up will rarely cut to another close-up of the same subject unless the two shots were taken from very different angles. Continuity is important. If a door is open in one scene it should not suddenly be closed in the following scene. Reaction shots are often useful to cover momentary technical

lapses or for providing relief from an especially long, stable shot. For example, an interviewer will often be shown reacting to statements by the person being interviewed. The audience is frequently shown listening to a musical performance.

Editing involves more than just technical cutting. Every shot should serve the purpose of carrying the story forward. A well-constructed introduction sets the scene and captures the viewer's interest. The body of the program develops the story or information in a clear concise way. Usually there is a central question or theme that is resolved in the conclusion of the program. Successful editing starts with good storytelling. Figure 3-1 is an example of an edit blueprint, based on the "Relocating" script seen previously.

Methods of Distribution

There are six primary ways of distributing video presentations to viewers ranging in cost and sophistication from the U.S. Postal Service to microwave and satellite transmission. Table 3-4 summarizes the major characteristics, users and merits of each method. These methods are not mutually exclusive; in fact, two or more methods are often combined to overcome the limitations of each in distributing video presentations (such as a microwave link to the nearest satellite earth transmission station, or telephone long-line transmission around obstructions in microwave line-of-sight).

The nature of the presentation will guide the choice of a distribution method. In addition to cost, the key elements to be considered include:

- The information. Is it of an immediate nature? Will the message lose effectiveness by a delay?

- The objectives. What is the most effective way to get the message across?

- The audience. Where are they? Who are they? What is most convenient for them? How can they ask their questions?

These elements, considered against the advantages and disadvantages of individual methods summarized in the table, will help the producer to choose the method that best suits his or her needs.

COMMERCIAL FACILITIES

Commercial facilities are available for organizations that do not have in-house video tape production facilities, or for users wishing to produce a particular show requiring special equipment or creative talents. Some organiza-

Figure 3-1. BLUEPRINT: "RELOCATING"

Time Code In	Speaker	Audio	Picture	Time Code Out	Elapsed Time
1:03:00		Theme Music	—Opening Montage Slide Animation	1:04:10	1:26
00:21:16	Bob Peterson:	"Welcome To Philadelphia What you have just seen is a first look at the area in and around our new Division Headquarters in Philadelphia, Pennsylvania.... As a first step Sharon Hamstead, who is our Manager of Public Affairs in our Philadelphia office and who has lived in the area for the past three years, will try to bring some of the facts and flavor of Philadelphia and the surrounding areas to all of you with this video tape.	—LS Peterson standing R of Key Screen	00:22:10	:54
00:30:12		In the next 20 minutes or so, we will show you how the site fits into the area's geography;.... it will give you some feeling for the advantages and the good living that this location has to offer.	—CU Peterson	00:30:40	:28
00:35:27		Now, since living in the Philadelphia area is almost as new to me as it is to you. I have asked Sharon Hamstead who knows the area to conduct our video tour — Sharon?"	—LS Peterson & Hamstead	00:35:40	:13
01:10:37	Sharon Hamstead:	"Thank you, Bob. Possibly the best place to begin is with a map... To give you an even better picture of the site... Let's see how it looks from the air.	—MS Hamstead & Map	01:11:09	:32
1:28:32		The site is the cone-shaped area.	—Helicopter film footage of area	1:28:44	:12

1:38:46	This is the general area in which we were flying. . . . Philadelphia, as you would expect, is the hub of this region.	—CU Map	1:39:05	:19
1:43:13	Many of the people living in the surrounding metropolitan area find themselves fighting the daily rush hour . . . Those who prefer city life and opt for sections of Philadelphia itself will be commuting against the flow.	—MS Hamstead & Map; zoom in to CU Hamstead	1:43:48	:35
1:46:07	To give you an idea of commutation times to work at our site by car, we've prepared this special map.	—MS Hamstead & Map Key	1:46:32	:25
1:51:42	The farthest line out indicates a 45-minute commute during the morning rush hour. As you can see, you've got great areas to choose from . . . which makes it possible to enjoy the the advantage of more than one lifestyle at a time.	—CU Map; zoom out to LS Hamstead & Map	1:52:06	:24
1:58:02	If there's one word to sum up the communities and housing in the Philadelphia area, It's 'variety' . . . Real estate figures show that at any given time, some 4500 homes are for sale in the area."	—CU Hamstead —Dissolve to edited film footage of area	1:58:15	:13

Table 3-4 METHODS OF DISTRIBUTION

METHOD	SUMMARY DESCRIPTION	SOURCE	PRIMARY USERS	ADVANTAGES			DISADVANTAGES			
				Relatively inexpensive	Two-way communication possible	Rapid transmission possible	Relatively expensive	Geographic: line-of-sight	Geographic: limited service	Slow
Postal Service	Includes all hazards of U.S.P.S.: damaged in transit, lost or delayed packages.	cassettes open reel	Most video users	●						●
Closed-Circuit Television	Usually implies distribution within one building or several buildings in close proximity by hardwire linked originating and receiving equipment.	live cassette open reel	Business and industry Schools Government Medical institutions	●					●	
Cable Television	Usually implies community distribution of information through coaxial cable which goes from source to receivers.	live cassette open reel film	Licensed commercial cable companies provide access channels for: Government Universities Business and industry Schools	●	●	●			●	
Microwave Transmission	Line-of-sight, point-to-point transmission of television signals over the air.	Usually live but can be pre-recorded	Commercial networks Business and industry Schools Universities Government		●	●	●	●		
Telephone Co. Long-line	Special AT&T long distance telephone lines carry television signals.	Usually live but can be pre-recorded	Business and industry Commercial networks		●	●	●			
Satellite Transmission	International and domestic distribution from earth transmission station to satellite to earth receiving station.	Usually live but can be pre-recorded	Business and industry Commercial networks Government Medical institutions		●	●	●			

tions with in-house facilities prefer commercial facilities on occasion to provide a new twist and freshness to regular programming.

Most video operations rent special equipment on occasion from equipment suppliers. Very few operations can afford to purchase *all* the equipment they will ever need. Equipment rental companies will supply everything from an extra camera to complete production studios, mobile video vans and editing equipment. Often the local television station or institution (such as a business or university) will rent their facilities when they are not in use.

Video production companies offer the video user full creative services as well as providing equipment. They offer the best available equipment and personnel which is a luxury many small production set-ups cannot afford to maintain.

Production companies vary in the scope of services they provide. Some will design an entire series of programs or communications systems. Others specialize in specific kinds of programming like documentaries, industrials, training programs or dramatic shows. Look at a production company's track record. Screen some of their past productions. Find out what they charge for their services but be aware that in video, as in any other field, you usually get what you pay for. An inexpensive program may save you money but fail to achieve your purpose.

The outside production company usually provides a producer. It is important to give him or her a clear idea of the objectives of the program. The producer may want to do some further research on his own, and then return with a treatment or proposal that outlines the purpose, content and cost of the program. Many video users solicit proposals from two or more production companies and then choose between them on the basis of cost and creativity.

Off-the-shelf or commercially available programming is another alternative for many video users. There are about 100 video "publishers" who produce and/or distribute generic programming in many areas of business, medicine and education.

SUMMARY

Twenty years ago video was the province of large studios and super-technicians. Now, small format production systems, mobile equipment and-easy to use playback equipment have brought video into many institutions across the country. As technical limitations disappear, the non-technical video user becomes more and more important. The medium is limited only by the imagination and managerial abilities of the user himself.

Equipment is important but specialists can handle technical details if they are pointed in the right direction. The video user must have a working

understanding of production procedures but he does not necessarily need to become an accomplished director or camera operator. Every video user should have clear objectives, know his audience, and think through the entire production and distribution process.

The following profiles provide examples of how video operations work in a number of organizations across the country.

4

Case Histories:
Business/Industry

ADOLPH COORS COMPANY
Television Department
Golden, CO 80401

Skills training needs at a brewery can be almost anything, ranging from truck driving to troubleshooting machinery. At Adolph Coors Company a large percentage of video tape production is spent on skills training programs for many of the brewery's 3500 employees.

The Television Department produces technical skills programming for all Coors brewery departments as well as for some departments in the Coors Porcelain Company. These programs are primarily talking head/demonstration style shows aimed at a very specific audience.

"Fifth Wheel Coupling Procedure" is a 10-minute tape which opens with a trucking song. The first part of the tape is a demonstration of how to properly couple a tractor to a trailer. The second part looks at the mechanical parts of the fifth wheel and how they work. A 10½-hour series on the video jet printer instructs employees on how to maintain and troubleshoot this piece of equipment. This tape is a combination talking head and demonstration, but also incorporates footage of the ink pulses at the printer head shot through a microscope. The video jet printer series was sold to a competitor's brewery as well as to the American Can Company.

Training tapes are produced after a department has carried out a pre-training needs analysis to discover the specific problem and if television can solve it. Programs are developed and scripted jointly by the requesting department and TV unit. Once a training tape is finished, it is used indi-

vidually or in groups with an instructor. Evaluation questionnaires soliciting comments on the technical quality and the clarity of information presented are sent out with tapes. Employee response is regarded by the Television Department to have been extremely positive.

An orientation tape is shown to new employees at the brewery. The ½-hour production includes drama, slides and film to inform newcomers about workmen's compensation, parking facilities, and so on.

The local community college gives courses for credit at the brewery. These are recorded for employees who miss a lecture. The Public Information Department conducts a speaker's bureau and tapes, with the aid of a portapak, those employees who need to improve public speaking skills. Occasionally, Coors' president will address employees on tape.

Departmental utilization of television has risen drastically each year. Utilization is up 400% from the initial two years of operation. The TV unit predicts that 1978 will experience an increase of 300% over 1977. Despite these encouraging figures, TV is not getting an active push from top management. The TV Department at Coors feels it could benefit tremendously by a larger distribution network and a larger color studio. However, in the short run, TV Department staff is concentrating on producing a greater quantity of skills training programming.

Organizational and Technical Information — In Brief

The Television Department at Coors is in the Training Department, which is part of Employee Relations. All other audio-visual production is the responsibility of the Creative Services Department.

The production facility is an 800 square foot studio and control room, with three black and white cameras, 1-inch and 3/4-inch recorders and related production hardware. Most production, however, is done on location with portapaks. Distribution is via 1/2-inch open reel and 3/4-inch cassette playback units in wheeled cabinets. The production facility represents a $70,000 investment, and investment in the distribution equipment is about $9000.

Scene from "Fifth Wheel Coupling Procedure" — Demonstration of coupling tractor to trailer.

ALLIS-CHALMERS CORPORATION
Internal Communications/Video Unit
Box 512
Milwaukee, WI 53201

Many companies have discovered that combining the use of commercial production facilities and off-the-shelf programming to meet communications needs can be the best of all possible video worlds, particularly when the annual production schedule is light and the production needs vary widely from program to program.

Allis-Chalmers Corporation's video unit provides complete television consulting services, production planning and coordinating, script writing, but facilities and crew are contracted for each individual production.

Allis-Chalmers is a major manufacturer of heavy equipment and employs 23,000 people in 18 U.S. and Canadian locations and in 10 facilities overseas. The annual production schedule is about 15 programs, supplemented by the yearly rental of 20 to 25 off-the-shelf training programs. Most programs that the video unit custom produces fall into the areas of special interest/informational communications and some training.

"Joint Venture Announcement," an informational production, is a video taped press conference which explained to employees an impending reorganization of Allis-Chalmers and what effect it would have on them. The press conference, with the chief executive officer and the chairman of the board, was taped on location at the main office in Milwaukee. An introduction by a company vice-president was shot at a local industrial video studio. The program was viewed by almost all of the employees in the 10 divisions to be affected by the reorganization.

"General Manager's Comment" is a program for employees used by Allis-Chalmers Medium Motor Division near Cincinnati to explain that plant's expansion plans. Done in panel discussion format, the program was taped at Cincinnati's CBS-TV affiliate station, with visuals produced by the division's local advertising agency.

The 1977 Annual Stockholders Meeting was taped from start to finish and made available to management of all divisions. A local industrial video house provided cameras and recording equipment and some technical crew. Allis-Chalmers' video unit supplied the camera operators and the producer/director. The two-hour meeting is kept on file by the video unit to serve as a legal record of the proceedings.

Informational programs are evaluated by the Employee Relations Department at each location which reports how well the information was understood by the audience; these evaluations are relayed to Internal Communications.

Much of the management and employee training utilizes off-the-shelf programming in areas such as data processing and general supervisory training. Specific training needs are by custom productions. Quality control is an area in which very detailed and specific procedures are crucial. The Total Quality Assurance (TQA) system was introduced to manufacturing operators via tape. On the tape, an instructor from manufacturing operations explains the TQA packet and how to use it to assure quality products. The video unit scripted the program and arranged for visuals. Production was done at an independent TV station in Milwaukee.

Other in-house training programs include a tape on manufacturing compressors which is part of a course series in which several hundred operators have participated, a blueprint reading course produced to upgrade skills of engineers and a series on management-by-objectives produced at the request of the Corporate Employee Relations Department.

When television was first used at Allis-Chalmers in 1967, the company had purchased black and white 1-inch format video equipment, which was used in addition to outside facilities — at that time a local TV station. Allis-Chalmers encountered problems in equipment breakdowns which discouraged potential user departments, and production at the TV station was judged expensive. At one time, there were plans to install a 3/4-inch format color studio and bring all production in-house. However, over the years, the increasing availability of good off-the-shelf programming and the appearance in the area of relatively low cost industrial production houses has proven to be a more cost-effective alternative.

A primary objective for the video unit now is in educating management on what the medium can and cannot do. However, management is supportive of television operations, and there are no plans to change the present production arrangements and programming applications.

Organizational and Technical Information — in Brief

Allis-Chalmers video unit is part of Internal Communications. Full-time staff is limited to one, with help from others in Internal Communications and in the Audio-Visual Department when needed.

Production is with rented facilities and crew. Programs are mastered on 3/4-inch as a rule, but 2-inch is used occasionally. Distribution is on 3/4-inch cassette to field locations. The average per program cost is quoted at about $1500.

AMERICAN MOTORS CORPORATION
Kenosha Division
American Motors Television
5625 Twenty-Fifth Avenue
Kenosha, WI 53140

Can two lady wrestlers teach American Motors Corporation (AMC) employees how to manufacture and assemble cars? No. But a video taped interview with them can certainly interest employees on a coffee break; and at AMC in Kenosha, employee interest is what video is about. Most video productions at Kenosha are community-oriented shows; and since Kenosha is largely an AMC town, almost every community event involves an employee or a member of an employee's family.

AMC television is a plant venture, and almost none of the programming originates from AMC corporate headquarters. However, the corporation has used some tapes produced by Kenosha Division Broadcast Communications Department. One program which had showings in the corporate offices was "Concept 80." This was an exhibition of futuristic cars designed by AMC and built in the Kenosha plant. The program featured a speech by AMC's chairman of the board explaining "Concept 80" — the future of AMC, its cars and their designs. The cars of tomorrow were displayed by women in evening gowns and discussed in interviews with media representatives at the show.

The one regularly scheduled showing on American Motors Television is the weekly employee news show which features company news, upcoming community events, employee news and a special interest spot. These spots range from an interview with Miss Kenosha to Little League pre-season exhibition games. The on-camera talent for interviews and news is the disc jockey for the AMC radio show, and the production end is basically a one-man show. (AMC radio, called the American Motorshow, is geared toward employees who listen on their way to and from work. It broadcasts between 6:05 and 6:30 am and 3:30 and 4:00 pm.)

Since 1972, a great many employee interest and entertainment shows have been produced. They are aired five times each week, three times a day. The special Olympics for the retarded, school swim meet coverage featuring interviews with participants whose parents work at the Kenosha plant and scouting events are just a few of the topics covered. Video tours and mini-documentaries of the various divisions at Kenosha are designed to give employees in all divisions the sense of the plant as one operation in which everyone plays an important role. Interviews with plant visitors, notable employees and Kenosha residents are popular spots. One example is an interview segment with the journalist wife of an AMC engineer who covered Egyptian President Sadat's trip to the U.S. Occasional series are produced, such as "Tips on Gardening," which includes tips on freezing home-grown vegetables and choosing the right mulch.

For employee entertainment programming, local bands, singing groups and performers are taped and used as fillers when needed. Light entertainment films on hunting, fishing, etc., are shown during the lunch hour or during breaks, and several times each week excerpts from network shows such as *Monday Night Football* are shown on the night shift. It is also not uncommon for employees to bring their families to the plant at night for scheduled showings of special interest and entertainment programming.

Programming ideas often come from the employees and management. Otherwise the manager of American Motors Television is responsible for programming decisions as well as program design, development, production and distribution. Programs are now being produced at an average rate of three per week. In the future, the Broadcast Communications Department is interested in becoming more involved in corporate communications programming and in training.

Organizational and Technical Information – In Brief

The Broadcast Communications Department consists of radio and television, for which there are two full-time staff members. Video programs are produced both in Kenosha's one-camera studio and on location, using primarily 1/2-inch format and some 3/4-inch cassette. Distribution is by closed-circuit television to 14 canteen areas and four conference rooms and by video cassette. Student interns from the local college are sometimes recruited to help out in production work, but otherwise, no outside production help is used.

AMC radio is broadcast from a glass studio in the plant lobby. Transmission is by telephone lines to a local radio station which broadcasts the signal.

FISHER SCIENTIFIC COMPANY
Audio-Visual Services
711 Forbes Avenue
Pittsburgh, PA 15219

There are many ways to introduce and demonstrate a product. Try this one: The subject — Fisher Scientific Company's Histomatic Tissue Processor. The scene — the Galactic Histological Space Station. The year — 2000. The characters — Astra, an attractive lab technician, and TP20, a three-foot high robot. In 11 minutes, using this set-up, the product, the $12,000 Histomatic Tissue Processor, is described and demonstrated. TP20's memory bank projects the history of tissue processing, the development of the Histomatic Tissue Processor and its theory of operation onto a screen in the lab for Astra to see; and Astra, in going about her job, demonstrates the product and points out its benefits and capabilities.

Sales product training programs, product introductions and direct customer sales video programs at Fisher Scientific are all rolled into one high quality, information intensive presentation like this one. Sales representatives view these tapes to become familiar with the products, then hand carry the program on Super 8 cartridge to customers.

Fisher Scientific manufactures and distributes laboratory equipment, instruments and chemicals to industry, medical and educational institutions. It employs 4000 people in the U.S., Canada, South America and Europe. In the decade since its video operations began (in 1968) with one black and white camera and one VTR for sales training and role playing, Fisher's Audio-Visual Services has steadily grown into a full broadcast quality operation striving to make maximum use of the medium's capabilities.

Fisher uses television for a number of applications — product training, introductions and sales; operations procedures; quarterly reports; marketing promotions; motivation; benefits, and employee orientation. Some productions are highly creative and entertaining, like the "Histomatic Tissue Processor," and others are more traditional corporate video.

In the area of sales skills training programming, tapes are produced on basic skills for new sales personnel and on more advanced types of selling for experienced personnel. These productions usually dramatize problems sales representatives will encounter. An on-camera narrator talks about solving the problems through a particular technique, and the technique is then dramatized. Off-the-shelf programming is also used in sales skills training.

Fisher's Art of Managing Employees (FAME) is a basic supervisory training series produced by A/V Services. The series covers employee interviewing, performance appraisal, constructive disciplining, safety and the art of communicating with employees. Most training tapes are instructor independent, but the FAME series is accompanied by student manuals and leaders' guides.

Scene from "Histomatic Tissue Processor" — Astra and TP20 discuss the
history of tissue processing.

Operations procedures programming is produced for all levels. Branch
managers must complete forms on a regular basis to help in the evaluation of
overall branch efficiency. A video tape demonstrates how to fill out these forms.
A tape for packers demonstrates how to pack·and handle hazardous materials for
shipment. Another program demonstrates how to process orders through the
data processing center.

The manager's quarterly report is a 15-minute program. The first five
minutes is devoted to a financial report and an update on the current business
climate. The rest is a mini-documentary "featurette" highlighting a particular
Fisher division or company-related event. The 1977 Year End Report, with the
president and the vice presidents of sales, distribution and manufacturing,
featured a new video documentary production which sales personnel will use
with customers to promote Fisher's Chemical Division.

Marketing promotion tapes focus on the special promotion of one product
and how to sell it better. An important part of marketing and sales is motivation.
At a 1977 sales meeting, a series of entertaining spoofs on well-known TV
commercials and hit movies taped using Fisher products raised spirits high.
"Ring around the test tube" is the catch-phrase in an "ad" for Sparkleen

cleaner. The durability of a Fisher microscope is tested by a gorilla trying to tear it (instead of Samsonite luggage) apart. Fisher Contempra laboratory furniture is "The Great Lab King" in a Budweiser ad spoof. And in a take-off on the movie *Rocky*, the underdog Tuf Temp Tornado is chosen to fight the world champion Biggy Brand for the #1 spot. At another sales meeting, a motivational program was "Bionic Sales Reps," in which two Fisher sales reps, Bob and Betty, fatally injured in an accident, are saved when Fisher executives call in a famous Austrian doctor. The doctor makes them bionic, and the audience then sees them using their bionic abilities to deal with the competition and sell Fisher products. When the company executives discover that Bob and Betty are far outselling the rest of the sales force, the whole group at the meeting is "made bionic." The program ends with a tag that reads "You're Bionic. Go Prove It."

A/V Services has produced 145 programs to date and has an annual production schedule of 20 tapes. Programming topic decisions are made by the Central Control Board, made up of the president and vice presidents of the six Fisher divisions. Program development, depending on the subject matter, is by the director of employee development or the product manager. The program requester and the director of A/V Services develop the script. There is no formal method of evaluation; however, employee and management support is excellent, and utilization, while it varies depending upon the target audience, is high.

A/V Services plans to expand programming in 1978 to the area of management training, but otherwise there are no predicted changes in applications. In terms of technical capability, Fisher will eventually bring tape editing in-house, and the company may also be moving in the direction of 1-inch production.

Organizational and Technical Information—In Brief

Audio-Visual Services is under the Personnel Administration Department, and is responsible for the production of film, audio cassettes and slide/tapes as well as video. The staff of six consists of the director, a writer, an engineer, a production manager, a production coordinator (who serves as a cameraman, artist and set designer) and a secretary.

Programs are mastered in the studio on quad. When shooting on location, broadcast quality 3/4-inch masters are stepped up to quad for editing and tape to film transfers. Tape editing and animation are done out-of-house. Distribution is via 20 3/4-inch color playback units, and 10 1/2-inch black and white open reel units. The television production facility represents a $175,000 investment, with an additional $10,000 in distribution equipment. The annual average capital budget is $60,000; and the annual operating budget, including salaries, is $110,000. The estimated cost per program (not including salaries) is $3200.

THE FOXBORO COMPANY
Audio-Visual/Sales Promotion
Neponset Avenue
Foxboro, MA 02035

Television has become integral to many activities at the Foxboro Company, manufacturers and suppliers of process control systems and other instruments for industry. It is used in the training of many of the company's 10,000 sales and service engineers and production personnel worldwide, in marketing support, communications, research, customer education, employee development and community projects.

The Audio-Visual Department produces training packages for sales and service engineers that provide an overview of a product, its features and benefits, technical information, product applications and instructions on how to sell the product. When a product is sold, a package can instruct service engineers on how to install and maintain it. The tapes in the package are usually demonstrations, lectures and some dramatization. A series of tapes on Foxboro's SPEC 200 control system can illustrate the company's audio-visual coverage of a product. "SPEC 200 Philosophy" is an in-house training tape presenting SPEC 200 as a control system that is "evolutionary, flexible, field proven and state of the art." "SPEC 200 Electrical System Security" describes the SPEC 200 electrical system and security features. "SPEC 200 Overview" is a dramatized presentation which uses two Foxboro employees portraying salesmen about to make a sales call as a vehicle for explaining the various aspects of SPEC 200 hardware. Other tapes cover SPEC 200 reliability, computer compatibility, maintenance procedures, and the advanced production and quality control techniques involved in SPEC 200 manufacturing. In addition, sales engineers can be supplied with the SPEC 200 sales presentation slide package to use with customers. This is accompanied by a guide to help sales personnel sort through the many slides available and develop a good slide presentation.

Sales aids for the 400 Foxboro sales representatives, like the SPEC 200 slide package, and information on how they should be used, are important at Foxboro. Sales aids have traditionally been slides, slide/tape and Super 8 cartridge because of their convenience, but video tape is also now being used. The Foxboro Democruiser is a large van equipped with products for customer demonstration, a video playback unit and a stock of customer information cassettes. The van is staffed by a salesperson, a service specialist and a power/energy demonstrator. "The Democruiser Systems Presentation" tape familiarizes sales reps with the Democruiser, its contents and how it can be used with customers. An accompanying tape discusses how to operate and maintain the Democruiser.

Customers often purchase Foxboro's service oriented tapes when they purchase a Foxboro product. These are used to train their own in-house service personnel on the new equipment. Customers are also invited to one of Foxboro's

Opening scene of the newsroom in "1985 Newscast."

10 demonstration centers worldwide to view customer education tapes. These tapes include: "Principles of Chromatography," a lecture/demonstration by a Foxboro specialist; "Industrial Pollution Control," a four-part demonstration series, and a series of tapes on digital technology. Customers can purchase these tapes as well.

In the area of employee and management communications, some examples of programs are: "The Trans-Sonics Story" which explains, in talking-head fashion, Foxboro's acquisition of the Trans-Sonics Company; "Men of Steel," a documentary on the Steel Panel Fabrication Shop at Foxoboro; and "The Transporter System," a documentary on the design and installation of a conveyor belt transporter system in a Foxboro manufacturing plant.

In production training, video tapes demonstrate methods in the manufacture of Foxboro products. The company finds these especially valuable for training production personnel abroad.

Public speaking courses, run by the Public Relations Department, use video tape to improve speaking skills. Any employee who deals with people on the job can participate.

Foxboro also does occasional production work for community groups such as the YMCA and the Boy Scouts. When the local fire department purchased a new ladder truck, Foxboro produced an instructional tape on how to operate it.

Video tape is also used to record seminars and research projects. One program, a 1985 newscast, was produced as a "ho hum crasher" for a Board of Directors meeting. The "newscast" features local Boston tv-anchorman Chet Curtis and field correspondents reporting news of an ordinary morning in September 1985, a talking computer reporting the weather and the Foxboro Company providing the "commercials."

Programming suggestions come from various sources, but primarily from the manager of Educational Services and the manager of Sales Promotion. The latter administers all media used at Foxboro. Program design and development is done in-house, as is the major part of all production and post-production work.

By early 1978, 238 programs had been produced, and the production schedule calls for 40 tapes per year. The tapes are distributed to 93 of Foxboro's 150 locations worldwide. There are five technical libraries in the U.S. and three in overseas locations, which have an active index of 115 programs for sales and service employees. Any program can be ordered from the main office by sales and manufacturing locations. The Foxboro Company also has classrooms and demonstration centers for employee and customer education and training.

Off-the-shelf programming is used generally for supporting internally produced programs in the area of management training. Typically 10 to 20 of these are rented or purchased each year.

Organizational and Technical Information—In Brief

Audio-visual services are administered by Sales Promotion, which is part of the Marketing/Communications Group. Sales Promotion is responsible for all audio-visual production at Foxboro. Three A/V coordinators, a producer, a director and three technical support employees staff the production operation. Outside services are used on a limited basis.

The present industrial quality 1-inch color and black and white production facility is undergoing a complete change-over to the new broadcast quality non-segmented 1-inch format equipment. The new system, composed of six color cameras, four recorders, a new switching system and electronic editing, represents an investment of $600,000.

All duplication is done in-house, and distribution is on both 1/2-inch open reel and 3/4-inch cassette. Investment in the distribution equipment is about $75,000. The annual operating budget is over $100,000. In addition, the sale of customer education tapes has generated about $500,000 for the company.

GEICO
(Government Employees Insurance Companies)
Media Center
5260 Western Avenue
Chevy Chase, MD 20015

GEICO's Communications Department reports that video has been an essential link between management and employees. Video has been proven uniquely effective as compared with other communications methods in reaching employees and letting them know management is working in their interest.

Several employee communications programs are produced on a regular basis. A monthly news show complements employee publications. The show incorporates a spotlight feature such as a department or an interview with a member of senior management. A panel discussion program with the chairman of the board and several employees is modeled after "Meet the Press." Topics have included a new job evaluation program and the role of employees in current business plans. In addition, GEICO's medical plan and profit sharing plan were introduced on TV using professional mimes as talent.

GEICO also uses video for corporate communications. The chairman of the board's state-of-the-company address is taped at the home office and distributed to regional and branch offices. Annual shareholders meetings are also taped.

As in many businesses, employee training via video is regarded by GEICO to be more cost effective than traditional methods. Video is used as an aid in insurance claims training. Such information as legal or medical terminology is presented in a program and reinforced by a video quiz. Taped dramatizations help employees learn to handle customer complaints. New and refresher training in data processing also utilizes video. Most video training programs are presented to a group with an instructor present.

Other video programming at GEICO includes marketing programs to announce campaigns and strategy to employees and employee orientation, which includes video office tours and benefits information.

The Media Center, operating since 1970, produces an average of 50 programs yearly. Programs are generally produced at the request of a particular department. Evaluation questionnaires accompany the finished program. Many of the Media Center's programs are designed for one-time use. Other programs, such as training, have an average shelf life of one year.

GEICO employs 6000 people, 3000 of whom are located in the home office. Their reactions to video have been mixed, but the majority has responded

positively. With top management firmly committed to video and its continued growth, programming requests increased sharply in 1977-1978.

Organizational and Technical Information — In Brief:

The Media Center, which includes video, graphics and photography, is part of the Communications Department.

All television production and editing is done in-house in a full color studio on 1-inch format. Distribution throughout the home office and to regional and branch offices is via 3/4-inch cassette. Investment in production equipment is approximately $120,000, with an additional $30,000 in playback equipment. The yearly operating budget for the studio is $25,000.

GEORGIA POWER COMPANY
Training Services
11 La Vista Parimeter Office Park
Tucker, GA 30084

Although the Georgia Power Company video network got its start around 1970 in skills training, management and employee communications has recently become high priority.

Management communications programming consists primarily of statements and addresses from the company president or chief executive officer on topics such as policy changes. A bimonthly news program for the company's 11,000 employees is presented in a magazine format. Programs have covered the company library, rate cases and employee or department profiles shot on location. Other employee information programs, such as benefits communications, integrate questions asked by employees, taped on location, and management's response.

Video is used in management training courses as a feedback device. With the aid of video, managers learn how better to communicate with the public and how to prepare for a rate request. First-line supervisors and instructors also benefit by a critique of their performances on replay.

Employees, used as on-camera talent in skills training programs, demonstrate tasks to new workers. Most skills training tapes are designed for group use with an instructor.

Georgia Power Company buys no off-the-shelf programming but does exchange programs with other utilities.

Training Services, responsible for all television production, produces seven to eight programs monthly in addition to producing all other audio-visual material used by the company. Departments request programming and all production jobs are performed by in-house personnel. There is no method of program evaluation.

At Georgia Power, top management has fully endorsed video. In the coming year Training Services plans more involvement in management training.

Organizational and Technical Information – In Brief:

Training Services, in the Employee Relations department, is responsible for all in-house media production. The staff of 20 includes writers, producers, directors, A/V technicians and artists.

Production is in color on 3/4-inch cassette, with 3/4-inch control track editing. Distribution is via 3/4-inch cassette to 110 playback sites located in district headquarters, plants and training centers around the state.

The company has $400,000 invested in production equipment and $40,000 in playback units. The capital budget for 1978 is approximately $120,000, and the operating budget is about $350,000.

GULF OIL CANADA LIMITED
Video Communications
800 Bay Street
Toronto, Canada

The Gulf Oil Canada video network, a relatively new operation, has come a long way in a short time. Program production began in mid-1974—and five programs, produced out-of-house, were completed and distributed to 19 locations across Canada that year. The current production schedule is 40 programs a year (still produced out-of-house), distributed to 60 viewing areas in 44 locations, reaching 95% of Gulf Oil Canada's employees.

Management development accounts for 50% to 60% of all programming produced. "Management One" is a series of management training programs to help the new supervisor to develop a set of work related skills. The course is divided into 30 modules (video tapes, collateral material and post-tests) that deal with 30 skill objectives. Trainees proceed at their own pace, supervised by managers above them, studying only the skills they do not already have. Depending on the individual, the course can take anywhere from 6 to 10 months to complete. The Broadcast Management Training program uses video tape to test managers' public presentation skills. The "Human Resources Development" program is designed for management training in performance evaluation. Extensive use is made of off-the-shelf management development programming from Advanced Systems, Inc.

Employee training programs are produced, rented or purchased upon request from individual departments such as data processing or marketing. Most training utilizes off-the-shelf programming.

The second major area of programming at Gulf Oil Canada is communications. The subjects and formats are diverse. Management communications and policy statements are usually interview format. These programs have included the introduction of a new senior executive, an explanation to management about a major budget cutback, and a discussion about the company's equal opportunity programs.

An ongoing profiles series consists of five- to six-minute documentary style features for employees on subjects like a special employee situation, such as a worker in the Arctic; a department of operation, such as a drilling operation in the Rockies, or special events, such as the construction of a new Gulf Oil special energy conservation building.

Employee information programs include an employee benefits show, which is divided into five modules presenting the information using a mime and special effects, and a hearing conservation program presenting general information on hearing protection and pointing out areas in Gulf plants that have dangerous noise levels.

The video communications coordinator at Gulf Oil Canada acts as an internal consultant to departments requesting video programming. The media coordinator and the requester evaluate the communications problem, then the coordinator contracts the necessary creative talent and production facilities, and ushers the program through to completion.

Program viewing is arranged at each location by a video coordinator. Viewing takes place in individual viewing rooms, auditoriums, cafeterias or anywhere the playback unit can go. There is no formal method of evaluation.

Gulf Oil Canada does have a small studio, equipped with one color camera and a 3/4-inch recorder, which is used for rehearsals and occasionally for limited scale, quick productions. The company is quite satisfied with the use of professional production houses and plans to continue in this fashion. Top management and audience support is excellent, but Video Communications would like to increase the number of departments producing programming.

Organizational and Technical Information—In Brief

Gulf Oil Canada TV is part of the Human Resources Department. Video communications are handled by a media coordinator, who functions as a consultant and producer, and an in-house technician.

Commercial facilities, professional freelancers and talent are contracted as needed for most production work. An internal studio is used for rehearsals and an occasional production. Programs produced out-of-house are mastered on 1-inch or, on location, Super 8 film. Distribution is by 3/4-inch cassette to 34 locations, and by 1/2-inch cassette to 10 locations. There is a total of about 60 playback units in the field, major offices having five or six.

Capital investment in the distribution hardware, supplied to all locations by the main office, is about $140,000. The annual operating budget for video is $225,000 for the production of corporate communications and corporate training. Individual operating departments pay for the programs they request out of their budgets.

HEWLETT-PACKARD
TV and Media Services
1501 Page Mill Road
Palo Alto, CA 94304

Since 1967, when Hewlett-Packard (H-P) television began as a one camera, one VTR operation, the company's TV and Media Services has developed into one of the leading industrial television operations in the world. The programs that have emerged from TV and Media Services are for all levels of personnel and for customers as well. The majority of the 150 to 170 annual productions fall in the areas of product support, personnel training and development, and communications.

Hewlett-Packard's video network consists of more than 700 playback units in 194 sales and manufacturing locations worldwide, and nearly all programs can be viewed by most of the company's 36,000 employees. Although many programs are designed for a very specific audience, the availability of new tapes is announced throughout the company.

Product support video programming encompasses product applications, new product introductions, and promotional and education tapes viewed by customers. Product applications tapes, intended for sales engineers, demonstrate how products work. For instance, a tape on a production line controlled by H-P computers shows how a number of H-P computers can be interfaced and work together in a system. New product introductions are sent to sales offices on tape so that by the time the product announcement is made to the public, sales engineers already know about the product. Program formats for product applications and introduction tapes range from highly condensed voice-over demonstrations to dramatizations. In one program, professional actors portray an H-P sales engineer demonstrating a computer terminal to a customer. A program introducing a calculator graphics plotter is a fully scripted voice-over demonstration of the 38 commands, seven line fonts and five character sets of which the machine is capable. Essentially, the calculator plotter demonstrates itself—drawing a picture of itself as a finale. Programs are not created specifically for customers. Customer viewing of these product tapes is left up to the sales force.

Support tapes for sales training are used in seminars and workshops. These tapes, usually dramatizations presenting role models, convey H-P sales philosophy and the company's recommended manner of dealing with customers.

Electronic technology is advancing so rapidly that H-P must continually train and update its engineers and technicians in manufacturing and product service. Some programs are how-to's for an oscilloscope and other basic electronic test equipment. At the other end of the spectrum is "Digital Troubleshooting," a series of 14 tapes and collateral materials for engineers. The course, helping engineers make the transition from analog to digital electronics, is designed for use in a classroom or on an individual basis.

Scenes from "Solving Group Problems"

3. . . . how to enlist his help.

1. Handling the dominating participant.

4. Dealing with . . .

2. The hostile participant.

5. . . . non-participation.

About 200 technical tapes are for sale to H-P customers to use in training their in-house technicians.

Personnel training and development at Hewlett-Packard utilizes video tape support in seminars and workshops. Clerical workers in the administrative support workshop view tapes, primarily dramatizations, on how to use the phone and how to deal with stress conditions. A series on *Preparing for Retirement* includes programs on health and physical fitness, financial planning, estate planning and use of time after retirement. "Solving Group Problems," part of instructor training workshops, deals with group dynamics. Using the Flying Karamazov Brothers, a juggling act, to dramatize situations, the program teaches how to recognize problems and deal with nonparticipation, objections from individuals, dominating participants and hostility.

The company also finds video tape valuable in intracompany communications. For instance, when the chairman of the board's schedule does not permit him to attend a meeting in Europe, a video tape of his presentation is sent in his place.

Off-the-shelf programming is used in personnel training and development. Hewlett-Packard makes use of ACE and the Stanford Honors Co-op Program, on both tape and ITFS, allowing employees to work toward advanced degrees.

Programs are requested by divisions and departments. However, TV and Media Services sets priorities and makes the final programming decisions. The requesting division and TV and Media Services work together to design, develop and script a program. TV and Media Services attributes the success of the programming it produces to extensive pre-production planning and to reviewing all programs fully for technical content, legal and ethical considerations and for target audience levels. No formal method of evaluation is used.

Organizational and Technical Information—In Brief

TV and Media Services reports to the Corporate Personnel Department. The staff of 22 handles production on 16mm, Super 8 and slides as well as video tape, but video clearly dominates.

The production facility is an 18,000 square foot studio with three color cameras and 2-inch quad master recorders. A second studio is used as a back-up. All duplication and film-to-tape transfers are done in-house. No use is made of outside experts or technical talent. Distribution is by 3/4-inch cassette to 700 playback machines in 194 locations in the U.S. and abroad.

Investment in the production facilities exceeds $1 million, and distribution hardware accounts for more than $700,000. The average cost per program is $5000 to $6000.

ILLINOIS BELL TELEPHONE COMPANY
The Television Center
225 West Randolph Street
Chicago, IL 60606

It has been estimated that one out of every 65 Americans knows a Bell Telephone System employee on a social basis. Illinois Bell, in informing its 37,000 employees on key issues of the business, such as rate filings and registration, feels it thus is generating an enviable public relations staff.

Employee information programming accounts for about half of the more than 100 programs produced annually at Illinois Bell. Many of the programs are of a documentary nature, educating employees on new technologies, such as fiber optics. Programs on rate filings and policy changes are often "talking head" productions, taped on location and in the studio. Salary plans, incentive pay programs, competition and marketing concepts have all been topics of employee information programming at Illinois Bell.

Since Illinois Bell is primarily a service organization, a large part of the training centers around keeping employees aware of the requirement of giving competent, courteous service. An Illinois Bell telephone operator may handle as many as 700 calls in a day, so there are programs for new operators to make them aware of what kind of service customers expect. There are programs for installers on handling irate customers. Customer complaints led to one program on the importance of courtesy in dealing with the public.

The formats of these training programs vary greatly, but they usually include dramatizations of real situations employees will probably encounter. These vignettes are often incorporated with a commentary from an announcer. The programs are viewed in small groups with a training leader present.

The Television Center at Illinois Bell provides video tape programs for management seminars. Examples of productions are tapes on a new sales campaign and one presenting a new approach to managing salaries. The TV Center also produces discussion starters for training sessions, seminars and groups at all levels. Role play activities involve video tape in executive training and speaker training seminars.

Tele-conferencing is a TV Center service that is gaining importance at Illinois Bell. The two-way conferencing facilities between the headquarters in Chicago and the Springfield offices saves Illinois Bell management considerable downtime and travel expense.

Though Illinois Bell does not sell its programming, some productions are made expressly for public audiences. A tape was produced for business customers on how to use the new Centrex telephone system, and a program on a new telephone aid for the hearing-impaired is presented to civic associations.

Illinois Bell purchases about 25 off-the-shelf programs yearly in the areas of health, safety, management development and sales motivation.

Programs are produced under a client/agency arrangement. Clients, coming from every department in the company, are usually served on a first come, first served basis. Utilization of Illinois Bell's network and production facilities is increasing steadily as departments are budgeting more each year for video. To name a few: The TV Center produces one show per week for the Marketing Department; Operating Services has a seven-minute video report produced quarterly; and the Public Relations Department produces a monthly employee news show. All Illinois Bell programs are developed, scripted and produced in-house, with some use of outside pre- and post-production services.

Illinois Bell has been producing programs internally since 1961. The company's network is now capable of reaching 150 locations in the headquarters building and around the state by hardwire net, long-line and microwave. The network also includes 200 video cassette playback units, and to reach locations that are too small to get a permanent playback unit, the "mobile video theater" is used to take video programs, films and slide presentations around the state.

There is no formal method of evaluation. However, the TV Center gets some initial feedback on all productions in the form of a questionnaire. The current trend of client preference of video to other media suggests that support of video is very good and growing steadily.

Illinois Bell TV Center's future plans are for improving remote capability by building a new minicam van, expanding live network capability for the purpose of company-wide management discussions of key issues and continued expansion of the video cassette network.

Organizational and Technical Information – In Brief

The Television Center, a part of the Public Relations Department, produces films and slide shows as well as video for all Illinois Bell departments on a charge-back basis. The TV Center also provides a consulting service and two-way tele-conferencing facilities.

The TV Center, operating with a staff of 20, is capable of full broadcast quality production. Production is on quad. Distribution is via 3/4-inch cassette, hardwire net and a mobile video theatre. Capital investment in production and distribution equipment is about $1.3 million. The annual operating budget is $780,000, of which $430,000 is salaries. The estimated average cost per program is $3000.

INTERNATIONAL PAPER COMPANY
Video Operations
220 East 42 Street
New York, NY 10017

International Paper Company's video network reaches 40 of the company's 300 worldwide locations with orientation programming, management and employee communications, sales and consumer-oriented programming.

The company's Video Operations began in mid-1976. Past productions include "Commitment at Androscoggin," a customer and employee information program about the Androscoggin mill expansion. "Directors Tour 1977" is a 20-minute tape, shown to all employees, of the board of directors' tour of the wood products area of a southern plant. For the "Directors Tour 1978" program, the video crew took a plant tour and the tape was later viewed by the board at corporate headquarters in New York.

Video Operations has produced a variety of short marketing tapes for internal and customer use. The programs, which cover products and operations such as corrugated box packaging and International Paper's (I.P.) unique Tree Fruit box, are produced in documentary format incorporating interviews with customers.

"Corporate Overview" is a corporate orientation package. The first program introduces the company, its locations and organization, products and marketing. The second tape features the chairman of the board leading a roundtable discussion of public and human issues in the industry.

I.P. also uses video in sales motivation and recruiting. There is to date almost no use of video in training.

Programs have been created as a result of Video Communications seeking out communications problems and from direct requests from managers. When a division requests a program, a charge-back system is used to cover production costs. All locations can borrow tapes at no cost. For locations without playback equipment, tape-to-film transfers are available.

Most of I.P.'s programs are taped on location. Therefore, production capabilities have been kept versatile, small and lightweight and programs often are produced on film. Video Communications is encouraging field locations to create their own programs and has held one seminar to teach field video managers and communications people how to produce television programs. Video Communications is also working toward establishing relationships with TV stations near remote I.P. plants. To facilitate interaction with the local community, Video Communications would like to provide local stations with public affairs, public service and corporate image programming.

Organizational and Technical Information — In Brief:

Video Operations at International Paper is part of Communications Resources. It is staffed by six persons at the corporate headquarters in New York and a video manager at each of the 40 locations receiving programming.

All production work is handled by in-house staff. Programs are mastered and distributed on 3/4-inch video cassette and film.

JOHN DEERE & COMPANY
John Deere Television (JDTV)
John Deere Road
Moline, IL 61265

The opening scene is a painting of the bucolic midwestern farm country-side. The camera slowly pans and zooms on farm houses, barns, fields, streams, farmers and teams of horses. The rest of the tape is composed of voice-over location footage, graphics and slides explaining what visiting farmers will see on the factory tour of the John Deere & Company Plow and Planter Works.

Deere & Company, a $3 billion a year corporation, has been involved in video since 1968, and its growth record in utilization, scale and sophistication of programming has been remarkable.

The categories of programming at Deere & Company can be broken down broadly into corporate, manufacturing and marketing information and training. The majority of productions are training type programs for service, sales and marketing—such as video repair guides to hydraulic pumps and steering valves, or the effect of Consumer Products Marketing Laws on the John Deere Consumer Product Dealer. Manufacturing tapes show how to run a drill press effectively, a Data Logic Application series is for industrial engineers, and the basic motion and time study series introduces and explains the "standard hour incentive plan." Training programs include stand-alone tapes, series integrated with work books and practical lab situations, and short motivational tapes used as discussion starters in training sessions. Management and employee development and orientation programming (such as a lecture on problems associated with alcoholism, or an orientation on preserving the integrity of Deere & Company's corporate identity symbols and logos) and informational programming on the company, the various divisions and the products for customers (such as the factory tour introduction program described above) have become important areas of involvement for JDTV.

Some other examples of JDTV programming are: a panel discussion of the skills necessary for the first-line supervisor, a discussion of company efforts to improve and provide future equipment designs and a reliable service network; interviews with John Deere Industrial Dealers showing how risk management can contribute to the dealership profit picture; electrical preventive maintenance; the *Snowmobile Safety Savvy* series, produced for JDTV by Hanna-Barbera, depicting the antics of a cartoon character who defies rules and suffers the consequences, and "Did You See What I Said?" on the "non-verbal" signals of body language.

JDTV has produced approximately 300 programs, ranging from three minutes to two and a half hours, utilizing all types of program formats. "JDTV Presents" is a tape for all Deere & Company departments which shows and tells about many of the video production techniques within JDTV's capabilities.

Excerpts from various productions are used to illustrate location taping, special effects—chroma key, wipes and motion in titles and graphics, slide and film-to-tape transfers, and some of the various program formats, such as vignette, demonstration, fully visualized and interview.

Programs are produced when the client department and JDTV staff evaluate television as an appropriate medium for a given message. A JDTV project manager assigned to the production puts together a project team that works closely with the client to fully develop and produce the tape. Generally, the project manager will follow up on a program for a three-month period to evaluate whether the objectives were met. On specific shows, pre- and post-tests are performed. Productions are on a complete charge-back system based on an estimate of $300 per screen minute.

About 25% of the management training programs are purchased from standard outside suppliers and some programs, such as "Chalk Talk on Alcoholism" and *Snowmobile Safety Savvy* are produced out-of-house.

Organizational and Technical Information—In Brief

JDTV is part of the Management Training Department. It operates with a staff of 10, and some writing, art work and set design are contracted.

John Deere & Company has a complete broadcast quality production and post-production capability. JDTV utilizes two color studio cameras and an EFP camera. All production, studio and remote, is on 2-inch quad and helical, with computerized on- and off-line editing. All duplication and film-to-tape transfers are done in-house. All distribution is via 3/4-inch cassette to more than 250 locations in the U.S., Canada and abroad.

MANUFACTURERS HANOVER TRUST CO.
Management Communications
350 Park Avenue
New York, NY 10022

Manufacturers Hanover's video efforts were originally, in 1974, centralized in the Management Communications office. During the first few years, Management Communications produced (on leased equipment) about 20 informational tapes which covered all of the major corporate services. At the time, a small number of off-the-shelf programs were used primarily to augment sales training. Video activity has since been decentralized, allowing each bank department to have the responsibility for its own specific programming needs, with support provided by the Management Communications office when needed. The leased equipment was returned and all departments either contract commercial facilities for production services or use off-the-shelf programming.

The Management Communications office still produces programming from time to time, but is primarily involved with other audio-visual materials. One recent video tape was a documentary type of program on the New York Marathon. The program, which was fully visualized with slides and action, was shown to other banks, civic groups and schools across the country. Most of the programs which were produced in the initial phase of video use are kept in "Mani Hani's" (as the bank is known) video library; and one tape, which is a film-to-tape transfer of a 15 year-old film, is a classic.

"The Inside Story" opens like a 1940s detective movie. It dramatizes how bank customers really feel about how they are treated by tellers and officers — and what effect their feelings can have on the bank's business. One point made in the new video introduction to the old film is that people do not change. Another tape for bank employees concerns security. It is primarily vignette-style reenactments of bank robberies, stressing the key points of acting so as to maximize personal safety, minimize cash loss and aid authorities in apprehension of bank robbers.

Another department that has found video useful is the Sales and Products Knowledge Resource Center, which utilizes video in selling seminars held daily to train bank officers in selling services and dealing with customers. Sales and Products uses video specifically as "an electronic notebook," for role playing and feedback and to present highlights of successful selling techniques. In addition, about 75% of its programming is off-the-shelf training packages. The Teller Training School uses video to teach tellers how to sell services other than checking, as well as for role play activities. The Corporate Trust Department is a large consumer of the bank services tapes mentioned above, and new advertising campaigns are occasionally sent out to branch offices via tape.

Many other departments have not found video a viable alternative because much of the information they need to communicate is too complex and technical.

"Mani Hani" has in total about 60 playback units scattered throughout the home office and branch offices. Since there are 200 branch offices, the relatively small number of units makes wide distribution a problem.

The Management Communications office now concentrates on slide and multimedia presentations. Occasionally, a meeting is recorded on tape, but otherwise no efforts in the direction of television are anticipated. Sales and Products does plan to step up the number of categories covered in training, and would like to replace the purchased packages with its own. When this activity gets under way, Sales and Products would like to sell video training packages to other banks.

Organizational and Technical Information – In Brief

The Management Communications office is located in the home office and is responsible for counseling video user departments, as well as the production of other audio-visual materials. There are no full-time staff members for video activities. Production is done out-of-house, and there is heavy use of off-the-shelf programming. Distribution is via 3/4-inch video cassette.

MANUFACTURERS LIFE INSURANCE COMPANY
200 Bloor Street
Toronto, Ontario

The Manufacturers Life Insurance Company video network serves 39 Canadian and 45 U.S. locations as well as offices in the U.K., Hong Kong, the Philippines, Puerto Rico, Jamaica, Barbados and Bermuda. As with most large insurance companies, video at Manufacturers Life is primarily used to give uniform, cost-effective training to agents in widely scattered locations. In addition, Manufacturers Life's network is used extensively for general communications.

Each branch office has a permanent library of training tapes for new agents and for branch management. Programs are primarily in the areas of new products and services training, human relations skills training and data processing. Tapes are accompanied by collateral material and viewed under the supervision of an instructor. On occasion, agents show product and services tapes to clients. Video is also used by agents in sales role-playing exercises.

Manufacturers Life's video group produces "news updates" on a regular basis. These programs feature company news highlights, a state-of-the-company address, and provide a forum for recognition of leading salespeople. Other communications programs have included sales campaign kickoffs, orientation and benefits. Off-the-shelf programs include motivational speakers and generic programs on such subjects as new tax law.

Company divisions request programming and priorities are set by the video group. Appraisal questionnaires accompany each program to viewing sites. In addition, the video staff occasionally follows up with interviews with audiences and clients.

The video group produces 70 to 80 media projects per year, 80% of which are television programs. Audio cassettes and multimedia presentations represent the remainder. Presently, 200 programs (aside from training tapes) are in the main office media library, and there is an average of 900 to 1000 requests for this material each year.

Top management and viewing audiences are supportive of television. The video group hopes to involve more clients within the existing programming areas as well as to produce point-of-sale tapes for customer viewing.

Organizational and Technical Information — In Brief:

Video at Manufacturers Life is part of the Human Resources department. The video group operates with a staff of four people (two producers, one technical engineer and a media assistant).

The production facility is located in the home office in Toronto. Programs are mastered and edited on 3/4-inch cassette and distributed on cassette to Canadian and international locations. Distribution to the U.S. locations is via 1/2-inch video cartridge. The equipment investment is about $150,000. The operating budget is approximately $80,000.

MUTUAL BENEFIT LIFE INSURANCE COMPANY
520 Broad Street
Newark, NJ 07101

When you're watching the Apollo 11 spaceship launch, listening to the sounds of mission control, you hardly expect that the next time you hear astronaut Jim Lovell's voice he will be talking about a life insurance company. It isn't 1968, but 1975, and the show is Mutual Benefit Insurance Company's (MBL) first communication with field office management on its video system.

MBL's video system was implemented by the home office in Newark, NJ, to provide uniform training of field agents in the company's 80 independently contracted agencies. Training of the 1800-person sales force remains the primary objective.

Most of the video programming supports the sales training system already in effect. Video provides the overview on a topic, such as the agent's customer approach, while manuals and audio tapes supply the specifics. "The Approach" is a 25-minute tape in MBL's Financial Service Selling System that dramatizes how fictional agent Bob Miller approaches prospective clients, the Morgans. On voice-over, the narrator emphasizes important points in the agent's presentation. Another kind of training tape is a canned lecture by marketing consultant J. Kenneth Wylie on sequential selling of disability insurance. A narrator's voice comes in from time to time to update material, such as insurance rates.

Style awareness is also part of MBL's field agent training that is aided by video. The Style Awareness Program's creator, Dr. David Merrill, explains on tape four different personality types—"analytical," "driving," "expressive," and "amiable"—according to how others see a person's actions. Pauses in the tape allow for trainee discussion of the tape's major points: understand your style by "reading" feedback from others; do not try to change your style—let it work for you.

MBL also has what it calls the "celebrity series," consisting of taped sales presentations by the company's top field agents. Video is also used for motivational programming, the introduction of new selling systems, role playing and orientation. "Career Path" is a 10-minute orientation tape for field agents on the various stages of a life insurance salesperson's career. The narrator explains the five phases, drawing analogies to athletes. The visuals are track and field events in slow motion.

The video system has been used occasionally for corporate communications between the home office and agency top management. MBL's company president delivered a five-year state-of-the-company report via video.

MBL's software budget is $250,000 per year. The current library consists of 21 programs, all produced out of house, for which the agencies pay duplication

and tape cost. In 1976 and 1977 MBL used eight off-the-shelf programs dealing with general issues that affect the insurance business—such as a program on the plight of a widow whose husband had no life insurance—for which agencies are charged a rental fee. MBL's director of training estimates that the majority of these programs have been viewed at least once by the entire field force. Through a "report card" type of feedback system, response to the programs has been largely positive.

The home office provides agencies with playback equipment at a minimal yearly fee. An agency that wants a camera for role playing must buy its own, and the vast majority have done so.

MBL's video system has not grown much over its two years of operation. It has been widely accepted and used by the independent agencies throughout that time. While future objectives in video use will remain the same, the system's projected growth will be in the area of communications and training within the home office.

Organizational and Technical Information—In Brief

MBL's video operations are the responsibility of the director of training and the training assistant and are based in the home office.

All production is done by commercial production houses on a contract basis. Distribution is via 3/4-inch cassettes to 80 independent agencies. The annual software budget is $250,000.

OWENS-CORNING FIBERGLAS
Television
Fiberglas Tower
Toledo, OH 43659

It looks like the evening newscast of many local television stations. The anchorman, the set and the story pace and delivery are all professional. Nonetheless, the chroma key background reads "Fiberglas in the News." This is Owens-Corning Fiberglas Corporation's monthly employee news show, shot predominantly on location, covering such stories as the filming of the new Owens-Corning TV commercial or the "Supply Center of the Year" and examining various operating divisions. The goal of the employee news show is, like the goal of all Owens-Corning employee communications programming, to broaden employees' scope, to familiarize them with industry-related issues, and to involve them in the whole company. The priority of video use is to maximize effective communication with the 22,000 employees in Owens-Corning's 73 manufacturing centers, 86 sales offices and 15 overseas affiliates and subsidiaries.

Owens-Corning does not utilize the more standard types of video presentations such as annual meetings and talking head productions. It takes a news-style approach to most programs, making extensive use of location taping and involving employees as the source of information as much as possible.

Owens-Corning has produced an extensive employee orientation package of six 10- to 12-minute programs that address the topics of what the company is and how it is organized, what the basic products are, how customers use Owens-Corning products, the Owens-Corning philosophy of marketing with emphasis on products and applications, and how projects and concepts are followed through. Voice-over/location footage is the basic format of the series; members of the sales force are used to inform viewers about the products, and a mobile production unit spent six weeks in the field taping customer applications.

Owens-Corning places a great deal of emphasis on employees knowing what benefits are available and how they can be used. Benefits communication is comprehensive, utilizing both video and collateral material. The tape covering the company's group insurance program takes the theme of birth to convey the information in a positive, up-beat approach to health insurance. In the field, after group viewing of a benefits program like the one on group insurance, a manager holds a discussion with employees. Employees then take with them a brochure which explains the plan.

Owens-Corning also has an Employee Assistance Program which utilizes video to educate managers on drug and alcohol abuse, and how to identify and help employees with problems. The video program outlines company policy and incorporates filmed dramatizations of the stages of alcohol addiction. Managers are also sent into the field to conduct employee viewings of the program and to lead discussions.

Marketing uses video for the education of both the sales force and customers. Programming for the sales force covers selling techniques, product applications and communication from top management on sales-related problems. One program centered on the problems caused by the high demand Owens-Corning was experiencing for certain products. Top management in manufacturing held a taped informal discussion to talk about what was being done to alleviate the problem and how customers should be handled during that time.

Product information programs for use by salespeople with customers are usually video taped and transferred to Super 8 film for portability. "Open Office Acoustics—Interior Systems" tells the story of the open office concept, what is involved and how it works. Testimonials and endorsements by customers are used to add credibility.

Managers are trained in the basic skills of effective interviewing via video since managers in field locations near universities handle much of the company's recruiting. Employee training is a recent addition to Owens-Corning's list of video applications. Owens-Corning is currently evaluating the cost involved in training workers in a new manufacturing plant in Texas.

Most program production at Owens-Corning is handled by two internal TV programming specialists who act as producers on behalf of the department or

Scenes from "Fiberglas in the News" —
1. Anchorman on the set of the employee news show.

division requesting a program. The internal producers work with the department in program planning and scripting and are responsible for contracting outside production facilities and seeing the program through to completion.

About 90 programs have been produced since Owens-Corning became active in video in 1971. The annual production schedule is about 20 to 25 programs. A questionnaire provides feedback on program effectiveness and helps the programming specialists spot possible programming needs. The response from all levels to the Owens-Corning network is very favorable and the plans are for continued growth along current lines.

Organizational and Technical Information—In Brief

TV Programming at Owens-Corning, a section of the Corporate Information Department, is staffed by two TV programming specialists who act as producers and consultants to departments requesting programming.

Owens-Corning relies on outside professional studios and crews for most productions. The company has some black and white equipment for role play and lower priority productions. Distribution is via 3/4-inch cassette players located in all plants and branch offices.

Capital investment in playback equipment is $150,000. Programs are paid for on a charge-back basis from the requesting department.

2. From a featurette on the Special Products Operating Division.

PEPSI-COLA COMPANY
PCMI Educational Television Network
Purchase, NY 10577

With the sunrise as a backdrop, a truck is barrelling down the road. A country singer accompanied by guitar sings a trucking song. So begins the fourth program in Pepsi-Cola Management Institute's (PCMI) video cassette *Sales* series, "Merchandising and Display." PCMI's spokesman/narrator tells the viewer the name of the game — "moving' out, movin' in and merchandising."

The idea for Pepsi's video network was conceived in mid-1971 to lend wings to communications with geographically scattered franchise management. Pepsi has independent bottlers representing 500 plants and roughly 25,000 employees. The bottlers are not forced to accept company policies or programs; but, of course, a common interest in areas of advertising, promotion, marketing and training exists between Pepsi and the independent bottlers. The PCMI Educational Television Network, of which 400 bottlers are members, was established under the leadership of PCMI and the Management Education Committee (MEC), which represents bottlers. The network is now being used to provide 90% of all personnel training programs. The network is also being used for some corporate programming—management communications, marketing and advertising.

PCMI has three major training series: *Sales*, comprised of 11 programs; *Production*, with nine, and the latest, the *Route Manager* series, with 11. There are also motivational and orientation programs. One orientation tape, "Welcome to Pepsi," presents the history of Pepsi and the major ad campaigns since the company's genesis. All programs are supported by print materials.

In the "Merchandising and Display" tape, the narrator, who is the spokesman on all PCMI educational tapes, stresses the importance of knowing how to merchandise, display and place point-of-purchase materials in order to sell Pepsi effectively. The keynote is increasing sales over the "eight to ten thousand competitive products" by maximizing customer attention and motivation to buy Pepsi and by being a walking, talking public relations presentation.

The tape presents the viewer with the opportunity to learn by evaluating another route sales rep's performance and spotting his errors. The narrator goes over an instant replay of the salesperson's performance and points out his mistakes. The narrator explains the why's of merchandising and the importance of being on top of the job—merchandising is a "game in which you have to play both offense and defense."

The narrator suggests discussing the details of the job with the route manager. He also encourages keeping Pepsi informed on all the competition's moves, like new displays and discount pricing, as well as the competition's weaknesses.

Scenes from "Pepsi People—It's Our Day"
1. Phasing out the old ad campaign for Mountain Dew soda.

The *Route Manager* series consists of dramatizations followed by the narrator's summary of the major aspects of a route manager's job. Through the programs, new route managers have the opportunity to evaluate ways of doing the job effectively.

The educational video series is paid for on a "co-op" basis, with Pepsi and the franchise sharing the cost equally. Each series costs about $1000 to $3000 per franchise, depending on the number of programs in the series and the franchise volume. The *Route Manager* series costs $58 to $120 per viewer, depending on the size of the franchise.

Educational programming subjects are identified by PCMI and MEC. Once a need, like training and refreshing route sales reps in the everyday basics of merchandising, is established, a task force comprised of bottler representatives, technical advisors, writers, producers, PCMI coordinators and an educational advisor is selected to develop a series of programs on the topic. Pepsi's major programs and some corporate programming are produced out of house by Reeves Teletape, which also coordinates and produces the collateral educational materials.

After viewing each program in a series, like "Merchandising and Display," a program evaluation checklist, developed by outside educational consultants, is filled out by trainees to help evaluate the program's effectiveness. The checklist

solicits opinions as to whether the program was boring or interesting, practical or theoretical, etc. From the two series, *Sales* and *Production,* the only ones from which feedback has been analyzed at this writing, average response was 7.8 on a scale of one to nine.

A substantive cost/benefit relationship of the Educational Television Network is difficult to determine. The major tangible benefit is the increased number of people able to receive training information. Prior to network implementation, that figure was 3000 annually. It was increased to 18,000 when the network was completed.

Corporate communications make-up is roughly 30% video, the rest being films, print, slides and live speeches. Corporate video uses the television network to communicate with top franchise management concerning new product introduction and the introduction of new advertising campaigns and materials.

The "1974 Action Plan" program was an overview presentation to bottlers by a marketing manager on a new Pepsi fund generation program. The "Sugar-Free Diet Pepsi" tape in 1973 was an explanation to bottlers about the decision to introduce the new sugar-free beverage after the cyclamate ban and the FDA investigation of saccharine. Another program viewed by bottlers concerned a new shelf stacking concept that appeared to increase sales. Part of that tape was viewed by chain store management to show how re-allocating shelf

2. Introducing the new Mountain Dew ad campaign.

space vertically by brand and size could increase total profits in their soft drink section. Pepsi's desire for bottlers to group together for bargaining leverage in purchasing vending machines was presented via video. A tape preceded the production of the *Route Manager* series that presented the concept of the series in order to sell it to individual bottlers. The tape consisted of actual bottlers supporting the series, a description of each of the programs and why they would benefit the entire franchise as well as the new route manager.

Corporate programming ideas do not come out of one centralized source, such as the PCMI, but from input of brand managers, ad departments, sales departments, etc.

There is room for network expansion with Pepsi International's production training, as Pepsi's production techniques are the same the world over in terms of quality control testing, water treatment, sanitation, etc. (Sales and merchandising techniques differ, however, from country to country.) And, in the future, Pepsi will be making greater uses of the network to further the original goal of more effective and efficient corporate communications.

Organizational and Technical Information—In Brief

Pepsi-Cola's Educational Television Network is primarily under the direction of the Pepsi-Cola Management Institute (PCMI). Both PCMI and Pepsi-Cola corporate departments utilize the network to reach the 400 independent bottlers who are network members.

All television production is done out of house. Two-inch quadruplex is being phased out in favor of 3/4-inch cassette format for mastering programs. Distribution is via 3/4-inch cassette.

PHILLIPS PETROLEUM COMPANY
Video Communications
Bartlesville, OK 74004

When a company's health plan booklet is distributed, employees may not be able to figure out whether they will be paid off "by money or by turnip." That is one of Phillip Allwell's concerns. What if, he says, "I get my foot stuck on some gum on the escalator and my head comes out looking like this?", as his head flattens on both sides and extends into a cone-shaped peak.

Phillip Allwell is an animated character, designed by Comart-Aniforms and adapted to specific purposes in four Phillips Petroleum employee benefits productions. In "Your Health," Phil not only lends entertainment and comic value to a dry subject but he is a good device for getting at the heart of the questions that are vital to employee understanding of the company health plan. Phil's many questions are answered by two people from Phillips' benefits department. The program also employs hospital footage to visually illustrate aspects of the health plan and interviews with employees who have used the plan. The benefits series also includes programs on Phillips' payroll savings plan, retirement plan and long-term disability insurance.

Video Communications at Phillips produced the benefits series in part as a result of a survey of the 28,000 employees in the 107 locations worldwide that receive video programming. Employees indicated that benefits plans were not uniformly understood and that explanations were time consuming.

Other employee communications programs include a series on salary administration. The series incorporates interviews with key people in each area of salary administration to explain to employees how salaries are determined.

Management communications at Phillips flows in an upward as well as a downward direction. That is, company executives talk about issues such as divestiture on tape for management and employee viewing, and employees and their concerns are featured in tapes for management viewing. An example in the latter category which has had a substantive impact on company policy was a program called "Just a Chance." This program featured 17 women employees in a roundtable discussion of current job and social situations that affect female employees at Phillips. The group addressed such issues as women's job expectations and career goals and how the supervisor should act on these, what the company might do to alleviate the problems of labeling women and slotting them in limiting job roles, and how the company could help women gain business savvy and prepare them for positions of responsibility. The program was viewed by all levels of management from first-line supervisors up to the company president.

Skills training takes place at Phillips' field locations around the world. Taped skills demonstrations on topics such as welding and pump repair, accompanied by collateral material, are in great demand in places like the new refinery in England and the gas treating plant in Norway. In producing training tapes, Video Communications has discovered that very relevant programs aimed at a specific audience are far more practical than a broad "what Phillips is doing" content/audience spectrum. The audiences for training tapes have become smaller, but the programs are considered to be more effective.

Another successful video training effort at Phillips is the taping of courses given by outside experts. Video Communications video tapes the presentation given by a top geologist, for example, to a group at the home office in Bartlesville, OK. The geologist receives a free copy of his presentation and Phillips uses the course in places as far away as Singapore at an estimated savings of $250,000 in tuition and travel time and expense. Video Communications has produced five courses of this nature and is planning three more.

Video Communications has also purchased about 25 off-the-shelf management development courses.

Two new programming areas that Video Communications plans to expand are safety and "management memos." The first safety series, now in production, is a joint effort of the safety, medical and video staffs. The programs will be for viewing in all Phillips' chemical, petroleum products and refinery divisions.

Management memos are short, loosely scripted, quick productions that utilize some of the studio downtime between big productions — for example, a meeting held in the studio and taped for the benefit of field management.

Phillips became involved in video in 1975. In the first year all programs were produced by an outside professional production company. These first programs were in many different areas for two reasons — to have something that would demonstrate to management the flexibility of video and to serve as a learning experience for internal video staff. Phillips built a studio in the second year with some outside assistance. In the third year of operation video was totally in-house.

Phillips now has a library of about 250 programs, with an annual production schedule of 50 programs. Programs are produced on a charge-back basis to the requesting department. Questionnaire evaluations accompany each viewing of a tape. The video representative at each location reports the reactions, which are then tabulated and the results sent to the client department.

For the future, Video Communications is planning another tour of field locations to find out what the employees need from video. They also plan to explore more areas of programming.

Organizational and Technical Information — In Brief:

Video Communications, under the Public Affairs department, is in charge of all internal video programming at Phillips Petroleum.

Production in the studio and on location is on 3/4-inch cassette utilizing broadcast-quality color cameras. In the near future the studio will be converted to a 1-inch facility. Computer-assisted editing is done in house. Distribution is via 3/4-inch cassette to 107 playback locations worldwide. Production and playback hardware represents an investment of $500,000. The annual operating budget is $300,000.

Scene from "Your Retirement" — Company benefits spokesman talks to Phillip Allwell about the company's retirement plan.

PRUDENTIAL INSURANCE COMPANY OF AMERICA
Audio-Visual Services Division
Corporate Office
Newark, NJ 07101

Insurance companies, because of the geographically dispersed nature of their organizational structure, are among the leaders in video tape networking. Prudential, with nine regional home offices, 676 field offices and nine satellite offices, is no different from many other insurance companies in its need to train and inform people uniformly in widely scattered locations.

The Prudential's network was initiated in the late 1960s after the company had researched private television. By 1977 video equipment had been installed in all 676 field offices, each then having a library of 20 training tapes and recording capability for role play activities. In addition to the main television production facility (and 100 to 120 playback units) in the home office, four of the nine regional home offices acquired production capabilities and the rest began producing out-of-house. The main home office production load has increased steadily with 25 tapes produced in 1975, 35 in 1976 and more than 50 in 1977.

The major emphasis of television production at Prudential is on training field agents, branch managers and computer systems personnel. Other areas in which television has been effective are community affairs programming and management communications—an application which is just beginning to gain importance for this company for such features as advertising compaign introductions and reports on annual sales results.

Many of the agent and manager training programs involve dramatizations and an on- or off-camera narrator. "Selling in the Family Policy Market" is a program for insurance agents which demonstrates how to sell a family insurance policy. A story centered around fictional agent Mike Mancini and the Bryant family illustrates how an agent makes the initial contact, explains the need for a family policy and describes the various policies available, and handles questions. "Selection Interviewing Techniques" is a program for field office managers. Dramatizations illustrate good and bad interviewing techniques, and a narrator summarizes and reviews the principles that make an interview effective.

But not all of the Prudential's video training programs are so straightforwardly structured. "The Basic Principles of Insurance" uses a very different, yet effective, approach—hand puppets. Merlin, a retired insurance agent, is seated behind a desk when his friend Rob comes to him, full of questions and misconceptions about how the insurance business works. With the help of a talking hat, Merlin explains the basic concepts of sharing losses, equality of risk and the law of large numbers to Rob and to newcomers in computer systems.

A series in production for the Computer Systems Training Department is the *General Insurance Training Course*. About 18 programs are finished, and

there is a potential for 40 when the series is completed. Each of the tapes is a compression of a two-hour lecture session into a 20-minute presentation. This reduces the training session from two hours to one, providing more time for questions and reduced instructor planning time. It also makes it possible for lower level personnel to administer the course. It is estimated that this series will be seen by as many as 15,000 to 20,000 employees, and that in time cost, over and above production cost, there is a savings of approximately $71,000 per taped session.

Prudential's Audio-Visual Services Division is responsible for evaluating all video programming requests from departments throughout the company in terms of potential money-saving or income-generating applications, and in terms of whether television is in fact the best choice of media for the specific purpose. The shelf life of a program is also considered. However, because of frequent changes in laws affecting the business, government regulations and forms, some programs that are produced never get released. In addition, because of the disparity in insurance regulations and forms from state to state, some programs must be designed to be as general as possible to be widely applicable. Some off-the-shelf programs are used by Prudential, primarily in computer systems training and motivational areas.

For the future, Prudential plans for the growth of video use in the area of management communications, and the company looks forward to a greater emphasis on feedback and evaluation of video's cost-effectiveness.

Organizational and Technical Information—In Brief

Prudential's Audio-Visual Services Department is in charge of all audio-visual materials. The corporate office's staff of 25 people spends about 25% of its time on television production. Production crew, except for the director and the video engineer, are hired on a per job basis.

Mastering is on 1-inch tape with in-house post-production capability and distribution is on 3/4-inch cassette to more than 100 playback units in the home office, 676 field offices and nine regional offices.

SOUTHWESTERN LIFE INSURANCE COMPANY
Audio-Visual Services
P.O. Box 2699
Dallas, TX 75221

People are often inspired and are able to learn more quickly by examples with which they can identify. In the insurance business, a successful agent can often motivate other agents toward success. Southwestern Life Insurance Company, among others, takes this tack. An interview on video tape with one of Southwestern Life's leading female agents, now in her 70s, is used in recruiting women agents. The interview, taped on location at the veteran agent's home, is also viewed by field agents. During the course of the interview, Willimett Rowland tells how she got started in the insurance business. She talks about her approach and her philosophy, and what she thinks it takes for a woman to be a success in the business.

Southwestern Life's Audio-Visual Services has a library of over 175 off-the-shelf and internally produced programs dealing primarily with motivation, agent and field management training, and communications.

Audio-Visual Services produces two news shows on a regular basis. One is designed in a video news format for field management and covers subjects such as changes in procedures and legal issues. Another, in a regular newscast format, is for field agents and covers such items as new services the company is providing and issues affecting the company. "Market Place," for agents, is co-anchored by the vice president of Marketing Services and the director of Audio-Visual Services.

Using video programs to train field agents and managers is the priority application of television at Southwestern Life. The company's agents and managers are scattered in 42 branch offices and 40 independent agencies in 38 states. New agents are flown in to the home office in Dallas for initial training, but extensive training goes on in the branch offices as well.

The typical training package includes a video tape, a trainer's guide and reference-text material for each trainee. The video tape is usually a mix of dramatizations by professional actors, and interviews with inside experts and successful agents. Often, the video tape is viewed at the start of the training session (either a small group or a one-on-one setting). The information and examples presented in the tape are used to initiate discussion and reinforce the key points of the lesson. "Steps in the Sales Process: Prospecting with Referred Leads" is an example. After the opening animation, an assistant branch manager and the Educational Director talk separately about the importance of integrating selling and prospecting for leads. Dramatizations illustrate two different approaches to obtaining referrals from clients. Many of the key ideas are reinforced by graphics. The tape also includes agents talking about what they do in different situations to obtain referrals.

Television is not used as much for the home office as it is for the field. For instance, the home office relies more heavily on lecture format training sessions, while the field relies more on the training packages. New field employees view a video tape documentary on the company, whereas new employees in the home office see the same material as a three-screen multimedia presentation. Audio-Visual Services has produced 50 to 60 multimedia presentations, primarily for home office training and conferences.

In 1978, Audio-Visual Services plans to produce 10 to 12 video tapes, and 6 to 10 multimedia shows. Programming topics are chosen in various ways. Requests for training tapes come from the Field Trainers Council and the home office Sales Training department. The groups jointly decide on priority topics. Audio-Visual Services and Sales Training then develop training packages. Motivational programming comes out of Audio-Visual Services, and requests for informational type programming come from all areas of the company.

Off-the-shelf programming is used in management training and sales motivation. Some generic programs, such as one on estate planning, are used when agents make presentations to civic groups.

Audio-Visual Services has begun to place a greater emphasis on formal program evaluation. A prototype tape is produced and tested in selected branch offices before the actual finished program is released. After release, Audio-Visual Services follows up by questionnaires and phone calls.

Feedback on programming from the field varies, but is basically positive; and top management is very supportive. Field utilization of television is substantial; and training demands are so great that Audio-Visual Services has just about reached its annual production capacity with the existing staff.

Organizational and Technical Information—In Brief

Audio-Visual Services is part of Sales Training, which is in the Marketing Services Division. Audio-Visual Services is responsible for all audio-visual production for the company but the primary responsibility is training. There are six staff members. Scripting is done by writers in Marketing Services, professional actors and narrators are hired, and occasionally local college students are hired to help with production work.

A new color facility was recently installed utilizing two studio cameras and two portable cameras. Production and distribution is on 3/4-inch cassette. The recent conversion to color represents a $120,000 investment. Normally, the annual capital and operating budget is $100,000 to $150,000.

UNITED STATES GYPSUM COMPANY
Video Department
101 South Wacker Drive
Chicago, IL 60606

In "The Perfect Frame-Up," Mary Astor wants doors to open for her. Humphrey Bogart helps her out—by instructing his friend Max on how to install the Pan-L-Fit door frame. Max constructs a "doorway fit for a princess and straight as the Holland Tunnel." In the end, Max gets the girl. As Bogey says, "When panels fit, you always get the perfect frame-up."

"The Perfect Frame-Up" is a sales training tape produced by U.S. Gypsum Company's Video Department and Mary Astor and Bogey are actually look-alikes. In the same spirit is "60 Million," a program in which it appears that the cast of CBS's *60 Minutes* is moonlighting to inform Gypsum sales people about Ultrawall partitions. The "point/counterpoint" segment centers on factors that will encourage contractors to use Ultrawall. Viewers are told about the 60 million square feet of partitions sold yearly, the incentives for contractors, the market potential and Ultrawall features and benefits. The "mail" segment features information on the tax savings possible with Ultrawall.

The Video Department produces about 10 sales training courses a year, each course utilizing an average of three tapes in addition to collateral material. Training courses are not mandatory, but suggested by supervisors, so the Video Department feels that programs must be as interesting as possible. Programs utilize every format from humor to drama to documentary. The courses do not require an instructor and are designed so that the trainee can proceed at his own pace.

The Video Department also produces technical training programs for U.S. Gypsum plant workers. Video is also used in marketing promotions and management communications.

Marketing promotion tapes are produced for U.S. Gypsum dealers on how to display and handle the distribution of new products such as moveable partitions and metal doors.

Management communications programming is a relatively new area of involvement, consisting of special messages and management development programs. A recent program was "Corporate Policy and the Law" viewed by the company's top 1000 managers. Vignettes portray six major areas of management's legal responsibilities. A professional on-camera narrator was also used.

The Video Department hires professional actors and narrators for most on-camera roles. Employees are used as content experts and in bit parts.

Program decisions are made by the Priority Committee, a group of company vice-presidents who meet annually. The video budget is based on the Committee's programming decisions. In addition, individual divisions and departments can request programming, but must pay for production out of their own budget.

There is random evaluation of programming by questionnaires and personal interviews. The general atmosphere for video is positive. Top management is supportive and there is an increased demand for program production.

In the future, U.S. Gypsum plans to merge video and other audio-visual production into one department. The Video Department is also considering in-house production of broadcast television commercials.

Organizational and Technical Information—In Brief

Video at U.S. Gypsum Company is part of the Communications Program which is within Corporate Marketing Services.

The present production facility is a black and white 1-inch studio; however, conversion to broadcast quality color studio is in the process. Distribution is via 3/4-inch cassette units in 60 learning centers in the U.S. and Canada.

A proposed new production facility will represent an investment of $750,000. The annual video budget averages about $100,000.

Opening scene from "Ultrawall-60 Million" — the sales training tape takeoff on CBS's "60 Minutes."

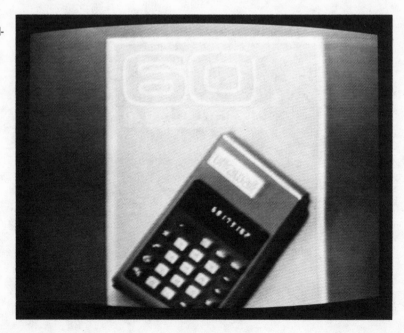

5

Case Histories:
Government

NEW HAVEN LEGAL ASSISTANCE ASSOCIATION
Community Legal Education
413 Howard Avenue
New Haven, CT 06519

The New Haven Legal Assistance Association (LAA) constitutes 3% of the area's legal services, yet its client pool forms more than 20% of the region's population. In addition, the annual staff turnover is high. So when video was put to work for LAA in January 1977, the challenge was formidable.

LAA video tapes authorities in areas such as housing law, health law and discrimination for viewing in workshops to train community workers in 75 area organizations. The programs teach how to resolve simple legal problems that do not require a lawyer. LAA has produced a library of these programs which average 20 minutes in length and constitute the formal portion of training sessions. After the tapes are shown, a personal follow-up discussion is conducted by a member of LAA's educational staff.

Self-help tapes in areas such as family law, automobile law and how to sue in small claims court teach clients about the law and their rights. The tapes, shown in the waiting room and by request, save more staff time for individual problems.

Lawyers and paralegal staff at LAA video tape training conferences for playback at other LAA offices. The staff also uses video for role playing and for taping lectures on new legislation.

Documentary programs on noteworthy New Haven organizations and on special cultural events in the inner city are taped for client viewing in waiting areas. A program on People Acting for Change, a block association, shows how the group organized their neighborhood and brought about change.

The LAA staff is trained in television production by Yale students and so far has produced more than 120 programs. For the future, the organization is investigating the possibility of a statewide video network among legal-services agencies.

Organizational and Technical Information—In Brief

New Haven Legal Assistance Association has three offices in New Haven and one each in Waterbury and Hartford. Video tape production is under the community education program started under a grant from the New Haven Foundation. Production is in black and white and color on 1/2-inch cassette. Distribution is via 1/2-inch cassette players in each of the five agency offices. Yearly operating budget for the entire community education program is $50,000, including salaries.

NEW JERSEY DEPARTMENT OF HEALTH
Division of Narcotic and Drug Abuse Control/
Alcohol, Narcotic and Drug Abuse Training and Education Center
Media Communications Unit
Route 1 and Emmons Drive
Princeton, NJ 08540

Few young people see the inside of a prison, much less hear inmates with life sentences talk about their lives there. This experience is available to young people in New Jersey in the form of a video taped documentary, produced by New Jersey Public Broadcasting Authority and made available by the Department of Health Media Communications Unit. "Warnings from Inside" is a program in which inmates at Rahway State Prison talk to a group of juvenile offenders who are going through the experience of spending two hours in prison. The inmates belong to a group that participates in various projects to further awareness of the consequences juvenile offenders may eventually face. The program applies techniques that exploit the intimacy and immediacy of television. Extreme close-up photography of the faces of convict after convict telling the facts of prison life and dramatic lighting work together to enhance the message.

Public education programming, such as "Warnings," is one of the communications functions of the Media Unit. Serving divisional and departmental training and communications needs since 1972, the unit has some 200 programs on tape covering areas such as drug abuse prevention, drug and alcohol treatment, drug education, minority issues, women's issues and drug and alcohol workshops. Some of these are local productions, others are off-air recordings of network specials or purchased commercially produced programs which the Media Unit makes available to schools, treatment facilities and other state agencies.

Another major application of video at the Training and Education Center is, of course, training. The Media Unit has about 30 training courses for clinicians and social workers that involve both in-house productions and commercially available tapes. Video is also used to tape role play situations and to record seminars, meetings and workshops. An introductory video course is offered to treatment staff, who learn the basics of video tape equipment and how to use it in training, public education and in taping one-to-one and group counseling sessions. It is up to counselors to apply the medium.

The Media Unit produces public service announcements which are aired on cable TV stations in New Jersey, and it occasionally provides services to other government agencies such as the Department of Civil Service, Department of Labor and Industry, the Division of Youth and Family Services, the Office of Women and the Office of Corrections.

Recently, the Media Unit, in conjunction with the New Jersey Public Broadcasting Authority, produced a program for broadcast on drug abuse

prevention. Another program on the same theme was done with the Metropolitan Regional Council (MRC) (for the training of municipal employees) in New York City and broadcast over the MRC television network throughout New York, New Jersey and Connecticut.

All the tapes which the Media Unit has produced or acquired are available to any group or organization interested in borrowing them. The titles available include: "The Behavioral Revolution," on biofeedback; "The Littlest Junkie," on infant drug addiction; "The People Next Door," on teenage drug abuse; "Feeling Good," on teenage alternative programs; "Women in Alcohol" conference; "Growing up Female"; physician's training seminars, and "Cop, Myth, Man," an interview with a former police chief.

Program design and development are the responsibility of the director of training and the media specialist. Training personnel help the media specialist in doing production work. There is no formal method of evaluating programs.

The Media Unit is pursuing several avenues by which to give their message broader exposure. There are hopes to co-produce more programs with the New Jersey Public Broadcasting Authority, and, through the cooperation of cable stations and the Metropolitan Regional Council video network, to broadcast programs throughout New York, Connecticut and New Jersey. In addition, the Media Unit would like to organize a lending library of training tapes in conjunction with other state agencies.

Organizational and Technical Information—In Brief

The Division of Narcotic and Drug Abuse Control is a sub-unit of the New Jersey Department of Health. Within the Division is the Alcohol, Narcotic and Drug Abuse Training and Education Center, a component of which is the Media Communications Unit. The Media Unit services both departmental and divisional training and communications A/V needs, as well as providing video programming and facilities to other state agencies. The Media Unit is staffed by a media specialist who is assisted by six training personnel.

Video production utilizes four 1/2-inch open reel units. Distribution is primarily on 1/2-inch open reel or by broadcast. The Media Unit does not have its own budget for equipment and software. Funds are made available for video needs out of the Training Center's operational budget for training equipment.

NEW YORK POLICE DEPARTMENT
Video Production Unit
Police Academy
235 East 20th Street
New York, NY 10010

Most of the New York Police Department's 20,000 police officers participate in ongoing in-service training programs, and to support these efforts the NYPD's Video Production Unit regularly produces video programming ranging from legal topics to how to service a revolver. In addition to these regular training tapes, the unit produces special training programs upon request from Police Department divisions, tapes and distributes announcements and statements by police officials and occasionally compiles information about suspects on tape to aid in the apprehension of criminals.

Two kinds of training programs, however, occupy most of the production time at the NYPD: area level training tapes and mini-training video messages. Area level training takes place at 23 sites where a new program is seen by approximately 18,000 officers every 10 weeks. These tapes, usually dramatizations, cover a wide range of subjects, and account for 30-40 minutes of a seven-hour training day. Eight to 10 mini-training messages are produced four times yearly, put on one video cassette and distributed to 150 training locations.

"Courtroom Testimony," a two-part mini-training message, is a dramatization of an officer testifying at the trial of a suspect he helped to arrest. As in all of the mini-tapes, extensive use is made of voice-over narration. "Courtroom Testimony" reminds officers of the importance of presenting a professional image, which is conveyed, not only by appearance, but by how well the officer articulates his story to the court. Part Two discusses techniques of voice control and eye contact and their importance in building credibility, as well as covering how to handle oneself during difficult moments of cross-examination. "Emergency Service Hydrant Hook-Up" demonstrates a new piece of equipment. "Ice Rescue" is a dramatization involving the rescue by police of a man who falls through thin ice in the middle of Central Park Lake. The message not only shows how to rescue the victim, but also demonstrates how to insure that the rescuer himself does not become a victim. Another two-part program deals with sex crimes. A dramatization shows the proper way to relate to a victim, the kind of evidence that should be collected and how it should be handled.

The Video Production Unit uses a series of forms to facilitate quality control and continuity of program development. A program status form, for instance, gives summary information on the chronology of events surrounding a program. A pre-production planning form contains such information as cast personnel, location of the taping and site survey information, a list of props, etc. A cast and crew requirement form, a camera log and an equipment checklist are

also used. Programs are developed, scripted and acted out by NYPD personnel; advisors from the various divisions are used extensively by the unit to insure a technically accurate program.

The unit produces an average of 40 programs each year at the present. There are no plans for expansion in either hardware or software.

Organizational and Technical Information—In Brief

The NYPD Video Production Unit, located in the Police Academy, was created in 1974, and is maintained with a $600,000 grant from the Law Enforcement Assistance Administration. The unit is divided into two sections— creative, responsible for researching, scripting, directing, shooting and editing programs, and technical, responsible for equipment operation and maintenance.

The NYPD television studio is equipped with three color cameras, two 1-inch master recorders, a film chain and six 3/4-inch video cassette recorders for duplicating. For remotes, the unit has three 1/2-inch color portapaks. Distribution is via the 150 video cassette units located at training sites throughout the city.

NEW YORK STATE DEPARTMENT OF CORRECTIONAL SERVICES
Correctional Services Training Academy/CSET-TV
The State Office Building Campus
Albany, NY 12226

Citibank of North America, the United Methodist Council, the U.S. Army Reserves, the American Red Cross, and the New York State Departments of Tax and Finance, and Parks and Recreation all have one thing in common. They have all been clients of the New York State Department of Correctional Services' "Video Rangers."

The Correctional Services Training Academy in Albany houses a fully equipped color television studio, part of a government funded vocational education project. The studio is jointly operated by inmates, called Video Rangers, and State University of New York student interns. It serves programming needs for Correctional Services and more than 20 agencies and public service groups. The Video Rangers are carefully screened inmates who are a minimum of one year away from parole eligibility, most of whom have at least a high school education. They produce, direct, write and act in programs as well as maintain and operate the video equipment. Correctional Services has produced more than 75 programs since the installation of the studio, dubbed CSET-TV, in July 1977. CSET-TV is the centralized video production facility for the closed-circuit television network of the 34 state correctional facilities and nine parole offices.

Priority program production at CSET-TV is in the areas of training and communications for the state's 18,000 prison inmates and 11,000 correctional employees. These programs include employee orientation and benefits, classification of fingerprints, hostage negotiations, conversational Spanish for correctional workers, the commissioner's statement to inmates on temporary release procedures and a bilingual social studies educational series for inmates.

The programs produced for outside clients range from a tape on the operation of Disaster Service Centers for the Red Cross viewed at 3100 Red Cross centers around the country to public service announcements for the National Alliance of Businessmen aired on local network affiliate and educational stations. Others include: a boating safety course for the U.S. Coast Guard Auxiliary, a tape on patient interviewing techniques for the Capital District Psychiatric Center, student and faculty orientation tapes for Schenectady Community College, a documentary on Hudson Valley Community College's 25th anniversary, recruiting tapes for the U.S. Army Reserves, and a series of tapes on subjects of interest to groups concerned with prison reform for the Parole Board and the State Commission on Corrections.

Only a very small number of inmates are accepted into the Video Ranger vocational education program, but inmates at all 34 state facilities are taught how to use video equipment and are active in covering events and producing

specialized training tapes for their facility. At one facility inmates produced a safety procedure tape; at another, inmates made orientation tapes.

The vocational Video Ranger program consists of three curriculum phases, each more demanding in terms of production requirements. The program is constructed so that the inmate-students can proceed at their own pace. In addition to the hands-on experience of television production, the program also utilizes television production texts currently used in college television courses. Inmate-students also act as instructors in television production workshops for Correctional Services staff, for staff of the Division of Youth and the State Probation Department and for members of community agencies.

Support for Correctional Services television efforts is very good—from within the department, from other state agencies and from outside organizations. There is also support from local television stations which broadcast some of CSET-TV's productions.

Future plans are for hardware growth in many directions, including possibly a microwave or cable system to allow live two-way communication with all facilities. They hope to expand the network to include studios at the 15 major state facilities.

Organizational and Technical Information—In Brief

CSET-TV is the centralized television production facility for the 34 correctional facilities of the New York State Department of Correctional Services. It is staffed by a supervisor of A/V training and production and two television specialists. Inmates serve as creative and technical "staff," and are assisted by State University of New York student interns. In addition to television production, CSET-TV is responsible for duplication and distribution of films and other audio-visual material to correctional facilities.

The production facility is a color broadcast studio. Production is on 1-inch and distribution is via 3/4-inch cassette and 1/2-inch open reel. The facility was funded with $150,000 of a two-year $4.2 million vocational education grant from New York State's Division of Criminal Justice Services utilizing federal funds.

NEW YORK STATE DEPARTMENT OF TRANSPORTATION
Staff Development and Training Bureau
1220 Washington Avenue
State Campus
Albany, NY 12226

The Staff Development and Training Bureau's off-the-shelf and in-house produced video programming extend staff training to areas that might not otherwise be addressed except in a hands-on situation. In this capacity, video accounts for about 10% of the Department of Transportation training.

Each of five Self-Development Learning Centers located at the Department of Transportation's regional offices have video libraries stocked with approximately 100 programs that include: "Management by Objectives," instructional tapes for secretaries on topics such as dictation; technical pre-operational instruction programs for engineers on operating heavy construction machinery, and miscellaneous training how-to's on such topics as using an oxy-acetylene torch and pruning and removing trees. Some personal development programs, such as the *Efficient Reading Program*, a series of 12 one-hour tapes, are available to any employee who wants to improve personal skills. Training tapes are for use in classroom training situations as well as for use by individuals.

Employees act as talent in local productions, and production is done by Training Bureau staff members who have been trained to use video tape equipment.

The Bureau's system is capable of providing learning opportunities to employees on a continuous basis and training when and where it is needed. However, no information on utilization and feedback is available.

Very little video programming has been produced in the last few years because of budget cutbacks. Since video is used in only 10% of the training efforts, the Bureau feels that it is not enough to warrant full-time television staff or expenditures on upgrading facilities. The other problem the Bureau faces is the incompatibility of its various kinds of equipment, making it impossible to integrate their hardware into a complete system.

Organizational and Technical Information—In Brief

The Staff Development and Training Bureau is in charge of providing the general training materials for Department of Transportation employees.

Video tape production utilizes three cameras and two portapaks, mastering on both 1/2-inch and 3/4-inch. Distribution is via five 3/4-inch playback units located in the Self-Development Learning Centers.

U.S. BUREAU OF PRISONS
Media Services Center
320 First Street N.W.
Washington, DC 20534

Like the majority of governmental agencies, the U.S. Bureau of Prisons uses television primarily in training efforts. In fact, approximately 70% to 80% of all video tape production done by this agency is related to training the 10,000 employees in 52 (out of a total of 60) locations nationwide. Other kinds of productions by the Bureau's Media Services Center range from informational programs for employees on topics which affect day-to-day activities, to the documentation of a wide range of events.

Most training tapes are used as teaching aids, either by a live instructor in a classroom setting or by the student in conjunction with a study manual. Often, a video tape introduction to a training session is used to trigger discussion among group members. These "motivational" introductions are usually vignettes, acted out by professional actors, presenting situations with which employees can identify and role models for them to emulate.

One program used in refresher training, which is a self-paced module with a study manual, is "Report Writing for Correctional Staff." An on-camera narrator explains some different kinds of reports, e.g., negative and positive inmate behavior, general memorandum, etc., and the need to learn how to write them well. A series of dramatizations illustrates the narrator's verbal examples and serves as sample situations for staff members to write about.

A tape on "Commissary Operations," intended for use by an instructor, is for new prison commissary clerks. The tape begins with a voice-over vignette explaining that the prison commissary is a likely target for inmate problems and that the new clerk is often an "easy mark." The tape does not deal with technical aspects of the job, i.e., the rules and regulations, but with judgments in situations that are likely to occur. The vignettes cover: handling inmate help in the commissary, how to insure the confidentiality of inmate accounts and handling inmate disturbances in the commissary. The scenes portray examples of bad decision-making as well as prudent judgments.

Informational programs range from tapes which highlight research being done within the agency and court decisions which affect day-to-day agency operations to programs about the winners of departmental awards. The Media Services Center also provides support for the inmate education programs at various correctional facilities. The Center dubs and distributes purchased educational programs for this purpose; and at several facilities, the inmates themselves are taught the basics of television production. At some facilities, the staff is taught how to use video tape production equipment and use it as it deems fit in working with inmates. A common application is for mental health personnel to tape inmates in therapeutic role play activities.

Scenes from "Commissary Operations"
1. "Shaking down" inmate help.

2. Keeping inmate accounts confidential.

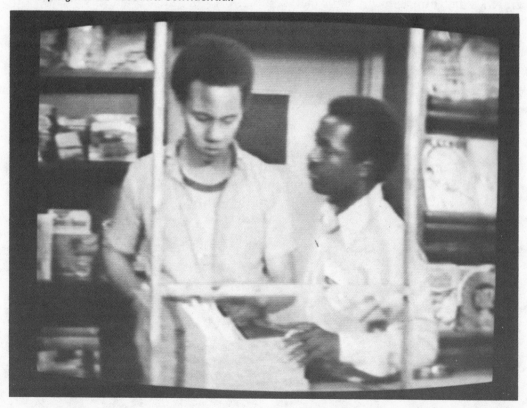

The Bureau also uses video tape to document activities ranging from prison disturbances to the dedication of a new prison facility. In one, inmates in a Midwestern prison were able to see, via video tape, the East Coast test of a Navy life raft that they had built.

Whether a program idea will materialize is determined after the requesting department or facility and the media director have evaluated jointly the parameters of the desired program. The applicant and the media director also work together to develop the program concept and specific content.

Off-the-shelf programming in areas of criminal justice, management training and educational/vocational training is used, when objectives match, since it is often a more cost-effective alternative to in-house production.

The Bureau of Prisons' Media Services Center has grown from the initial use of video tape in 1967 for role playing in training and education to the present full color productions numbering 30 in 1977 and 40 in 1978. The future seems to call for a greater quantity of programs in the areas in which the center is now producing.

Organizational and Technical Information—In Brief

The Media Services Center, acting as a support group for agency operations, is under the administrative control of the staff training branch. The center is in charge of all media production, including slides, 16mm film, audio tapes, graphics and filmstrips. Video tape accounts for one-third of all A/V use within the bureau.

Media facilities are housed in a 2200 square foot space, of which half is used as a television studio and control room. Video tape production and distribution is on 3/4-inch cassette. The total investment in production and distribution equipment is estimated at $45,000. The annual capital budget is $10,000, and operating budget is $65,000.

The Center hires outside crews and talent for all productions. Equipment and facilities are used by other government agencies, such as the Federal Home Loan Bank Board, the Government Printing Office and the Federal Judicial Center.

WILMINGTON, DELAWARE, BUREAU OF FIRE
Wilmington Fire Department Television (WFD-TV)
10th and King Streets
Wilmington, DE 19801

All 225 firefighters of the Wilmington, Delaware, Fire Department receive two hours of training each day. In the summer, much of this "company schooling" is done out of doors. But in the winter, video becomes integral to the ongoing training and development of the firefighters.

Wilmington Fire Department Television has produced about 50 video programs, most of which are related to new or refresher training. Programs are generally candid black and white taped demonstrations, lectures, discussions and actual events. Some examples of programs are: the emergency care education program, a demonstration of the Mine Safety Appliance (MSA) air mask repair procedure by an MSA representative, explanations and demonstrations by the training officer of new equipment such as the MSA explosive meter and the infra red heat detector. "High Rise Fire Evacuation," produced with a portapak, demonstrates high rise fire drill procedure for firefighters and for residents of high rise apartment buildings in the community. A complete 16-hour arson course for arson investigators was taped in the fire department's studio (known as WFD-TV). These tapes cover preliminary investigation procedures, how to interview suspects and what to do in the courtroom (presented by representatives from the Attorney General's office).

Scenes from "MSA Air Mask Repair Procedure"
1. An MSA representative lectures firefighters on air mask repair procedures.

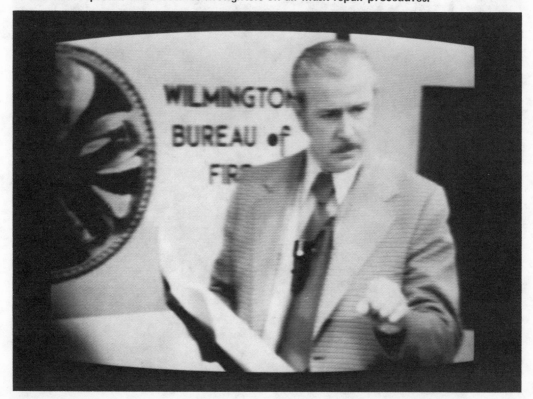

Video is also used for critique and evaluation of fire ground operations. A portapak is used to tape an actual fire in progress. Fire chiefs and officers later view the tapes and evaluate response procedures, which are then reviewed with firefighters.

The portapak is also used to make a video record of people in the vicinity of a fire. Investigators go over the tapes to look for suspects and known arsonists.

The Wilmington Fire Department never buys or rents programming. However, some tapes on fire-related subjects are borrowed from the nearby DuPont Company's tape library. These titles have included two CBS "Close-Up" programs and a show entitled "Firebug."

Video activity began in 1972 when a small studio was assembled and fire department employees were sent to a community college for TV production courses. WFD-TV has grown slowly, but it seems to be reaching its goals and management is pleased with the ease of video training, procedure evaluation and investigation. Now WFD-TV staffing is structured in such a way that there are always eight or nine employees available—at any time of the day—to produce a tape.

The training officer has overall responsibility for programming. Program ideas are generated by the training officer and the planning and research officer. The TV unit coordinates and produces the tapes.

2. The representative and a firefighter demonstrate the procedure.

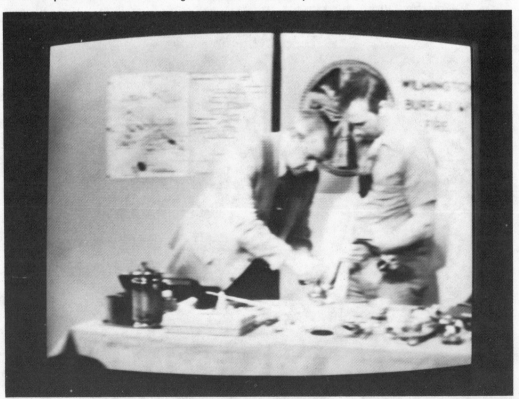

Tapes and playback equipment are physically carried to each of the eight fire stations and viewed in a group setting with a training leader present. At present there is no formal method of evaluation. However, many of the advantages of video are obvious, i.e., it is far easier to tape a real fire than it is to stage a fire for the purpose of procedure evaluation while the sense of immediacy about a real fire just cannot be duplicated in a hot drill.

WFD-TV would like to produce more programs of the types described here, and to be able to distribute them with greater ease and speed. To facilitate this, cable to the fire stations is being installed, and the system should be complete in 1980. At that time, all programming, live and taped, will originate from the studio.

Organizational and Technical Information—In Brief

WFD-TV is part of the Personnel and Training Unit and is considered an arm of the training division. Staff consists of three employees on day work and 26 on shift work—which means there are always eight or nine staff members available to put on a production. Outside crews, talent or production services are never used.

Production facilities, representing an investment of about $27,000, include a small studio with four black and white cameras and two portapaks for location taping. Most production is on 1/2-inch open reel, with distribution utilizing one 3/4-inch playback unit that is carried to each of the eight fire stations.

3. Close-up of repair demonstration.

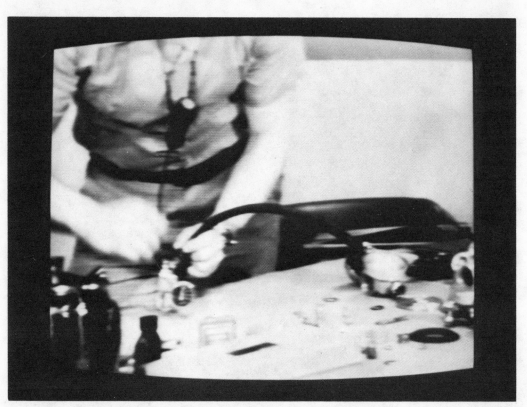

6

Case Histories:
Education

ARCHDIOCESE OF NEW YORK
Instructional Television Center
Seminary Avenue
Yonkers, NY 10704

The Instructional Television Center (ITV) of the Archdiocese of New York is the largest closed-circuit educational television system in the country. It broadcasts a variety of programming to more than 200 schools and parish centers and 11 hospitals in a 4717 square mile area. Programming includes adult education, in-service training, instructional programs and religious education.

One of the most popular programs viewed in archdiocesan schools is "News and Views." Each week student teams from two schools write, produce and deliver the 20-minute program, each team covering a newsworthy topic in depth. Students, ITV staff and interns from five colleges in metropolitan New York operate video equipment. On one program, a junior high school team covered the then upcoming inauguration of Jimmy Carter. After news stories were delivered by the announcers, two students engaged in a point/counterpoint on the inaugural tradition, and a young reporter gave the results of a student opinion poll in which he had asked seventh and eighth graders how they would conduct inaugural day events. The poll revealed that seventh graders thought "Surf and Turf" would be appropriate fare at the inaugural, while the eighth graders said they would prefer peanut butter and jelly and sardines. Seventh graders said the appropriate location for the inaugural was the White House; however, eighth graders preferred to celebrate the event at Arnold's Drive-In

with Fonzie. High school students devoted their half of "News and Views" to looking at what's happening on Broadway and the redevelopment efforts in the neighborhood surrounding New York City's theater district.

Each year the "Eddy" awards ceremony is held to honor outstanding achievement in reporting and broadcasting by student teams on "News and Views." The awards are presented by celebrity newscasters from local New York stations or network talent such as ABC-TV's Frank Gifford.

Instructional programming for classroom use includes off-the-shelf courses from such organizations as the Agency for Instructional Television (AIT) and Great Plains National Television Library as well as many local productions. Local productions have included a series of 10-minute interviews with Senator Sam Ervin on the Constitution and "Math 9," an advanced algebra course for selected eighth grade students. The arts are an important area of ITV programming. "Time to Draw," an elementary school course, features a former Disneyland artist and cartoonist. A secondary-level course features scenes from plays staged, acted and filmed by members of the Stratford Shakespearean Festival Foundation in Canada. *Experience of Film* is a series for high school and college students consisting of interviews with actors, actresses and motion picture producers. The ITV Center also produces programming for religious instruction of all levels. Aside from regularly scheduled broadcasts, more than 65 programs can be requested by teachers on the "Dial-a-Lesson" plan.

Scenes from "News and Views"
1. Student newcasters.

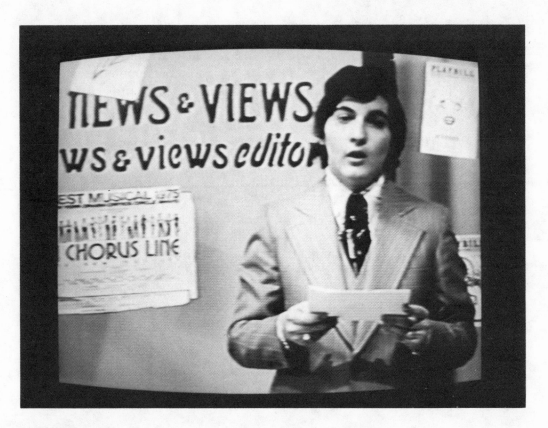

2. The editorial.

Adult education programming is a new priority area at the ITV Center. The first program produced expressly for adult education is a series on home gardening produced in conjunction with the New York Botanical Gardens. The series includes "Container Gardening" and "Roof-Top Gardening" and has been broadcast to parochial schools in the Northeast Bronx. The "Math 9" algebra course has been broadcast in the evening for adults. Other special programs produced for community viewing include a cancer detection program for women, a panel discussion on Zionism and a critical view of the controversial Rev. Sun Myung Moon.

Many in-service training programs are aimed primarily at religion teachers. Typically, these programs feature experienced and accomplished archdiocesean teachers who present their teaching methods in specific areas. An in-service workshop held at the ITV Center to introduce a new instructional series was taped for subsequent showing to teachers unable to attend.

The latest in-service production is a three-part inquiry on the impact of television on children, entitled *Coping with Television*. The programs focus on how TV affects learning and values and what role the teacher should play in molding students' television viewing habits. They largely involve panel discussions with such people as the vice president of the CBS network programming, the TV critic and editor of a New York City newspaper and several professors of media.

ITV programming is broadcast over three channels on ITFS eight hours daily, including from 7:00 to 9:00 pm on designated evenings and sometimes between masses on Sunday when there is special programming as part of a liturgical education program. Soon, a fourth channel will be utilized for health programming.

The ITV Center started in 1966 when the New York Archdiocese purchased the broadcasting equipment from the RCA pavilion at the New York World's Fair. The equipment, the most advanced in the nation at the time, was acquired at half the market value. Since that time, ITV has been growing steadily and still maintains one of the highest quality broadcast facilities in private television.

Because it has such a complete facility, ITV offers courses in television production to students of five metropolitan New York colleges. Students receive regular course credit and often return to ITV for an internship in production. A 12-week course in 3/4-inch tape production is offered to institutional video users who would like to produce specific needs programming such as training tapes.

In addition to ongoing questionnaire evaluation of both off-the-shelf and local productions, ITV Center's utilization team visits schools to assess attitudes and utilization patterns and to conduct workshops to involve teachers with ITV.

In the future, ITV Center hopes for more involvement with colleges and universities so that the Center can offer college credit courses to high school students, to teachers and to adults.

Organizational and Technical Information – In Brief

The Instructional Television Center of the Archdiocese of New York is responsible for all instructional television programming needs of schools in the 10 counties of the New York Archdiocese.

In-house programming is produced in two broadcast quality color studios at the ITV Center. Production is on 2-inch, 3/4-inch cassette and 16mm film. Distribution is via three-channel ITFS to over 200 elementary and secondary schools and parish centers and 11 hospitals in a 4717 square mile area.

Funding for the ITV Center comes from an annual $2.25 per elementary and $1.00 per high school pupil charge and from fund-raising ventures such as a celebrity golf tournament.

BURLINGTON COUNTY COMMUNITY COLLEGE
Media Services
Pemberton-Brown's Mills Road
Pemberton, NJ 08068

At Burlington County Community College, both faculty and students are actively involved in video. Instructional tapes produced by Media Services and faculty aid professors in lectures and laboratory sessions. Students tape presentations in labs, speech and theater classes.

Instructional aid tapes are primarily produced for humanities, fine arts, speech and natural sciences. About 50 off-the-shelf tapes have been purchased in the social and natural sciences. For students who are motivated to learn more than is normally included in the curriculum, tapes with topical information in areas such as physics or microbiology are available.

In some departments, like physical education, demonstrations of exercises such as proper archery techniques are taped and shown to classes year after year. Sports events such as a free-style swimming competition are taped for general-interest viewing.

Each week students and Media Services staff produce a news show featuring campus and county news. The programs are transmitted over the school's closed-circuit system at noon. Media Services has experienced such a positive response to non-instructional programming that it is now interested in producing programming for general community interest.

Media Services has produced about 25 programs since the conversion from a color to a black and white studio in the fall of 1977. Over 175 programs were produced prior to the new system. Media Services plans a production schedule of 50 programs yearly.

Faculty members work closely with Media Services on the production of instructional tapes. Outside vendors are used only for equipment maintenance. All production jobs are done in-house by a six-person Media Services staff assisted by students and faculty.

Organizational and Technical Information – In Brief:

Media Services, part of the Division of Learning Resources, is in charge of all video activity at Burlington County College.

The television facility utilizes three black and white cameras, and production is on 1-inch and 3/4-inch cassette. Control track editing is done in-house. Distribution is via three-channel closed-circuit system and by 3/4-inch cassette. The production facility represents an investment of $40,000. The annual operating budget, including staff, is $500,000.

THE COLLEGE OF STATEN ISLAND
(City University of New York)
The Media Center
715 Ocean Terrace
Staten Island, NY 10301

As colleges and universities cut back budgets, the television budget is often one of the first to be reduced. This is currently the problem at The College of Staten Island.

After the installation of a sophisticated color studio in 1971 and the production of some 200 programs, television activity has virtually stopped. Currently the Media Center duplicates and distributes tapes already on hand and produces other audio-visual materials.

The Media Center serves the A/V needs of both the upper and the lower division campuses. In addition, The College of Staten Island originates two hours of broadcast instruction each week on City University of New York's CUMBIN (City University Mutual Benefit Instructional Network).

Video programming available to College of Staten Island classes and individuals is primarily instructional and informational. The Media Center has an extensive nursing program on video tape covering topics from respiration to

Scene from "A Conversation with. . . ."—A professor interviews marine conservationist Dr. George L. Small.

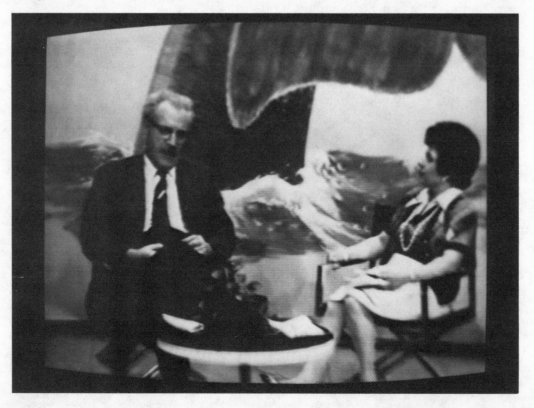

pregnancy. *The Dissection of the Cat*, for example, is a 12-part demonstration series. *Spanish for Paraprofessionals* is another series using professional actors dramatizing a bank transaction, a visit to a physician's office and so on.

Informational tapes are primarily interview-style conversations with such persons as the college president, a marine conservationist, and the executive vice-president of the New York City Bicentennial Corporation. The interviews are conducted in the studio by college professors, and incorporate slide shows and film clips.

Commercial tapes are purchased for instructional and informational purposes. NBC's "Speaking Freely" with Edwin Newman, *How to Write a Research Paper*, a nine-part reference aid, *The Adams Chronicles* and a documentary on the hazard of competitive sports are some examples of the commercial programs available to students and professors.

The Media Center is now trying to organize a video tape loan system among all the City University of New York branches so that campuses can expand their video resources. In addition, the college is investigating the possibility of setting up a microwave link with CUMBIN.

Presently, individual departments make the decision on which tapes will be purchased or duplicated. When video production was active, programs were produced on a departmental request basis. Department members also work with the Media Center to design, develop and script their programs.

Organizational and Technical Information—In Brief

The Media Center is staffed by 15 employees who are primarily involved with photography, film, audio material and graphics. One staff member is assigned to coordinate video tape playback.

The Media Center's production capability consists of a 1200 square foot video complex with four color studio cameras, 1-inch recording equipment for mastering, a film chain and other related hardware. Distribution is via 3/4-inch cassette.

The production facility represents an investment of $150,000, and another $20,000 for distribution equipment. At present, The Media Center has no annual capital or operating budget for television.

CORNELL UNIVERSITY
ETV Center
MVR Hall
Ithaca, NY 14853

Cornell University Educational Television (ETV) differs from most educational video operations in that its priority application is not instruction. The primary programming consists of public service announcements and documentaries aired on educational and commercial television stations throughout New York State. Video's secondary mission is to facilitate university research. Only since 1976 (ETV started in 1968) has the use of ETV for resident student instruction blossomed.

Public service announcements (PSAs) pertain to topics that are related to current problems, often containing information that university researchers have produced. Presently, Cornell is active in the area of energy. PSAs, using a news brief format, cover such topics as weather-stripping and insulation. The ETV Center also produces PSAs for organizations such as 4-H clubs.

The ETV Center produces documentaries based on ongoing university projects. Topics for these have included housing, the elderly, nutrition and child abuse. Programs are distributed free of charge to New York State broadcasters and rented to other organizations. They have been viewed in all 50 states and in 10 foreign countries.

Specialists on campus also work with the ETV Center in producing programs for Cornell's cooperative extension program. Primarily in the areas of agriculture, home economics and community development, informative programs are produced for broadcast or video cassette distribution throughout New York.

In university research, video is used for documentation of processes and findings. In addition, faculty members produce programs concerning their research work to send to conferences that they are unable to attend.

The chemistry and biology departments are the largest users of ETV for classroom instruction. Twenty-two laboratories in the chemistry building are hardwired to receive televised lab experiments. A 7- to 12-minute demonstration of the experiment is viewed at the beginning of the lab session. These tapes are available on cassette so students can view the demonstration again during the lab session or use it for later review. Since the scripts are written by the department's top professors, all students get an expert and uniform explanation. Tapes produced for the biology department are similarly used. These tapes make extensive use of material recorded through the microscope so that all students can see simultaneously what would take hours for them to see individually.

The ETV Center also tapes guest lecturers and special events, while graduate teaching assistants use video for feedback on their classroom performances.

Programming originates from faculty suggestions. The ETV Center works very closely during production with faculty, department heads, deans and administrators. The cost to a department of producing a program can range from $200 to $6500. In order to encourage utilization, the ETV Center tailors services to the requesting department's budget.

The major expansion taking place with Cornell ETV in the next few years will be instructional programming for on-campus use. In addition, all media services will ultimately be linked under one unified communications system.

Organizational and Technical Information–In Brief

The ETV Center includes both television and other media services. Television is staffed by seven full-time persons, and often part-time or freelance crew are hired.

The production facility is a broadcast quality color studio. Studio production is on 2-inch, 1-inch and 3/4-inch tape. Location footage is acquired on 16mm film, and 1/2-inch tape is used for research support. There are 90 viewing locations on the campus hardwire network in addition to a large number of 1/2-inch open reel and 3/4-inch cassette VTRs on campus. Production hardware represents an investment of $1 million, with over $50,000 invested in distribution equipment.

DANVILLE DISTRICT #118 SCHOOLS
Central Learning Resources Center
516 North Jackson
Danville, IL 61832

When the resources are available, some schools with television production capability are becoming more experimental in different areas of programming. Danville District #118 Central Learning Resources Center is a good example. Besides supplying commercially produced instructional programming for 9600 students in grades K through 12, Danville has created several hundred home-grown productions ranging from "public relations" programs to a behind-the-scenes look at the production of a high school play.

Television in the 18 schools serviced by the Central Learning Resources Center is used primarily for instructional programming, most of which is off-the-shelf packaged series with collateral material. These programs include "Math Factory," "Ripples," "Vegetable Soup," "Portrait in Black" and "Writing Time." Broadcasts are scheduled by request and reach schools via the school district's 24-hour access channel on local CATV as well as by 1/2-inch cassette player/recorders in six schools.

The Center also transfers films to tape for informational, entertainment and instructional purposes. These include: "Barney Butt," an animated film showing the story of a smoker and heart disease; "Truly American–Dr. Martin Luther King"; programs on Thanksgiving, Christmas and other holidays and events; a program on shoplifting for Shoplifting Week, and a program on school safety rules for the opening week of school.

The Center, providing programming since 1970, now cablecasts live coverage of school board meetings into as many as 13,000 Danville homes. This practice has eased communications problems for teachers and parents. The Center also cablecasts informational programs for parents about school services such as the hot lunch program. When no programming is being shown on the cable channel, a message wheel containing special announcements such as school closings due to snow is aired.

In-service teacher training utilizes off-the-shelf and local productions. An example of commercially produced in-service programs is Dr. William Glasser's "School Discipline."

The schools equipped with 1/2-inch player/recorders also have video cameras and produce their own programs, such as plays, dance programs, athletic events and projects. A Danville High School Industrial Education class video taped student projects in vocational drafting. For the program, each student chose a topic, such as systems of measurement or air pollution, to discuss and illustrate with graphics.

The video library consists of about 500 titles. Although the production schedule has been reduced recently due to staff cutbacks, television still constitutes one-third to one-half of all audio-visual material used in district schools.

The Center has been considering the addition of another channel on CATV; however, since cassettes are more convenient for schools, the Center may encourage expansion in that direction.

Organizational and Technical Information—In Brief

Danville District #118 Central Learning Resources Center is responsible for coordinating all media usage for the district's schools. The Center is staffed by a director, an audio-visual clerk and a part-time technician.

The production facility includes a studio with two color cameras and 3/4-inch and 1/2-inch cassette players and recorders. Distribution is via the school district's 24-hour CATV access channel and by 1/2-inch cassette.

The investment in production equipment is about $15,000, and about $60,000 in distribution hardware. The annual materials budget is $1000.

EDISON INTERMEDIATE SCHOOL
1400 Earl Street
Pekin, IL 61554

It is becoming more common for students to get "hands on" practical experience in school at increasingly younger ages. This trend has extended into the area of television. At the Edison School, the main idea in having a television studio is to give the 500 sixth-grade through eighth-grade students a chance to investigate careers. Students actually handle all production and post-production work at the school, and the instructors rarely even touch the equipment.

Two regular 15- to 20-minute news shows are written, delivered and produced by students. The "Edison News" is produced by the TV Club every other week. It features stories on newsworthy events and people around the school—complete with graphics and photography. "Edison News" also includes a school sports report and a weekend weather report. On alternate weeks, "News in Review," presented by a different social studies class each time, covers current events in world, national and local spheres. Social studies students do all news gathering, writing and reporting, and the TV Club does the production and post-production work.

Students also produce a number of special interest programs, which the assistant principal helps to arrange when necessary. A series of programs, featuring the mayor of Pekin, concerns city government. In the series, the mayor discusses such topics as the organization of the police department and the city's budget. In another production, a student panel interviews a state senator. "Selling America" is a presentation by an insurance salesman. Another show features a local historian talking about the history of Pekin. The state championship basketball game was recorded with network-like commentary on the action. When the school proposed a local referendum, a three-student panel interviewed the school superintendent for broadcast on the local educational channel. Language arts classes produce plays on tape for the entire school, and students in a junior high class produced a special program on Mayan Indians and their culture, complete with graphics and clay models.

The news shows are prepared on Monday, Tuesday and Wednesday, then taped on Thursday. They are played back over the closed-circuit system seven times on Friday. The news shows are sometimes broadcast via the local cable station's access channel for parents to see. Often parents come to the school to see programs in which their children have participated.

Edison's curriculum makes use of ITFS programming from Bradley University, as well as commercial ITV programs for which the state has acquired dubbing rights. This programming is scheduled and transmitted over the school's closed-circuit system, and is integrated into regular class lessons. Although there are scheduling problems, ITV programming is used extensively.

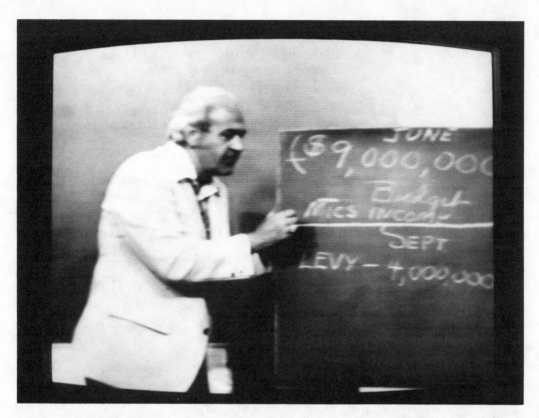

Scene from "Personalities in Government"—Mayor of Pekin explains the city budget.

Edison's closed-circuit system, installed in 1965, reaches 60% of the school's classrooms. The school board provided the basic television production hardware, and students in the TV Club raised money to purchase additional equipment such as microphones and lighting.

The "hands on" television program at Edison has been judged a success by administrators and teachers, allowing students greater opportunities for responsibility, teamwork, leadership and recognition. Whether or not students go on to careers in television, they have the opportunity to learn about the organization, design and presentation of a total communications package—a skill that will be useful in any career. The only problems that have been encountered are indicative of the success of Edison's TV project—that is, excess demand for the studio and the lack of time available for *all* students to gain experience in front of and behind the camera.

Organizational and Technical Information—In Brief

Television at Edison is under the supervision of the assistant principal. The facilities are located in the school's Instructional Media Center. The 15 foot by 22 foot studio is equipped with three black and white cameras, two 1/2-inch VTRs and related production equipment. Portapaks are used for location taping. Distribution is via a closed-circuit system that reaches 60% of Edison's classrooms.

GLASSBORO PUBLIC SCHOOLS
Educational Media
Annex A Delsey Drive
Glassboro, NJ 08028

A first grade teacher wanted to teach her students the days of the week. She did this by humorously acting out the day-to-day activities of an elderly lady. Another teacher told students the story of Abraham Lincoln in New Salem by playing a citizen of that community. Costumed in period dress, she simulated baking bread and spinning wool, talking of Abe Lincoln as one of her neighbors. Three teachers told the story of the Dred Scott decision in the roles of the judge, the slave owner and Dred Scott. A group of third graders acted out Revolutionary War incidents.

These are all video tape productions produced as part of Glassboro Public Schools' Educational Media television program. Educational Media serves students and teachers in six district schools encompassing grades K-12 and a special education program.

Instructional television has been in use in the Glassboro Public Schools since 1967. Programming in the areas of science, social studies, music and language arts originated from Philadelphia, sponsored by a consortium of school districts from Pennsylvania, Delaware and New Jersey. In 1967 Glassboro teachers, administrators and school board members decided to make a more extensive commitment to educational television. An in-service program in TV production and utilization was held for Glassboro teachers and a production training program was established for high school students.

The instructional needs of the school district were studied and objectives for educational television were set. The system would be used to: 1) overcome scheduling problems and facilitate easier use of ITV programs; 2) involve students in production of television programs; 3) allow teachers to produce instructional programs to meet local needs, primarily for their own classroom use. With the goals for the television effort set, Glassboro purchased equipment and hired staff.

Through needs evaluation, good planning and support from all levels, television has become an integral part of the school district and of the education process in Glassboro. Educational Media now has over 800 hours of tapes in the library, about 25% of which were locally produced, and 50 to 75 local programs are produced each year. Four channels of the 12-channel RF distribution system are now devoted to local productions. About one-third of the school district participates in actual production, while approximately 45% participate in overall programming utilization.

The majority of instructional tapes are dubbed, with permission, off ITV. Teachers request the broadcast over the RF system of the programs they want to

use. Many instructional programs are produced by teachers who participate in the five-week summer television workshops held each year. These programs include a series on French poetry, a series on bicentennial occupations, programs on auto mechanics, arts and crafts, multiplication and a series for the hearing handicapped. Teacher productions involve demonstrations, dramatizations and graphics, documentary, quiz show and interview formats. Programs are taped on location as well as in the studio.

An Educational Media staff member teaches four television courses for high school students — one in production techniques, an advanced production course, one in acting for television and a course in making film for television. Students in these classes have produced news shows, career education game shows, and have acquired and produced scripts from broadcast programs such as "Welcome Back, Kotter."

Elementary classes are invited to visit the studio. Many times after the field trip teachers bring their students back to do their own productions. These have included seasonal plays, "Tools for Tots" on career education and technology and a story program for which students drew pictures and wrote the accompanying narration.

The television studio, located in Glassboro High School, is almost always in use. Portapaks and 16mm film are used for remotes. The Educational Media staff includes a teacher coordinator who, in addition to teaching the TV courses, helps in production work and the development of programs. Some teachers become familiar with how the production equipment works, but the crew usually consists of students in the TV production technique course.

Educational Media hopes eventually to be a part of a municipally owned cable television system now under consideration in Glassboro. Through a cable system Educational Media would like to increase community contact with the school district and offer adult education programming, school sports, school board meetings and instructional programming for pre-schoolers. In addition, Educational Media would like to make the studio available to community groups desiring to produce programs for cable TV.

Organizational and Technical Information — In Brief:

Educational Media is in charge of all television production for the Glassboro Public Schools. The staff consists of the Educational Media director, a teacher coordinator, a part-time technician, a head end operator and a secretary. The staff is assisted by a crew of high school students.

Production is in black and white, primarily on 3/4-inch cassette but also on older 1-inch and 1/2-inch equipment. Distribution is via a 12-channel RF system to 90 classroom monitors in six district schools. The studio is located in the high school.

The original investment in video was made possible by a federal grant. Most funding is now locally generated. The RF system and a production van were purchased for $100,000. Approximately $10,000 was later invested in the studio. Each year the budget allots $4000 for new equipment and $5000 for materials such as tape stock, film, etc.

GRANITE SCHOOL DISTRICT
The Media Center
360 East Penney Avenue
Salt Lake City, UT 84115

As one of the first educational television users to conclude licensing agreements with producers of education films to duplicate and distribute titles to district schools, Granite School District still relies heavily on commercial films and video tapes for instructional support. However, there is another vital area for which Granite has found no alternative to in-house production: in-service teacher training.

The Media Center recently completed five one-half hour programs designed to give teachers background on energy issues. The programs include an interview with the executive and associate directors of the Utah Petroleum Association on the topic of gasoline marketing, an interview with a research engineer for Utah Light and Power Company on future sources of electrical energy for the state, and two lecture presentations on nuclear power by a professor at the University of Utah. Teachers are also supplied with elementary level activities guides. The activities tie energy education on the elementary level to studies in language arts, career awareness, art, social studies, science and math, and include such activities as a "Sources of Energy" coloring book, plays and the construction of a simulated mini-community.

In-service video programs demonstrate simple ways to teach the metric system. Another program demonstrates the science processes that all district elementary level teachers are expected to teach. The Media Center also runs continuous in-service workshops for the district's 2700 teachers and media coordinators on how to use video equipment.

The Granite School District includes 73 school buildings serving some 62,000 students. The district is equipped with about 600 3/4-inch cassette players in school buildings. About one-third of the schools have cameras and the others have access to cameras.

Music teachers are encouraged to video tape one of their best performances to use over the years as an example to students. Teachers also make demonstration tapes in areas such as vocational education. Students and teachers handle the equipment to tape sports events and plays for feedback and for parent viewing.

The commercially produced instructional programs are available for most subjects. Teachers choose the titles they want to use to support their own lesson plans. Frequently used titles are stored in school buildings. Others are kept in the Media Center and duplicated when requested. No packaged lessons are used and there is no course in which the basic content is taught via television.

There is no formal method of evaluation of television in the district; however, the motivation of both teacher and students to utilize video is high.

Organizational and Technical Information — In Brief:

Granite School District's Media Center is responsible for the duplication of commercial films and tapes and for most production of instructional and in-service video programs for the district's 73 schools.

Production by the Media Center and by schools is on 3/4-inch video cassette. Distribution is via 600 3/4-inch cassette players located in schools. The investment in production equipment is approximately $40,000, with about $1.4 million invested in distribution hardware.

MICHIGAN STATE UNIVERSITY
Instructional and Public Television Services
Academic Services
East Lansing, MI 48824

In 1956, students of veterinary medicine at Michigan State University (MSU) were able to view surgical procedures without having to crowd around the operating table. Cameras and monitors that had been recently installed in a teaching auditorium provided close-up views of intricate surgical demonstrations, and teaching time as well as surgical time were saved by not having to stop for as many as 60 students to observe the procedure individually. This was the first use of closed-circuit instructional television on the MSU campus. In addition, MSU had been broadcasting instructional material over public television station WKAR-TV for several years.

Soon after this initial phase of experimentation, cables were installed connecting several adjacent buildings of classrooms to the originating teaching auditorium. In 1960 video tape studios were built, and from them programs and whole courses originated, both live and recorded. The demand for recorded lessons soon grew, and the tape library, tape duplication center and the network of classrooms were expanded.

In the 1960s, the student population at MSU boomed. In an effort to cope with this growth, dormitory classrooms were connected to the CCTV network. The largest classes originated from the original teaching auditorium, and additional sections watched from classrooms around the campus. Tape recordings of these classes were played back for more sections at later times. This arrangement developed into a pattern, and by the late 1960s 54 such TV courses enrolled more than 36,000 students.

Today, MSU transmits instructional programming through the 70-mile campus cable network to 26 buildings with 178 classrooms, 19 of which have talk-back circuits. The campus network handles 11 channels and operates from 8:00 am to 9:00 pm in the fall, winter and spring terms. The broadcast station provides a full schedule of PBS and local programming including MSU courses for credit and programming for continuing education. And since 1974, two channels of instructional programming have been fed to two CATV systems in the Lansing metropolitan area.

Almost 10% of introductory lower division undergraduate MSU course credit hours and almost 5% of all course credit hours are video based. The uses of ITV in courses fall most easily into three categories: the transmission and recording of lectures, the use of outside or locally produced materials for class enrichment, and special in-house production of fully scripted programs for use in existing classes and for individual instruction.

"Introduction to Economics," a lecture format course, is taped as it is presented to one class section. In past years, the lecture has been played back for

up to nine additional sections around the campus during the day. The professor administers the course, prepares examinations and supervises graduate assistants who attend the televised sections to answer questions and clarify assignments. The professor and graduate assistants are also available to students for consultation throughout the week. The lectures are also played back for review from week to week as well as before mid-term and final examinations. Other courses in this category include "Principles of Accounting," "General Biology" and "Introductory Computer Programming."

The "Music in Elementary Education" course meets six hours a week. One hour is a lecture that all enrolled students attend. The remaining hours are small group sessions which occasionally view televised demonstrations of exemplary teaching techniques. Many MSU courses use television in this way. Physiology students view video taped lab demonstrations of physiological phenomena; humanities courses use the network to show films, and a communications course uses TV to present materials to stimulate class discussions.

"Human Sexuality" is a course with a large total enrollment divided into many sections which are then subdivided into small discussion groups. Informational, attitudinal and modeling presentations, in the form of specially produced short video taped segments, are delivered to the discussion groups via the network. Other courses using special productions are "Wilderness Survival," "Typing," "Shorthand" and "First Aid."

Analyses of the impact of ITV on classes made in the late 1960s at MSU showed that, for the most part, there was no significant difference in grades attained by students in televised sections compared with those attained by students in live lecture sections. And overall, student and faculty acceptance of instructional television has continued to increase significantly every year.

During 1977, 70,450 students enrolled in MSU courses using television; 7,283 hours of programming were produced (including live transmission), resulting in over 69,100 credit hours on television.

Instructional and Public Television Services (IPTV), a division of MSU's Academic Services Department, is ultimately responsible for all programming decisions and program production. IPTV and faculty of the requesting department together determine the concept and content of the tapes. Scripting is done by both IPTV and the faculty. IPTV is responsible for technical evaluation of material that will be stored, while faculty evaluate content.

MSU plans to build a new telecommunications center which the staff and facilities of IPTV will share with several other units in the Academic Services Department. There is also the possibility that a new broadband cable system will be installed linking all classrooms, offices and service facilities on campus.

Scene from a demonstration tape for the "Music in Elementary Education" course.

Organizational and Technical Information—In Brief

Instructional and Public Television Services, a unit of MSU Academic Services Department which comprises 18 units providing academic support for the university, has a staff of 90 (40 production positions, 35 engineering and 15 administrative). All production, post-production, creative and consultative services are done in-house.

Present facilities are five color studios and a mobile unit, all equipped with broadcast quality cameras, a total of 18 quad recorders for mastering and editing, and associated equipment. The distribution systems include: large screen projectors in two teaching auditoriums; extensive 1/2-inch, 1-inch and 3/4-inch cassette playback hardware; over 70 miles of on-campus cabling to 178 rooms in 26 buildings; two channels on two CATV systems in the Lansing metropolitan area, and a public broadcast station. The total investment in facilities and equipment is approximately $4.5 million and the 1977-78 operating budget is approximately $1.8 million.

MISSOURI STATE DEPARTMENT OF ELEMENTARY AND
SECONDARY EDUCATION
STATE SCHOOLS FOR THE SEVERELY HANDICAPPED
Audio-Visual Services
P.O. Box 480
Jefferson, MO 65101

The Missouri State Schools for the Severely Handicapped serve a total of 2800 students between the ages of 5 and 21 who are defined as trainable mentally retarded, severely retarded, multiple handicapped and severe behavior disordered or autistic. Audio-Visual (A/V) Services produces instructional support video programming for the 67 facilities in the system.

The programs take a "Sesame Street" approach to seven major areas of instruction—self-care knowledge, language and communication, sensory motor, arithmetic, interpersonal relationships, fine arts, and practical arts and occupational skills. These tele-lessons supplement the teacher's activities, serving not only to teach, but to motivate and stimulate the students. They are aimed at working within and overcoming the low attention and retention capabilities of the students. Each school is equipped with playback units so that programs can be used as they are needed.

Tele-lesson programming covers using the telephone, making a sandwich, counting, manners, days of the week, money, introductions to the doctor, policemen and firemen, musical instruments, various consonant sounds, safety on the playground, and so on. "A Trip to the Zoo with Mr. Trix" is footage of animals in the zoo set to music. The 13-minute program opens and closes with Mr. Trix, an animated character. "Your Social Security Number," for young adults, explains what a Social Security number means and demonstrates how to fill out the application form. In "Frenchie's Famous Recipes," all of chef Frenchie's recipes begin with the letter "S." Programs use puppets, animated characters and fictional characters portrayed by professionals and university students—all as part of an effort to capture these students' attention.

Since many teachers receive little formal training in working with severely handicapped students, in-service series on "Physical Education Activities" and "Educational Rhythmics" and tapes on specific mental and physical disabilities help teachers develop methods of working with these students. Some of the tapes in the latter category are of experienced teachers working with a particular student or group of students, after which the teacher discusses and explains, on tape, why certain techniques were used. A/V Services also produces programs to instruct teachers on how to use specialized teaching equipment, such as the Mancino adaptive therapy chair.

Observation tapes recording student progress and response to specific teaching methods are made for viewing by both teachers and parents.

Workshops, conventions and speakers are taped and kept on file for viewing by teachers, management and supervisory personnel. A/V Services has also produced some special programs, such as a documentary on the Missouri Special Olympics and an informational tape on the State Schools' deaf/blind program.

Programs are produced on an as-needed basis. Most topic ideas originate with teachers. Programs are designed and developed by A/V Services and the state's Television Projects Planning Committee in conjunction with teachers and/or outside professionals.

More than 70 programs have been produced by A/V Services. Utilization is left to each teacher's discretion. Members of the Television Projects Planning Committee evaluate all programs before release, and teachers are required to conduct formal pre- and post-test evaluations on two tele-lesson titles each year. Television has been very well received by teachers and administrators in the State Schools, and evaluation results indicate that the programming is achieving the teaching objectives.

For the future, A/V Services plans to expand the number of playback units in each school and to purchase EFP equipment for location shoots.

Organizational and Technical Information—In Brief

Audio-Visual Services provides all media production for the 67 schools that comprise Missouri State Schools for the Severely Handicapped. Permanent staff is limited to the supervisor of A/V Services. Outside professionals and university students are hired for production work and talent.

The television production facility is a three-camera color studio set-up. Most programs are mastered and edited on 1/2-inch tape; 16mm film is used on location shoots. Distribution is by 80 1/2-inch cartridge players. Investment in the production facility is $250,000, and an additional $135,000 in distribution equipment. The annual operating budget is $20,000. The estimated production cost per program is $500.

NEW TRIER TOWNSHIP TELEVISION
385 Winnetka Avenue
Winnetka, IL 60093

High school students in New Trier Township had an intimate meeting with Tutankhamen, the Egyptian child king. Without traveling to Egypt or even to a museum in nearby Chicago, they got a long look at King Tut, his life and death, and particularly his burial and the myths, legends and symbolism surrounding the young pharaoh's tomb. The students viewed a documentary produced by the New Trier Township Television, the ETV media library and production facility for the 30 schools of New Trier Township.

The New Trier network, operating for over a decade, transmits over 4-channel ITFS to some 500 television sets in classrooms and media centers. In addition, 60 locations are equipped with video cassette playback units. The network reaches 17,000 students in kindergarten through 12th grade with programming that includes off-the-shelf educational tapes and films ranging from primary science to pre-college humanities and specially tailored productions on almost anything from King Tut to driver education. In other words, programming on this ETV network ranges from the strictly functional to the exotic, and it is available by phone-in broadcast request or video cassette.

New Trier's off-the-shelf programming, making up about half of the ETV fare, largely comes from the Illinois State Educational TV Network, the Agency for Instructional Television, Great Plains National, McGraw-Hill, Disney and Oxford.

New Trier acquired rights from Document Associates, Inc., to dub a collection of 35 futuristic films, entitled "Toward the Year 2000," to set up an innovative project. In 1974, New Trier Township Television received a federal grant to help set up this project in which 700 high school students, their teachers and local community resource people joined together to probe such topics as future developments in education, genetics, art, cities and roles. The objective of the project was to interface these thought-provoking programs with the target students' regular daily learning environment and curricula—to open the classroom to the world of tomorrow and to stretch curricular thinking. The project was a success and the programs are still being used.

Local productions, such as the King Tut documentary, are beginning to take up more and more of the production crew's time. The King Tut program is an impressive production which was also broadcast by a local TV station. The program is a mixture of old and modern film footage of Egypt, photographs of King Tut's tomb and shots of the King Tut museum exhibit. The narration guides the viewer through the burial chamber, the annex, the treasury room and so on, explaining the religious significance of each room in the tomb and its contents. The program describes the young king's gold mask, headdress, and the 143 bracelets and jewels adorning the mummy case.

Other enrichment programs have included a series of informal interviews with such notables as Margaret Mead, Ralph Nader and Studs Terkel, performances and demonstrations by visiting theatre companies, scientists, newsmakers and video taped field trips.

Toward the more functional end of the spectrum are the documentary-like programs on departments within the schools. A short tape on the Home Economics Department tells the viewer what the department is about, what courses are offered and why they could be important to any student. A tape for the Driver Education Department demonstrates how to parallel park. A video taped how-to-use-the-library demonstration and video tours of the high school campus for incoming students from the eighth grade cuts repetitive use of staff time. Twenty-five biology lab demonstrations ranging from how to dissect a fetal pig to how to capture insects both frees the teacher for one-on-one teaching and eliminates the need for teaching assistants.

Parents can watch video memos to learn about the school system's needs. Teachers explain their teaching techniques to other teachers on tape, and when the "new math" was introduced, a local math expert was sent around via video to help teachers learn the new concepts.

Scene from "King Tut Exhibit"—King Tut's burial mask.

In the individual schools, students use portable cameras to tape speech and drama classes and news shows. Students in the Special Education Department use video to learn communication skills.

Ideas for local productions originate with the director of educational TV, school administrators or individual departments. The director of educational TV is usually responsible for program development and scripting. Off-the-shelf programs are usually previewed via ITFS broadcasts, and teachers and administrators jointly determine which programs will be used.

New Trier Township Television's library exceeds 1500 programs, 200 of which are locally generated. Since each New Trier school has the capacity to be its own TV station, New Trier Township television plans to reduce ITFS broadcast time and spend more time dubbing tapes for each school to use on its own schedule. In addition to the added flexibility, this would free more time for making on-location productions.

One long range plan for New Trier schools could be a switch-over to 1/2-inch cassette distribution format should many homes acquire this equipment, thus facilitating video homework assignments.

Organizational and Technical Information—In Brief

The New Trier Township Television functions with a permanent staff of 5 plus a 25 member student crew that assists in dubbing, broadcasting and producing remote shoots. The facility includes a four-camera color studio, a graphics center and a transmission room. New Trier Township television also makes extensive use of portable field equipment. Distribution is via four-channel ITFS transmitter, 3/4-inch video cassette and film. Investment in production facilities is approximately $200,000 and $100,000 in distribution equipment. The yearly operating budget is $115,000.

OKLAHOMA STATE UNIVERSITY
Educational Television Services
Stillwater, OK 74074

Oklahoma State University (OSU) is part of an educational television consortium of 12 Oklahoma colleges and universities. This statewide network makes possible shared curriculum among member institutions in addition to the continuing education services offered to Oklahoma businesses and industries.

Ten of the colleges and universities have facilities to originate programming which can be received at approximately 60 locations. Some institutions, including OSU, emphasize graduate level courses, mainly in business, engineering and education. Others, such as junior colleges, emphasize general courses. All courses are lecture oriented and are transmitted live (taped lectures being used only when the professor is absent).

OSU's Educational Television Services (ETVS) also produces a wide variety of informational/instructional tapes for public viewing at the 60 statewide viewing locations. Topics have included ethnic problems, solar heating, fitness activities and energy conservation.

Other ETVS productions of an instructional/public service nature are aired on public and commercial television stations. These programs have included a four-part series on the history of labor in Oklahoma, a consumer affairs series and a series on higher education in Oklahoma, now in its sixth year.

ETVS also does production work on a contract basis for outside organizations. It produces public service announcements for the Oklahoma Highway Safety program and all training tapes for the Oklahoma Department of Transportation field personnel. Outside contracts generate a significant portion of the ETVS budget.

ETVS has produced more than 300 programs. Programming is requested by university departments, which provide the budget for production; program development and scripting is a cooperative effort of the department and ETVS. Occasionally outside consultants are hired for content and there is some use of professional narrators for voice-overs.

ETVS sells its programming but does not rent or buy off-the-shelf material.

OSU administration is very supportive of television and ETVS plans no changes in current practices.

Organizational and Technical Information—In Brief

Educational Television Services, a division of Academic Affairs, has been producing OSU video programming since 1967. It is staffed by seven people.

The television facility is a full broadcast quality color studio with complete in-house editing and duplication. Production is on 2-inch tape and film. Distribution is primarily by RF (radio frequency) to 60 locations statewide, with some distribution on 3/4-inch tape and film.

PENNSYLVANIA STATE UNIVERSITY
Division of Instructional Services
University Park, PA 16802

Pennsylvania State University has been active in televised instruction since 1953, and instructional programming is still the primary application of video. Penn State consists of 19 branch campuses, most of which are two-year lower division campuses, in addition to the four-year and graduate level main campus. Video taped course material in general lecture courses makes uniform teaching possible throughout the system. In addition, students on both the main and branch campuses can review taped lecture classes in self-learning centers. And in some courses, students can view video tapes to finish the course ahead of the scheduled routine.

Instructional programming topics include a broad spectrum for undergraduates from floods in a geological science course to human sexuality in a health education course. Tapes can be an entire 60-minute lecture, a demonstration segment or a relevant video "essay" to open or close a class session.

When an entire lecture is video taped, the on-camera professor is supported with film or tape footage and still photos or graphics illustrating lecture material. For example, the "Individual and Family Studies" program on family adjustment opens with still photographs of children and the lecture as voice-over, then cuts to the professor on camera. About 70% of the productions each year are in this category. About 18% of programming consists of segments that are integrated into traditionally taught courses. A short video taped introduction to a health education class on human sexuality is a series of still photographs to music. The visuals include modern and classical art, a scene from the "Little Annie Fannie" (*Playboy* magazine) comic strip and stills from motion pictures.

About 14% of the programming produced at Penn State is for university services rather than instruction. "The Interview Game," produced for Career Development and Placement, is a game show about job interviewing. "Staff Benefits," produced for the Personnel Department, features Mr. Answerman and many special effects to get the group insurance plan message to faculty. University-related public service announcements are produced occasionally to be aired on local broadcast television.

Topics are suggested by university departments and all programs are produced by the Division of Instructional Services. Faculty members contribute program content. Producer/directors in Instructional Services rewrite, reorganize and help visualize content. Although all programs are produced on the main campus, branch campus faculty sometimes participate in program concept and development.

Scene from "The Interview Game," produced for the Career Development and Placement Office.

Instructional Services has produced over 2000 tapes and has an annual production schedule of 250 to 300 programs. Tapes are constantly being updated or erased and reused. The shelf life of most programs is three to four years.

Programming is occasionally sold to outside educational agencies. No off-the-shelf video programming is used; however, films are sometimes transferred to tape and used for instructional purposes.

All programming is evaluated for production quality by Instructional Services. The requesting department is responsible for evaluating program content.

Even with considerable university experience, the primary limiting factor for television's growth is the faculty's lack of familiarity with the medium. With the objective of greater faculty acceptance, Instructional Services holds workshops for faculty on how to teach with media. Support for instructional television from all levels at the university is generally excellent.

Planned is the acquisition of portable field equipment and the possible addition of 1/2-inch cassette playback units to the existing distribution system.

Organizational and Technical Information—In Brief

The Division of Instructional Services, operating with a staff that consists of a supervisor, three producer/directors, six technicians and up to 30 student production assistants, is responsible for all television production at Penn State.

The production facility is a full broadcast quality color studio with adjoining control room and work space. All studio productions are mastered on 2-inch quad. Location footage is acquired on 16mm film; however, there are plans to purchase EFP equipment. Distribution is via a five-channel CCTV system on the main campus in addition to cassettes for a total on all campuses of 75 3/4-inch video cassette playback units.

The investment in production facilities is about $2 million, with more than $250,000 invested in distribution. Yearly operating expenses are approximately $500,000.

Mr. Answerman explains group life insurance in a scene from "Staff Benefits."

SAN DIEGO CITY SCHOOLS
Hearing Handicapped Department
Project Video Language
6125 Printwood Way
San Diego, CA 92117

In San Diego, television is being shown to be the best visual medium for teaching the deaf—because next to personalized attention TV can best provide the intimacy, immediacy and involvement necessary for deaf education. The San Diego City Schools' Hearing Handicapped Department is producing *Project Video Language*, a series of video tape programs based on the Apple Tree (Dormac) curriculum for deaf education. Ongoing evaluation of the project indicates that the San Diego students involved are learning twice as fast as they learn without the aid of television, and that they are being taught concepts which otherwise could not be taught.

The programs in *Project Video Language* are a combination of entertainment and drill, ranging from simple to complex stories, each of which uses sign language and captions and is designed for student/TV interaction. Show formats involve kids, teachers, animation, puppets, mime, clowns, magicians, Sea World and the San Diego Zoo. The programs teach vocabulary, grammar and simple to complex sentence patterning.

The "Magic S" teaches the concept of singular and plural. Objects appearing in thin air are named; and if there is more than one, an "s" appears. The concept of changing the verb "to be" from "is" to "are" is included in another tape in the same package. In the "Animate Adjectives" program, a troupe of professional clowns depicts in skits adjectives such as afraid, angry, sad and sleepy. Mr. Trash, the mechanical man (portrayed by a professional mime), manipulates dolls, boxes and balls to illustrate prepositions such as in, on, beside and between. In the "Jobs" show, a professional mime acts out different occupations which students are asked to identify. "Star Lost" is a space adventure story which teaches complex sentence patterning. One program teaches about the verb "to live" by going on location to the San Diego Zoo. Also at the zoo, another program asks riddles about animals. A story about swashbucklers, perils, buried treasure and two mischievous youngsters teaches complex sentences.

These tapes, 37 in total, are the central element in the language curriculum for the 100 students involved in the project. The tapes are accompanied by support materials such as teachers' guides, other audio-visual material and pre- and post-tests. The tapes are intended to be still-framed so that teachers can teach along with them, and so that students can proceed at their own pace. Each show is viewed 10 to 20 times during a month of study on one concept.

Project Video Language grew out of a need for more concentration on language acquisition skills discovered during the federally funded Project

TEACH. Project TEACH, running for three years prior to *Video Language,* produced four different kinds of programming: programs to orient deaf students to new surroundings, vocabulary and language development tapes dealing with specific practical areas of concern ("locker" and "gym" are examples), information and awareness programs for other students and parents, and tapes for in-service training. The experience with the project was disappointing, primarily because parents and the general public were uninterested. Therefore, *Video Language* was designed solely for language skills instruction.

The Ellis Corporation has conducted a thorough ongoing evaluation of *Video Language* against control groups taught by more traditional methods. Since the series production is still in progress, no conclusions are as yet available, but the findings reported so far have been extremely positive.

The Elementary and Secondary Education Act (ESEA), which provides funds for *Video Language*, may make money available to distribute the programs to other schools. These programs would most probably be available on a grant basis.

The San Diego City School District plans to create a media center for deaf education to produce programming in all academic areas. The media center would produce programming on a teacher request basis, with production funded by the school district. The hope is to sell these tapes outside the district to recoup production costs.

Organizational and Technical Information—In Brief

Project Video Language of the San Diego City Schools Hearing Handicapped Department is staffed by the project director and a TV specialist. All production work is contracted on a per program basis, with hired facilities, talent and technical staff. Mastering was originally on 1-inch, but now both production and distribution are on 3/4-inch cassette.

The project is funded by Elementary and Secondary Education Act (ESEA) Title IV C, a federal grant for experimental projects, which allocates $60,000 to $70,000 per year for the entire project.

UNIVERSITY OF ARIZONA
Microcampus
Building 72
Tucson, AZ 85721

The Microcampus project uses video technology to make any University of Arizona course available, at any time, to anyone, anywhere in the world. By early 1978, more than 3500 people from business and industry, military installations and government agencies in 16 states and one foreign country had viewed Microcampus classes for resident credit or personal enrichment.

Microcampus offers two kinds of educational services via video cassette, Regular Courses and Short Courses. Regular Courses are simply spontaneous recordings of regular class meetings. Any lecture-based course from 20 different university departments can be requested by subscriber organizations each semester. The classes that are to be recorded are held in one of two specially equipped classrooms. The subscriber student gets the same information as the student in the classroom, as every part of the class period is recorded, including the presentation of lecture-supporting graphics and class discussion. Students registered for graduate or undergraduate credit do the same assignments and take the same exams as on-campus students. Regular Course subjects range from home economics to computer science. Class offerings have included "Principles of

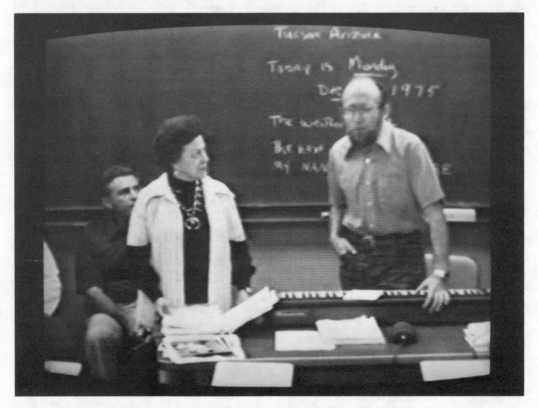

Scene from a short course, "Social Responses to Aging Care"—"Music as a Bridge to Reality."

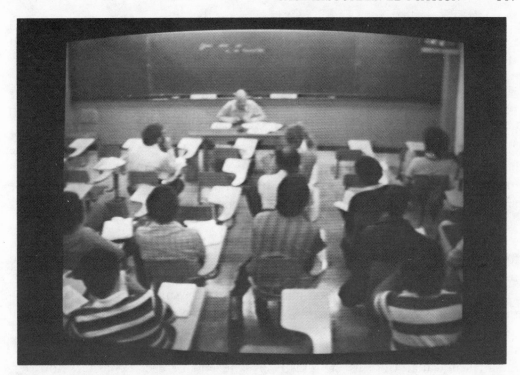

Scenes from a Regular Course, "Minicomputers and Analog/Digital Links"
1. Candid recording of class lecture session.

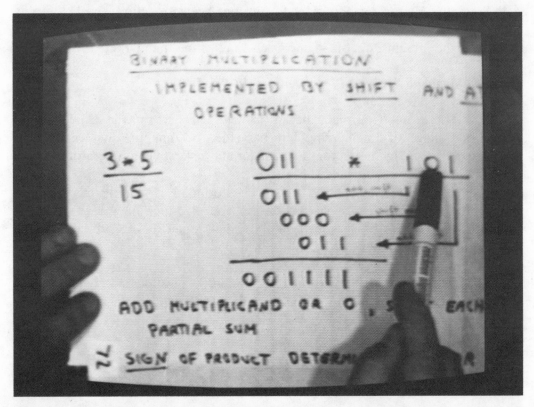

2. An overhead camera lets remote students see what on-campus students see.

Economics," "Solar Energy Engineering," "Digital Logic Design," "Women in Management," "Business Law" and "Federal Income Taxation."

Short Courses are classroom presentations in specialized subject areas. Like Regular Courses, they are lecture based, but they are shorter (from one to 10 hours for a complete course), and are not for degree credit. Short Course topics have included "Probabilistic Design" (four hours), "Resume Preparation" (one hour), "Dealing with the Troubled Employee" (one hour) and "Medical Instrumentation for Nurses" (seven hours). Custom tailored Short Courses can also be arranged to fit specific requirements as an organization requests.

In the five years of operation, enrollment for degree credit has grown from four students to 111 students in a single semester. Microcampus has recorded over 4300 hours of programming to date, averaging 15 courses per semester. Programming decisions are based almost entirely on subscriber request. Evaluation forms accompany tapes to the viewing site to solicit feedback on technical quality only.

The Regular Courses are erased by the end of each semester; however, Short Courses are retained since they are only presented live one time.

Since the Microcampus project format has been so well received, the only changes anticipated are expanded classroom facilities for recording, and improvement over the present direct-mail approach to reaching the market.

Organizational and Technical Information—In Brief

The Microcampus project began in 1972 as part of the University of Arizona's College of Engineering but has since become its own entity. The operation is staffed by a director, an engineer and several video operators.

Production facilities consist of two classrooms, each equipped with black and white cameras, six 3/4-inch cassette and four 1/2-inch open reel recorders. Distribution is via 3/4-inch cassette and 1/2-inch open reel to subscribers who rent or purchase the tapes.

The total equipment investment is $50,000, all allocated to production equipment (playback units are purchased by subscribers), and the yearly operating budget is $80,000.

7

Case Histories: Health/Medicine

BLYTHEDALE CHILDREN'S HOSPITAL
Audio-Visual Department
Valhalla, NY 10595

Nurses, therapists, teachers, medical students, therapeutic recreation interns, social workers, patients and other health care facilities benefit from the active use of television at Blythedale Children's Hospital. There, at a full research, training, diagnostic and rehabilitation hospital with 93 in-patients and 40 day patients, television resources range from an encyclopedic library of tapes on medical dysfunctions to movies, student productions and recorded special events run over the hospital cable system for staff and patient entertainment.

New hospital staff and volunteers view patient tapes to gain an understanding of an individual patient's history and present abilities, and to familiarize themselves with the types of dysfunctions with which they must deal. Tapes are also available on the types of therapies used at Blythedale. New staff members see therapy tapes such as "Respiratory Care," "Immunization," "Oxygen Therapy" and "Cast Care." Department heads explain the functions of their department to new volunteers, and then volunteers view tapes of other volunteers talking about their experiences at Blythedale and how they overcame problems.

Training tapes are produced by hospital departments. These tapes form the basis of a library in dysfunctions. Single programs center on one patient to describe a dysfunction, to show methods of evaluating abilities, to demonstrate

therapy programs and to measure the patient's progress. These tapes also allow students to study types of disabilities and impairments which they may not be able to observe during their internship at Blythedale.

Tapes are also made by one department for use by other departments for training/informational purposes. For instance, "Bracing" was made by the Physical Therapy Department for the Nursing and Volunteer Departments to demonstrate specific bracing techniques used at Blythedale. "Patient Transfers" and "Positioning for Better Performance" were made by the Physical Therapy Department for use by all hospital personnel. "What Is Cerebral Palsy" is a valuable aid to all staff, students and volunteers in dealing with Blythedale's large cerebral palsy population. "Blissymbolic Communication," "Feeding Brain Damaged Children," and "The Non-Verbal Child" are all examples of training-oriented tapes. Whenever these training tapes are viewed, a knowledgeable staff member is usually present to provide an in-depth explanation of the information presented.

Many tapes produced at Blythedale are of interest to other health care facilities. Seventy-five tapes were sold to other institutions last year. An example of one of these is "A Normal Baby—The Sensory Motor Processes of the First Year." This tape is a documentary type of program which follows a normal baby

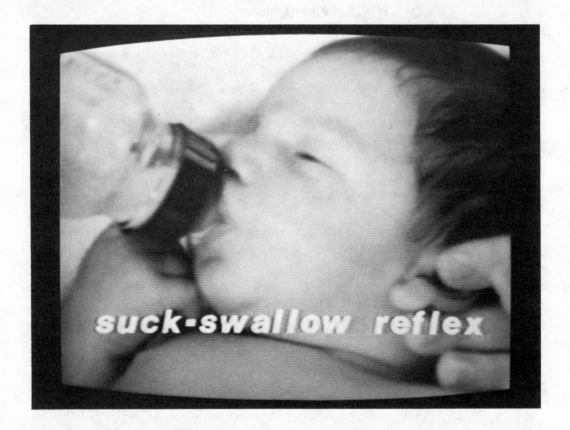

Scenes from "A Normal Baby: Sensory Motor Processes of the First Year"
1. The first week.

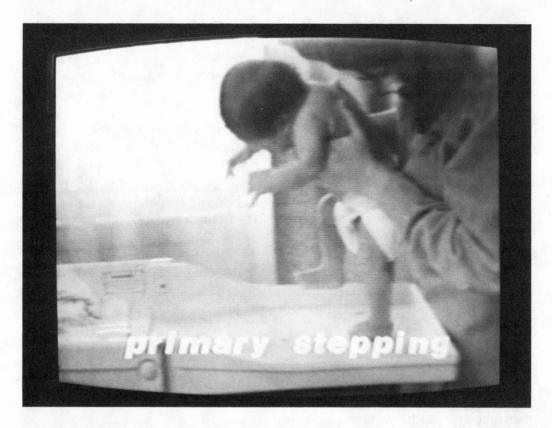

primary stepping

2. The first week.

through its first year's growth. The tape is divided into sections on the first week, the first months, the middle months, pre-toddler and toddler stages, detailing and demonstrating the normal stages of sensory motor development. The tape is accompanied by a manual and a chart.

Many patients are taped at intervals from admission to Blythedale to discharge. Initial tapings are used by rehabilitation therapists in writing evaluation reports. Analysis of a patient's abilities is easier and more accurate because the tape can be replayed, still-framed and played in slow motion. Successive tapings determine progress in therapy and serve as a tool for evaluating the therapeutic program in which the child is involved.

Patients can also view their personal tapes to see the progress they have made. Viewing these tapes can often convince skeptical patients that therapy is helping, and parents can be encouraged by seeing improvement of which they are often unaware.

When a patient is discharged, one tape may be assembled from the archival tape material complete with instructive narration to be sent along with the child to another institution, school or rehabilitation center. These tapes are usually a simple history of the child while at Blythedale, demonstrating the type of treatment received, his progress and present abilities. But it can also include further suggestions for treatment.

Lectures and workshops at Blythedale are recorded and kept on file. A two-month workshop in basic sign language, a lecture on immunization, a six-week workshop on neurodevelopmental treatment and a week long workshop on normal movement are examples.

Programs are suggested, developed and scripted in a cooperative effort between individual departments and the Audio-Visual Department. Outside professionals are used in this process on a volunteer basis. Two hundred fifty programs have been produced, varying in length from 15 to 30 minutes. Normally, 5 to 10 tapes are used each day at Blythedale. Viewing can be scheduled or not, voluntary or suggested, self-administered on an individual basis or in a group setting with a leader.

In the near future, the Audio-Visual Department plans to reorganize the production facility, to provide patient programming during evenings and week-ends and to increase production of tapes for other health care facilities and for public viewing.

Organizational and Technical Information—In Brief

The Audio-Visual Department at Blythedale is staffed by the director, a part-time aid, and five volunteers and interns who work an aggregate of about 75 hours per week.

The production facility is a 500 square foot color and black and white studio, and an adjacent 125 square foot control room. The present 125 feet of work area and office space is being converted to a production and post-production area, and an additional 500 square feet will provide both work and office space.

Production is primarily on 1/2-inch, with editing on 3/4-inch. Duplicating is done out-of-house. Distribution is by cable to most hospital areas and by six mobile viewing centers. Investment in production facilities and hardware is about $35,000, plus $15,000 for the distribution system. The annual operating budget is about $25,000.

DUKE UNIVERSITY MEDICAL CENTER
Division of Audio-Visual Education
Durham, NC 27710

Anatomy lab practicals are medical school examinations which commonly take place in a laboratory. Stations are set up at which a student has several minutes to study and name the designated muscle, vein, bone or whatever. A bell rings and each student moves on to the next station. At Duke, however, medical students take video examinations. The professor holds a skeletal foot in front of the camera, points to one bone and asks students to identify it. Video exams are one of the numerous innovative applications of the Duke University Medical Center Video Network.

Pharmacology, pathology and anatomy pre-lab exercises are demonstrated on tape which students view prior to doing the exercise. Video tape is often used as a lecture aid in the basic sciences. Medical students also have the option of being video taped through a one-way mirror while performing clinical examination of patients for feedback and evaluation.

At the Medical Center, grand rounds are video taped, thereby bringing patients to the conference room and classroom without ever moving them. These grand rounds tapes are later re-edited and distributed to health education centers around the state. Video tape is used in the psychiatric wards and in the clinic to record therapy sessions for physician review. In medical research, video is a data gathering aid, used to record phenomena found in the research process. These research documentation tapes are sometimes shown in the classroom, and in regional and national medical meetings. Research reports are also recorded and sent to medical meetings if the researcher cannot attend. Faculty in the allied health areas are trained in the use of video tape equipment and techniques to make the technology more accessible to this area of study.

Video use at Duke began in 1959 and has enjoyed increasing popularity with faculty, students and administrators. In 1977, the Division of Audio-Visual Education produced about 75 programs. With the implementation of a new color facility late in the year, Audio-Visual Education planned 125 productions for 1978. Besides being responsible for television production and the production of other A/V materials, Audio-Visual Education also assists various departments in acquiring off-the-shelf programming. Departments most active in the use of off-the-shelf programs are psychiatry, pediatrics, obstetrics/gynecology, medicine, surgery and anatomy.

Programming is produced on a departmental request basis. The department works closely with the media producer to develop the idea and script, when necessary.

Since the Division of Audio-Visual Education has recently acquired more sophisticated facilities, the plans are to step up production in terms of quality and quantity in the areas which they are now producing.

Organizational and Technical Information—In Brief

The Division of Audio-Visual Education is within Medical and Allied Health Education. Audio-Visual Education is responsible for all A/V materials except print. The television complex, housed on the main campus, is staffed by six people.

Recently, black and white equipment was phased out and replaced by a full color 3/4-inch facility, representing an investment of about $100,000. Distribution is by hardwire net and RF (radio frequency) to 40 locations within the university. There is also use of ITFS and 3/4-inch cassette distribution.

HENDRICK MEMORIAL HOSPITAL
Center for Continuing Education
19th and Hickory Streets
Abilene, TX 79601

Well-informed patients could be expected to have a better outlook and to be more at ease than patients who must embark on their hospital stay dreading the unknown. Patients at Hendrick Memorial Hospital are familiarized with their environment by Pete Patient, a cartoon figure who helps introduce them to nursing service, the laboratory, radiology, surgery, the pharmacy and many other departments that they will encounter during a stay. Pete Patient is integrated with footage depicting routine activity in hospital units and departments. Off-the-shelf patient medical education programs on diseases such as diabetes and renal disease, aired over the hospital's four-channel cable system, help answer medical questions patients most frequently ask.

The priority video programming produced and purchased by Hendrick's Center for Continuing Education is medical instruction and information for the eight affiliated allied health schools and for the 100 affiliated physicians. The Center for Continuing Education supplies programming on request to support the traditional curriculum for nursing students and medical, laboratory and operating room technicians. Physicians view, in scheduled groups and by request, continuing education programs and taped lectures and seminars.

Scenes from "Fifty Years and Beyond"
1. Pete Patient introduces patients to radiology. . . .

2. . . . one of its forms.

The Center for Continuing Education also supports the in-service training and continuing education of health care staff by making programs on major medical topics, such as cardiopulmonary resuscitation, available for viewing by request. Nurses and paramedical staff are also encouraged to view the taped lectures and seminars originally recorded for physicians.

Hendrick's staff of 1000 nurses, paraprofessionals, administrative and maintenance people also view hospital policy and procedure tapes, generally during orientation. One program, "Code Five," demonstrates fire drill procedure. This 12-minute program is accompanied by a brochure.

Hendrick has been active in television use since 1971 and has a library of 40 in-house productions and 2000 off-the-shelf programs. Program topics are chosen both by user groups and the center's media director. Future programming plans include the acquisition of more patient education programs.

Organizational and Technical Information — In Brief

The Center for Continuing Education is in charge of all audio-visual production at Hendrick, and is staffed by a medical director, a media director, an engineer and a media coordinator.

Production and post-production is done in-house on 1-inch format. Distribution is via a four-channel cable system and 3/4-inch video cassette.

MILTON S. HERSHEY MEDICAL CENTER
Continuing Medical Education Program
Pennsylvania State University
Hershey, PA 17033

A young woman in a bathing suit and a man with a felt-tipped pen could be considered merely a gimmick to hold audience interest. However, in the case of Hershey Medical Center Continuing Medical Education (CME) Department's *Physician Update* series it is not a gimmick, but a functional method of illustrating techniques of physical diagnosis. The physician uses the pen to mark ridges on the woman's fingernails and to accentuate fingerprint patterns – to illustrate what can be learned by close examination of the hands. In the same manner, he illustrates how examination of the head can reveal systemic diseases, and so on, with the neck, the abdomen, the back, etc.

The *Physician Update* series is part of a range of continuing education services that CME offers to practitioners in Central Pennsylvania. The series covers topics of general medical concern, including the management of the patient with angina pectoris, technical and interpretive aspects of the EEG, infection control, various neurological disturbances and head trauma. The programs are typically lecture-based presentations by practitioners, supported with graphics, taped and "live" demonstrations.

Scenes from "Physician Update"
1. "Physician Update" logo.

The *Physician Update* series, other CME productions and purchased off-the-shelf programs are broadcast over the educational television station of Pennsylvania State University. The programs are also rented on 3/4-inch cassette by 45 hospitals in Central Pennsylvania and used in continuing education workshops, conferences and courses held at the Medical Center. Although CME programming is aimed at physicians, other health care personnel (nurses, nurses' aides, technicians) participate in viewing.

CME has produced about 28 programs, and has an annual production schedule of 12 programs. Twenty-five off-the-shelf programs are purchased each year, primarily from medical video publishers.

Organizational and Technical Information — In Brief

The Hershey Medical Center is part of Pennsylvania State University. The Continuing Medical Education Department provides continuing education activities to physicians in Central Pennsylvania and is responsible for all video programming for the Medical Center.

All production is done at the Pennsylvania State University television studio. Distribution is via broadcast on the university's educational channel and by 3/4-inch video cassette.

2. Illustrating what examination of the fingernails can reveal.

INDIANA UNIVERSITY SCHOOL OF MEDICINE
Medical Educational Resources Program (MERP)
1100 West Michigan Street
Indianapolis, IN 46202

At least once a month, physicians, nurses, physical and respiratory therapists, dentists, pharmacists and speech clinicians in 47 counties in Indiana participate in continuing medical education via television. The continuing medical educational (CME) programming comes from the Indiana University School of Medicine and goes out to hospitals and physicians by broadcast, closed-circuit and cable TV and video cassette. In addition, patients at area hospitals receive health care information in their rooms, and medical students can see for themselves, in one class period, the clinical manifestations of a disease before, during and after treatment. Indiana University School of Medicine's biomedical telecommunications network, which began with a major funding effort by state legislation in 1967, has grown to be one of the largest medical video networks anywhere.

The Medical Educational Resources Program's (MERP) statewide closed-circuit Medical Television Network station, WAT 21, has been broadcasting far-ranging continuing medical educational programming since 1969, and now broadcasts up to 40 hours each week to 38 health care facilities in 16 Indiana cities. WAT 21's CME broadcasting consists primarily of three live, ongoing series produced by MERP.

Today's Medicine, which began in 1972, provides demonstrations of medical procedures to health care personnel. This anthology of medical topics includes anterior nasal packing technique, examining children for ocularmotor disturbances, and a series on the Indiana state malpractice act. Another, the *Grand Rounds in Surgery* series, is in its second year. These programs follow a grand rounds discussion format and feature pre-operative history-taking and patient examinations. The series also includes selected segments of surgical procedures. The operating room from which these segments originate is wired for two-way audio permitting viewer participation from all receiving points.

The Newborn series, the latest addition to live, ongoing CME broadcasts, features video taped programming for primary care physicians, nurses and respiratory therapists followed by live talk-back sessions. Programs include "Birth Trauma," "Physical Examination of the Newborn," and "Determining Gestational Age." The viewer/specialist talk-back session is part of a comprehensive program to regionalize quality care for critically ill infants.

Video cassettes of the CME series are available through MERP's Video Cassette Mailing Network, begun in 1967, to 101 Indiana hospitals (which are equipped with playback machines by the School of Medicine). In addition, special arrangements with cable companies have made it possible for 75 physicians in certain areas to receive CME programs in their homes.

In addition to regular CME programming, MERP has video taped medical conferences and symposiums, and has participated, via satellite, in two live medical conventions and demonstrations. Live demonstrations of intricate medical techniques performed at Johns Hopkins University School of Medicine were transmitted via newly launched Communications Technology Satellite (a joint venture of NASA and the Canadian government), and recorded by MERP in 1976. The footage was edited into a documentary which is kept on file in the MERP office. Satellite transmission of the 1976 American Hospital Association convention in Atlanta was viewed throughout the state of Indiana over WAT 21.

A second area of emphasis for MERP's Medical Television Facility is the production of video tapes to support traditional medical school curriculum materials. TV enhances lectures by allowing students to see a patient at various stages during a disease's progression. Video taped demonstrations of patient examination techniques prepare sophomore medical students in the "Introduction to Medicine" course for their initial clinical experience. Tapes are produced for the basic science courses, such as anatomy, microbiology, biochemistry and pathology, and for laboratory experiments. Student utilization of television adds up to over 20,000 hours annually.

The last hour of programming on WAT 21 each day is devoted to patient education programming produced by MERP. *Talking with Your Physician*, a series of 46 five-minute segments, seeks to improve communication between patients and their physicians. Two physicians from the School of Medicine talk with specialists in medical areas ranging from depression to cirrhosis, anticipating questions most likely to be on patients' minds. The doctors discuss medical problems in terms of the type of information the patient needs — explaining the cause of the problem, what to do when symptoms occur and the ramifications of treatment. These programs are also broadcast for general public viewing by Indianapolis Public Broadcasting System station.

Feedback on the School of Medicine's programming, which is developed by MERP, often in conjunction with faculty members and department chairmen, has been very positive. A survey conducted by MERP's Television Facility showed that 83% of physicians and 85% of nurses were regular viewers of WAT 21 CME programming. Faculty support of television in classrooms and labs has been strong, as faculty members find they can improve teaching time efficiency and curriculum structure by using video tape. A survey of representative hospitals receiving patient education programming revealed that 94.4% of the patients liked receiving health information via TV. The same study also showed that 47.9% of the nursing staff involved felt that the programs improved communication between hospital staff and patients.

Indiana University School of Medicine predicts no change in the existing program offerings, but plans more involvement in the areas of national networking demonstrations and satellite tele-conferences.

Scene from "Today's Medicine" program on "Crossed Eyes in Children" — Examination for ocular-motor disturbances.

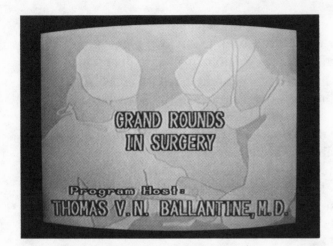

"Grand Rounds in Surgery" logo.

Organizational and Technical Information — In Brief

MERP encompasses six facilities in addition to the Medical Television Facility which are involved in production services: Motion Picture/Audio Production, Graphics/Design, Instructional Media, Projection Service, Educational Design Testing/Evaluation and Administrative staff. It operates with a total staff of 35.

The television production capabilities include a three-camera broadcast quality color studio and a three-camera broadcast quality mobile van. Studio mastering is on 2-inch quadruplex and for remotes, a portable minicam is used. Distribution is via broadcast on closed-circuit Medical Television Network Station WAT 21 to 38 health care facilities in 16 Indiana cities, the Video Cassette Mailing Network to 101 Indiana Hospitals and cable to the homes and offices of 75 physicians.

PURDUE UNIVERSITY SCHOOL OF VETERINARY MEDICINE
Veterinary Medical Illustration and Communications
West Lafayette, IN 47907

Veterinary Medical Illustration and Communications develops and produces packaged instructional programs which play a key role in the medical education of Purdue's veterinary students. In addition to video tape programs these packages often include slides, print, audio tapes, film, tissue sections, live specimens and models. One or more of these materials, often including video tape, are also used to support continuing education, research, diagnostic services and patient care at the School of Veterinary Medicine. Medical Illustration also provides audio-visual support for the Indiana University Medical School's first and fourth year programs located in the same building. In addition, Purdue has a veterinary technician program which utilizes Medical Illustration productions.

Video tape is used to supplement basic science laboratory experiments. Pre-lab information is recorded and played back prior to student experiments, allowing students to start work in the "middle" of the experiment. This procedure not only reduces repetition and saves time, but provides students with a more uniform understanding of the experiment.

Class lectures that are repeated from year to year are recorded and played back during the lecture period and are available for review in the self-study lab. Often, case study clips on the lecture topic will be arranged on tape. At appropriate points during the lecture, the professor plays back the desired segment to illustrate the discussion visually. These segments are also adapted for quiz purposes.

At the veterinary school, there are standard surgical procedures that all students must perform. These procedures are video taped for students to study prior to doing the actual operation. Students also have the option of being video taped by "candid cameras" in examining rooms to be able to review their own performances with patients and clients.

The largest auditorium at the school will hold 150 people, which is the equivalent to the size of two classes. When guest lecturers are on campus, their presentations travel via video to other classrooms and are recorded for later viewing.

Much of the video taped instructional material viewed by students in classrooms and the self-study lab is used in continuing education for practicing veterinarians. A program on the treatment of swine herd diseases, for example, is geared to a higher level than is needed in undergraduate study and viewed by practitioners in on-campus continuing education workshops or in regional veterinary medical meetings.

Purdue Veterinary recently acquired a video-microprojection system that has become integral to instruction. Microscopic tissue slides are photo-

graphed and shown on an eight-monitor distribution system. Though it is generally live, this process of image magnification can be recorded and integrated in video tape programs.

The faculty gives video strong support and works closely with Medical Illustration to develop programming. All production work is done by Medical Illustration staff. Most instructional needs can be fulfilled by in-house efforts, but some off-the-shelf programming is used. Usually these are lecture and lab supplements in the areas of clinical medicine, anatomy and physiology.

Medical Illustration has produced about 350 programs to date, and produces an average of 30 tapes each year. Some tapes are sold and rented to other veterinary schools.

In the future, Purdue Veterinary would like to get more involved with sharing faculty and curriculum with veterinary schools around the country via satellite. In addition, the acquisition of color EFP equipment in the near future will open up new areas of programming, allowing a stronger orientation toward field case studies.

Organizational and Technical Information—In Brief

Veterinary Medical Illustration and Communications is responsible for all production of in-house instructional media. In addition to video, this includes medical art, graphics, surgical photography, slides, film, photomicrographs, print and models.

The television facility is a three-camera color studio set-up. The current 1-inch production equipment is in the process of being replaced by 3/4-inch video cassette equipment with electronic editing. Distribution is via 3/4-inch cassette to an attached 14-carrel self-study lab (open 24 hours a day, seven days a week), and most classrooms and teaching labs have playback units. In addition, the campus vet clinic is equipped with playback units for client education.

Investment for the total production facility is $100,000, video representing $73,400 of this. Distribution hardware investment is $67,000. Medical Illustration's annual video budget is approximately $10,000 for capital expenditures and $15,000 for operations. Per program cost is about $150.

TUCSON MEDICAL CENTER
Department of Education
P.O. Box 6067
Tucson, AZ 85733

The Tucson Medical Center (TMC) is a not-for-profit hospital which has been involved in video since 1968. Currently video activity includes recording meetings, conferences and lectures, procedure review, employee communications, patient education and diversion, community health education and instructor training.

Recorded lectures and conferences provide the hospital's patient care personnel with a permanent reference library on relevant special topics such as care of patients with pituitary gland surgery, orthopedic surgery, cosmetic surgery, arthritis and diabetes. In addition to improving the quality of care a nurse can give, the tapes can better enable staff to instruct patients on self-care.

TMC has also taped a wide range of procedures from traction set-ups to operating room procedures to applying hand splints.

Employee communications consists primarily of a monthly news show on staff orientation programs that cover such areas as benefits and safety. The news show, which features news items about employees, won the National Hospital Public Relations Award in 1976.

Patient education tapes are mostly off-the-shelf informational programs on health-related topics such as heart disease, emphysema, exercise and diet, high blood pressure and stress. Patient entertainment tapes are produced by TMC in conjunction with a local arts administration group. Programs feature dance performances, chamber music, puppeteers and local theatre groups. Patient programming is broadcast on a two-channel closed-circuit television system for 12 hours every day.

Video is also made available to any staff member who wants to use the instant replay capability to help sharpen lecture and public speaking skills.

Community health programming is the newest area of involvement. Most programs focus on health problems that occur in the region, such as Valley Fever. Some tapes contain general information such as how to use a hospital in a cost-effective way. These programs are distributed for TMC by the Tucson Public Libraries.

The education department, responsible for video production, has produced 250 programs to date. They average 30 minutes in length and are made in both color and black and white. Programming decisions are made by the education department staff based on requests by hospital departments. The requesting department and the education department work jointly on program planning and scripting.

Freelance crew members and consultants are used for "spot jobs" such as lighting a set or producing a news show when the education department staff is very busy.

Equipment and crew are routinely rented to not-for-profit organizations and independent producers in the area, which helps generate funds for on-going video activity at the hospital. TMC hopes to acquire a flexible mobile production van to be able to produce programs for other hospitals in the area.

Organizational and Technical Information — In Brief:

Tucson Medical Center's education department is in charge of all video production and operates with a permanent staff of six persons assisted by occasional freelancers.

All production and editing is on 3/4-inch cassette. Patient television utilizes the hospital's two-channel closed-circuit system. All other programming is distributed via three 3/4-inch cassette players and monitors on rolling carts. Production hardware investment is approximately $58,000.

UNIVERSITY OF ILLINOIS AT THE MEDICAL CENTER
Office of Public Information
1737 West Polk Street
Chicago, IL 60612

Public and patient health information programming is a fast growing field in private television. University medical centers, in particular, have been producing health care programming not only for in-patients but for nationwide distribution as well.

University of Illinois at the Medical Center produces the award-winning *Consultation* series, consisting of programs generally lasting half an hour, featuring a discussion between an interviewer and a guest who is an expert in the area of the program subject. Each program focuses on one health topic, such as high blood pressure or prenatal care, in which the guest specialist gives viewers a thorough explanation of causes, symptoms, methods of treatment and prevention. The discussion is supported by visual inserts (films, slides and graphics) and demonstrations. The objective of the series is to impart technical information in layman's terms, answering questions most likely to be on viewers' minds, toward the goal of nationwide preventative health practice.

Each year, approximately 50 new *Consultation* programs are produced. A cross-section of programs illustrates some of the different techniques that have been applied in the series. These examples make it clear that in 10 years of presenting health education programming, many varied approaches can be taken to public medical education.

Scenes from the series ''Ask Your Doctor''
1. Ask Your Doctor logo.

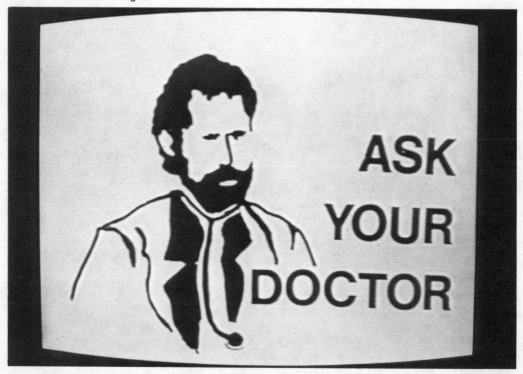

In a typical discussion format, an otolaryngologist from the University's Eye and Ear Infirmary, for example, explains chronic hoarseness, its causes, treatments and preventative measures. Visuals include footage of healthy and diseased vocal cords as seen through a procedure of indirect examination and footage demonstrating laser treatment of cancer of the vocal cords.

"Pre-Clinical Research" takes a documentary-like approach to the use of animals in medical research. The program examines the role animals play in two research programs, and the restrictions placed upon experimentation with animals.

"Total Joint Replacement" makes use of one case study as an example of the major form of treatment for bad joints. Film footage of the patient demonstrates the "before" effects of a deformed hip joint, and the patient in the studio with the physician and moderator demonstrates the success of total joint replacement.

In "Hyaline Membrane Disease," a special filmed report from the High Risk Nurseries of the University of Illinois Hospital documents the causes and treatments of this disease that afflicts newborns. "When Minutes Count . . . the Newborn" incorporates another special filmed report on the neo-natal intensive care unit operated by the University of Illinois Hospital.

A program on cerebral palsy brings a physical therapist in to join the physician and moderator to demonstrate exercises and techniques parents can use with afflicted children who live at home.

2. A panel of laymen get answers to commonly asked health questions.

The "Ask Your Doctor" series is designed to encourage improved doctor/ patient relationships. A panel of laymen join physicians in the studio to discuss how patients can achieve a good rapport with their personal physicians and get answers to their medical questions. The panel also gets the answers to some of the commonly asked health questions such as "What causes ulcers?" or "Can cracking the knuckles cause arthritis?"

In the "Social Dilemmas of Our Time" series, a program on teenage sexuality brings the executive director of Chicago's Planned Parenthood Association to the studio to explain that group's role in counseling and educating teenagers.

"To Live in a Wheelchair" profiles two persons confined to wheelchairs. The show is aimed at enlightening family members of the handicapped.

Some programming suggestions originate with viewers, but usually topic ideas originate from the various departments on the University of Illinois campus. Three to four months are spent in pre-production planning and all programs are taped in Telemation Production Studios in a Chicago suburb during two recording sessions yearly.

Guests on the series are generally specialists from the five colleges of the University of Illinois Medical Center. The *Consultation* staff works closely with the guest expert to plan the program's specific content and to help assure that the program taping runs smoothly. The programs are shot in one take and no post-production editing is done.

The series, a nonprofit public service, is shown on over 70 cable and public TV stations in 35 states. Programs are also used by universities, hospitals and health organizations. On the University of Illinois campus, selected programs are shown in conjunction with exhibits in the anatomy museum. The programs are used by first and second year students at the School of Basic Medical Science.

Organizational and Technical Information—In Brief

Consultation is produced by the Office of Public Information of the University of Illinois at the Medical Center. The staff for the series consists of an executive producer, a syndicator/secretary and a part-time production assistant. Some pre-production jobs are filled by freelance personnel.

Production is done out-of-house in the Telemation Production Studio, using Telemation staff. Programs are shot with two or three broadcast quality color cameras and are mastered on 2-inch quadruplex tape.

Consultation is funded, in part, by a grant from Abbott Laboratories, which also distributes the series free of charge.

8

Current Assessment and Outlook

Overall acceptance of video by institutional managements and viewers has improved significantly since the first days of private television in the early 1970s. The case histories show that the majority of those responsible for video in organizations expect that video acceptance and utilization will follow a path of continued growth. The specific path varies among organizations — for many it involves an increased volume of program production, for others it involves exploring larger or even different audiences or new applications, and for some it means a larger production facility and more staff. Feedback indicates that, in most cases, institutional managements support growth. A number of in-house producers have reported that video operations are not always the first to be eliminated when budgets are cut. In fact, video is sometimes used, under those circumstances, to provide cohesion to an organization during transition or cutbacks. However, it must be said that many video operations do continue to experience budget difficulties, shortage of staff or underutilization.

LESSONS LEARNED

In interviews with in-house producers and media directors, some lessons about the medium were commonly reported as central to the growth and success of a video operation. Of greatest importance, careful and efficient management in planning and producing programs improves program quality and helps ensure success. Some of the best programs originate from video operations which report that weeks and sometimes months are spent in pre-production planning. In many cases, a detailed annual production schedule is prepared in advance of the year and updated as needs and priorities change.

Video involvement is relatively expensive, and clearcut objectives for the network and demonstrable results can help justify the expense. Because those

who fund a video operation want evidence that it is accomplishing something for the organization, some video managers directly involve top management in the programming decision-making process. Some video operations provide management with a tabulation of viewer questionnaire responses. Others provide cost savings analyses on large productions or series.

Feedback from viewers provides insights into what is needed from video and what is actually delivered. Many program success stories started when the video staff went into the field to ask potential audiences what *they* wanted on tape. Questionnaires can tell a producer how well a program was understood, or if anyone even bothered to watch it.

Managers, teachers and other users who are often involved in production must be educated as to the medium's characteristics and capabilities. Some video managers and media directors hold seminars on television production and programming for managers, teachers, professors, training directors, counselors, etc. Some operations have utilization teams that go into the field to get viewers more involved with the medium.

In-house producers and video managers expressed a broad range of viewpoints on the subject of hardware. Some reported that their experience indicated that expensive cameras and recorders and the latest special effects gadgets meant very little to viewers, especially if programs lacked planning and relevant content. Others expressed the view that better equipment makes better programs. To a degree, both are true in that the hardware used should give appropriate quality and flexibility for an organization's specific purposes.

Successful institutional video operations all acknowledge one important principle: The end product is not the video program but, rather, the knowledge it imparts or the action it facilitates. Interviews with teachers and department managers revealed that they are concerned primarily with good programming and easy, reliable distribution. For this group, the promise of the future is not technology, although improvements in distribution methods and hardware are important. What the user sees and cares about is good software at economically justifiable prices.

Producing effective programming presents a considerable challenge for institutions, and particularly for corporations. Organizations have accepted video for employee training more than any other application, yet even in training there still prevails a limited vision of television's capability. Recording existing lectures and providing support for lectures or seminars is the norm in business, government, medical and academic programming. Specially produced *video-based* training is not fully accepted as a formal training method, although many organizations have logged impressive successes.

It is also in training that organizations, particularly businesses, can most easily show substantive time and cost savings with video. Television's benefits are

often considered "real" only when they are seen in dollars saved. Pursuit of value-added benefits accomplishing new tasks in support of organizational objectives has been more limited. The risks involved in these types of programs, which are necessarily more of a pioneering challenge, have kept many operations from further experimentation with the medium.

OTHER PROBLEMS

The problem of limited career paths for video professionals within their own organizations is serious. While video departments strive to become more a part of their organization's workings, the employees' skill backgrounds seldom qualify them for managerial advancement in non-video areas. In the case of writers this problem is contributing to what video managers acknowledge as a skill/talent gap. In spite of projections for continued growth, institutional video has difficulty attracting the writing talent it needs. While many professional writers specialize in writing about one subject for one audience, corporate writers typically must understand and write for many different levels of audiences. They must become familiar with a wide variety of subjects; they generally must make very complicated material simple, and they must have a complete understanding of the medium. In addition, those who are writing scripts in organizations may have many other functions: hiring a full-time writer or writing staff is often not thought a justifiable expense.

All of these factors have left many institutional video script writers with a sense of blunted career path opportunity. Also, the tremendous pool of graduates of film programs — there are now more than 1200 schools in the U.S. offering film degrees — has begun to turn to institutional video as a source of work, although often thought of as a temporary station. This rapidly growing pool of essentially unemployed film skills is having a double-edged effect on institutional video: The price for freelance writing services is declining and the career outlook for in-house writers is growing less certain. Many video managers feel this is among the most serious problems facing growth of the medium.

Managers of successful video operations have learned the necessity of careful strategic planning to overcome many of the problems of producing programming within an organization. Generally speaking, the key is ongoing needs analysis and monitoring: constant updating of organizational and audience information needs; strategic communications and network planning; going into the field to encourage an exchange of ideas with potential audiences; soliciting and evaluating feedback to monitor video's actual achievements; promoting the network to the people who use it, e.g. programming public relations.

OUTLOOK: NEAR TERM AND BEYOND

The technological advances that affect video have been rapid and they continue. Higher resolution cameras, more complex switchers, more accessible satellite distribution, the growing network of cable linking homes with institu-

tions and institutions with other institutions, 1/2-inch cassettes, two-way TV — all of these innovations are having an impact on production/distribution economics and on the state of the art.

Two-way television, used in several communities experimentally since the early 1970s, provides a whole new dimension to communications. "Talk-back TV," as it is sometimes called, can change the relationships between the off-campus student and the on-campus professor, parents at home and the school board, politicians and their constituents, corporate executives and the community their company serves or operates in, and consumers and merchants. Talk-back TV is already having the same effect on learning in education and medicine that the video cassette had when first used in business. It will certainly further the breakdown of geographic limitations previously imposed on institutions and individuals.

Large-screen video projection use is becoming more common, offering students in the classroom a larger-than-life-size vision of the world they study. Large-screen projection has already had a tremendous impact on medicine by allowing intricate and even microscopic procedures and occurrences to be recorded and easily viewed by groups.

The 3400 U.S. cable systems in operation are now permitted by FCC rule to use a small dish antenna to receive satellite communications. This will allow CATV to expand program and information distribution options at considerable savings, as well as to open satellite services to institutions in their communities.

Over the years the demand for continuing education has been a significant factor in the growth of private television: It is more the case now than ever, and it affects every sector. Like most services, a trend in education is the move away from geographically bound education — and television best facilitates the individual-to-education linkage. Using video cassettes and live closed circuit and microwave links, the student can be hundreds of miles or even years away from a course professor. More corporations are beginning to realize that what has been good for engineers, the group that has been most active in advanced studies and advanced degrees via television, may also be good for other employee groups. Bringing continuing education to employees is a benefit more progressive companies already view as a form of non-salary compensation which yields higher motivation and productivity, and more "promotables."

The nature of television is in a period of radical transition. The emphasis is expected to be less on *watching* television but rather more on *using* it. Although much of the change is currently focused around home use, institutional users are benefiting. Half-inch cassette recorders and small cameras developed for the consumer market have presented many small organizations, and some organizations with large networks, with the most affordable alternative to video production and/or distribution to date. Certainly the change in options for consumer use of TV is going to be felt among institutional users. Homes may be

linked not only to schools and universities, but to businesses, government agencies and even medical centers.

Video spread quickly with the single development which has most improved the institutional utility of television, the video cassette — a complete program in a compact form which anyone can operate. Suddenly, networks of video cassette players began to spring up in organizations. Many of those stories are contained in this volume. Where will the next wave of growth for the medium originate? Certainly, greater software development is a necessity, but progress will be gradual, and is slowed by the institutional reluctance to take new kinds of risks in programming.

As with many other management systems, computers may be the catalyst in stimulating new video growth. Visual information from video and film cameras can be stored digitally in computers in film to video tape transfer processes. Meanwhile, another branch of television technology has been proliferating throughout institutional organizations even faster than video: The CRT (cathode ray tube) computer terminal. These terminals have become a very familiar sight during the past 10 years; they are now in supermarkets, ticket counters, and virtually every medium and large size business or institution. Most organizations that have video have, in fact, many more CRTs than video cassette players. It seems likely that these CRTs may eventually be the preferred means of gaining access to "video-based" and "film-based" information, through a library reference system. These terminals will allow the user to tell the terminal *exactly* what he or she wants to learn and the appropriate visual module is played back, including interactive programming wherever appropriate. The use of the technology for such a system may not be so far in the future.

Organizations already have their own satellites conveying data between computers. As the computer systems grow larger and larger, the computer will be able to greatly improve what video can do for its user institutions, namely in the areas of ease of access to referenced, comprehensive learning materials.

Regardless of the development of technology, video is an extremely flexible information medium and video networks will grow. More people need to be trained and retrained more often. Continuing education is becoming thought of as an entitlement for many employees and in many cases video is the most efficient means of providing continuing education on the job. And the managements of most institutions are eager to find solutions to the problems of managing large, complex organizations. The place for video in these priority areas is that of a resource which is essential.

Glossary

Amplifier — An electronic device for boosting, or strengthening, a video or audio signal.

Angle shot — A camera shot taken from a position either above or below the subject.

Animation — A production technique utilizing cartoon-type artwork to create the illusion of movement.

Audio — Pertaining to sound, specifically here to the sound accompanying the visual, or video, portion of television.

Audio track — Portion of tape carrying sound.

Backlight — Illumination of the subject from behind, opposite the camera.

Black — The screen with no video on it.

Blocking — Working out the physical movement of people and objects on the set.

Boom — A crane-like device for suspending, raising or lowering a microphone or camera in the air.

Break-up — Image distortion on the screen.

Broadcasting — Transmitting electronic signals over the air.

Camera — In television, an electronic device utilizing an optical system and a light-sensitive pickup tube to convert visual images into electrical impulses.

Cassette — A self-contained package of reel-to-reel video tape.

Cathode ray tube (CRT) — The television picture tube.

CATV — Cable television: a system which distributes broadcast programs and original programs and services by means of a coaxial cable.

Chroma key — In color television, an electronic matting process of inserting one image over a background.

Clogged head — A build-up of oxide on the VTR recording or playback head that causes noise, breakup or loss of picture.

Closed-circuit television — A system of transmitting TV signals in which the receiving and originating equipment are linked by cable, microwave, etc., without broadcasting to the public.

Coaxial cable — The cable used as a hardwire link between receiving equipment and originating equipment for the transmission of television signals.

Collateral material — Material, such as a brochure or training guide, which accompanies and supports a video program.

Common carrier — Any point-to-point communications relay service available to the public at non-discriminatory rates.

Compatible color system – Color signals receivable as black and white pictures on monochrome television sets, and black and white signals receivable by color sets.

Contrast – The difference in brightness levels among the elements of a television picture.

Control room – Room from which the production activity is monitored and coordinated.

Control track – The area on the tape containing a series of synchronizing pulses used primarily to control the longitudinal motion of the tape.

Conversion – Procedure by which a program recorded on one tape format is transferred to another format.

Cover shot – Also called an establishing shot, a wide-angle shot giving a view of the entire set or scene, used to orient the viewer to the overall place and action.

Crawl – Graphics or copy that move up or across the screen.

CU – Close-up camera shot.

Cue – Signal to begin.

Cut – Instantaneous switching from one picture to another.

Dissolve – Gradual transition from one television picture to the next by which the first picture is faded out and the second faded in simultaneously.

Dolly – Movement of the camera toward or away from the subject.

Downtime – Period when video tape equipment or studio is not in use.

Drop out – Loss of part of the video picture caused by dirt or grease on the tape, faulty head to tape separator or a lack of iron oxide on that portion of the tape.

Dub – a) To make a copy of a recording; b) A copy.

Earth stations – Ground terminals that transmit, receive and process communications via satellite.

ECU – Extreme close-up.

Edit – The process of putting together on one tape the desired production footage and any special effects in final program form.

Educational channel – FCC rules require cable systems in the top 100 markets to set aside one channel for educational uses, to be available without cost for a specified period of time.

Establishing shot – See **cover shot**

ETV – (Educational Television Station) A noncommercial television station primarily devoted to educational broadcasting.

Fade – A fade-in or fade-out is when a picture gradually emerges from or recedes into black.

Feedback – a) The loud squeal from improper microphone hookup; b) The reaction of the receiver of a communication back to the source.

Field – One-half of a complete scanning cycle; two fields are one frame.

Film chain – The equipment used so that 35mm slides and motion picture film can be used on television.

First generation – The original or master of a video tape program (the first copy is the second generation).

Footcandle — A unit of measure of the amount of light falling on a surface.
Format — Width of tape on which a VTR records — 1/4 inch, 1/2 inch, 3/4 inch, 1 inch and 2 inch. VTRs are designated by their format.
Frame — One complete television picture.
Freeze frame — Repeating or holding one frame so that it appears that action has stopped.

Gain — a) In audio, the term for volume; b) In video, contrast.
Generation — A copy, or dub, of a film or tape.
Government channel — A channel on cable systems in the top 100 markets set aside for use by local government at no cost.

Hardware — The equipment involved in production, storage, distribution or reception of electronic signals.
Hardwire net — Refers to hardwired, or cable, system of distribution (as opposed to over-the-air method).
Head — The device on a VTR for signal pickup and recording.
Headend — Electronic control center which receives and transmits broadcast TV signals or original signals to receiving locations on a cable system.
Helical scan — Method of tape recording in which the signal is recorded diagonally on the tape as it passes a revolving drum.
Hot spot — Too much light falling on a performer or object on the set.

Immediate access — To store and retrieve information instantly.
Insert — An additional piece of video tape or film clip added to a scene during the edit.
In sync — When sound and picture match perfectly.
Interference — Extraneous energy in the signal transmission path which interferes with the reception of the transmitted signals.
ITFS — Instructional Television Fixed Service is a method of broadcasting using a special microwave frequency which can only be received by television installations equipped with a converter to change signals back to those used by a television set. With a range of 30-50 miles, it is ideal for school systems.

Kinescope recording (also **Kine**) — A motion picture film made from a television monitor.

Lag — The image on the television screen trails behind actual movement.
Leased channel — At least one channel on a cable system which is available for lease by part-time users.
Lip sync — The recording of words or song synchronized to the lip movements of the talent.
Live — When the viewer sees what is taking place on television at the same moment it is happening.
Location (also **Remote**) — A shooting site other than the studio.
LS — Long shot.

Master — The original recording of a finished program.

Matte — Imposition of a scene or title over another scene.

Microwave — Method of transmitting television signals over the air from an origination point to a receiver in line-of-sight at high frequency.

Moire — A wavy effect produced on the television screen by a convergence of lines.

Monitor — A television set that accepts direct cable feeds from a television camera or VTR.

MS — Medium shot.

Narrator — On- or off-camera talent who delivers the copy in a television program.

Network — a) Broadcast network — television carried on a national basis by many stations which receive and telecast programming from a central point; b) Private network — having a number of locations which receive television programming by cable, microwave, cassette, RF, etc.

Noise — Random electrical interference in the television image being received.

Off-the-air — Reception of a TV signal that has been broadcast through the air.

Off-the-shelf — Professionally produced, pre-packaged programs, usually of a generic nature. Its alternative is Custom Produced Programming.

Optical effects — Special effects on the video.

Pan — Movement of the camera to the left or right across the scene.

Pay TV — A system of television in which scrambled signals are distributed and are unscrambled at the subscriber's set with a decoder that responds upon payment for each program; pay TV can also refer to a system where subscribers pay an extra fee for access to a special channel, such as Home Box Office.

Public access — One channel on cable systems which is free and available at all times on a first-come, first-serve basis for noncommercial use by the general public.

Pickup tube — An electron-beam tube in the television camera by which light from an image focused by the lens is converted to an electrical current.

Picture tube — The cathode ray tube of a television set.

Playback unit — A video tape unit for the playback of recorded tapes.

Post-test — A test given after viewing a video program which measures what was learned from the program.

Pre-test — A test given before viewing a video program which measures what the audience knows about the subject.

Public Television — Noncommercial television broadcasting.

Quadruplex recorder — A VTR which has four record and playback heads for use with 2-inch tape.

Remote — see **Location**

Resolution — The ability of a video system to reproduce details.

RF — Radio frequency — transmission system using the radio spectrum to carry audio and video signals.

Scanning — The movement of the electron beam of the camera tube by which an image is broken down into a series of elements representing light values.

Scene — a) A sequence in a television program; b) The setting in which the action is occurring.

Shelf life — The period of time a program's content is usable.

Shooting script — A television script which includes a narration or dialogue and related camera shots, sound effects and other production information.

Signal — Visual or auditory information converted into electrical impulses.

SMPTE — Society of Motion Picture and Television Engineers.

Software — Programming.

Storyboard — Drawing of the major shots in a television program accompanied by key dialogue cues.

Super — Superimposition of a picture or title over another.

Switcher — A control unit which enables switching from one video source to another.

Talent — The performers in a television program.

Tilt — Vertical camera movement.

Time code — A code developed by SMPTE that can be laid down on video tape which uses time [frames (1/30 of a second), seconds, minutes, hours]. The time code is displayed on the video and used in editing.

Video — a) Television; b) The picture portion of a television signal.

Video tape — Magnetic tape for the recording and playback of television and audio signals.

Voice-over — The words spoken by an off-camera narrator.

VTR — Video tape recorder.

Wipe — An optical effect in which a new scene gradually replaces the old scene.

Zoom — A camera lens that is variable from a wide angle to a telephoto position.

Selected Bibliography

Barnouw, Eric. *Tube of Plenty*. New York, NY: Oxford University Press, 1977.

Barwick, John H., and Stewart Kranz. *Profiles in Video*. White Plains, NY: Knowledge Industry Publications, Inc., 1975.

Barwick, John H., and Stewart Kranz. *Why Video?* Prepared for Sony Corporation, 1975.

Bensinger, Charles, et al, eds., *PhotoGraphic Magazine. Petersen's Guide to Video Tape Recording*. Los Angeles: Petersen Publishing Company, 1973.

Bunyan, John A., and James C. Crimmins. *Television and Management: The Manager's Guide to Video*. White Plains, NY: Knowledge Industry Publications, Inc., 1977.

Brush, Judith M. and Douglas P. *Private Television Communications: The Awakening Giant*. New Providence, NJ: International Industrial Television Association, 1977.

Educational and Industrial Television. Ridgefield, CT: C.S. Tepfer Publishing Co., Inc.*

The Focal Encyclopedia of Film and Television Techniques. New York, NY: Hastings House Publishers, 1969.

Industrial Television News. New Providence, NJ: International Industrial Television Association.*

Millerson, Gerald. *The Technique of Television Production*. 9th ed. rev. New York, NY: Hastings House Publishers, Inc., 1972.

Murray, Michael. *The Videotape Book*. Toronto and New York: Bantam Books, Inc., 1975.

Quick, John, and Herbert Wolff. *Small-Studio Video Tape Production*. 2nd ed. Reading, MA: Addison-Wesley Publishing Company, Inc., 1976.

Shanks, Bob. *The Cool Fire*. New York and Toronto: Random House, 1977.

Veith, Richard. *Talk-Back TV: Two-Way Cable Television*. Blue Ridge Summit, PA: Tab Books, 1976.

Videography. New York, NY: United Business Publications, Inc.*

The Video Handbook. New York, NY: Media Horizons, Inc., 1972.

Video Systems. Overland Park, KS: Intertec Publishing Corp.*

VU Marketplace. White Plains, NY: Knowledge Industry Publications, Inc.*

Zettl, Herbert. *Television Production Handbook*. 3rd ed. Belmont, CA: Wadsworth Publishing Company, Inc., 1976.

*periodical

Index